5/7 End of Art By Artist
Anthol.

1992 1ST 24⁹⁵

ARTISTS *and* BOHEMIANS

100 YEARS WITH THE CHELSEA ARTS CLUB

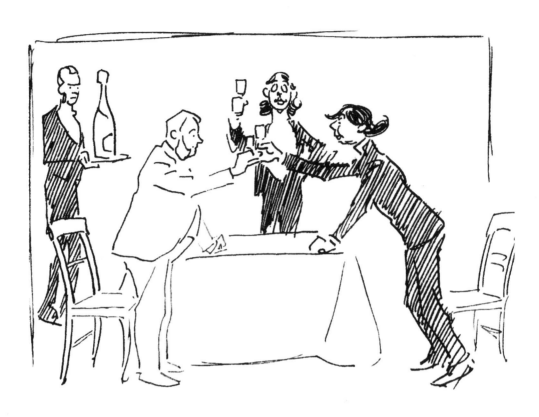

'A Toast' by Phil May RI, NEAC.

ARTISTS *and* BOHEMIANS

100 YEARS WITH THE CHELSEA ARTS CLUB

TOM CROSS

QUILLER PRESS

LONDON

First published 1992
by Quiller Press Limited
46 Lillie Road
London SW6 1TN

ISBN 1–870948–60–2

Produced by Hugh Tempest-Radford *Book Producers*
Consultant Designer Sally Jeffery
Typeset by Goodfellow & Egan
Printed in Great Britain by Jolly & Barber Limited

Contents

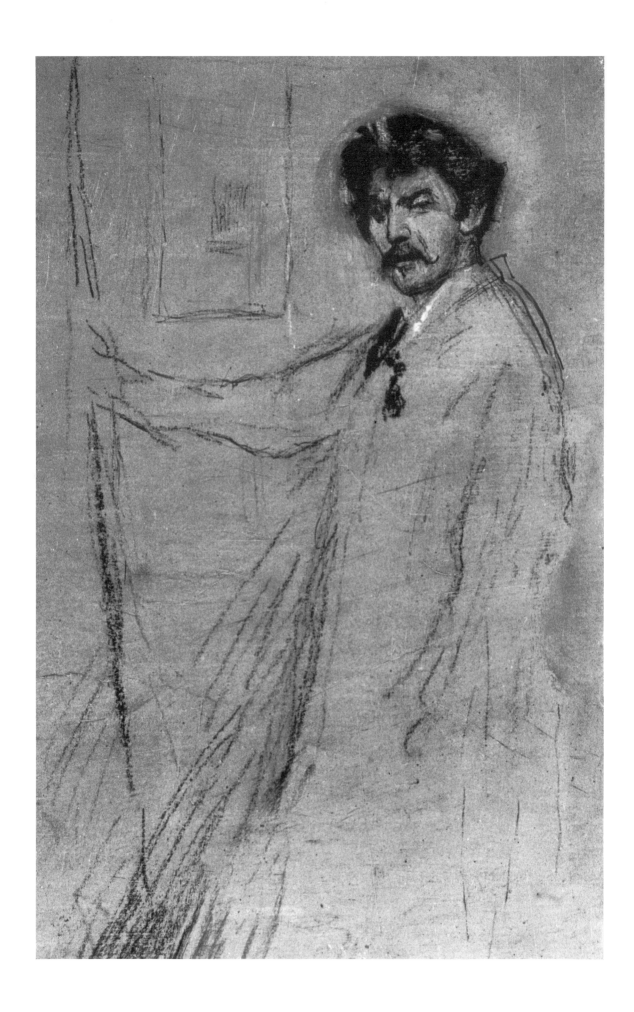

Preface

When the Chelsea Arts Club opened in March 1891 with 55 members, it is to be wondered how many of them would have foreseen that its Centenary would be celebrated in 1991 with some 1600 paying members. Even when the Club moved to its present location in 1901 the town membership stood at only 104, and its lease was to expire in 1911. Few would have imagined that the Club would be able to purchase a new 99-year lease in 1987 at the cost of over £720,000, of which some £450,000 was immediately raised from the members by the way of cash and the donation of pictures sold at Sotheby's on behalf of the Club, thus leaving a relatively modest bank loan which is being steadily paid off over 20 years.

The character of the Chelsea Arts Club has undergone minor changes from time to time, but anyone reading this history will appreciate that although there have been periods when it was on the 'stodgy' side, as indeed it was when I first visited it, there were many characters among its members to whom such a description would be most inappropriate. As one who has used the Club for some 30 years, I would say that its character has remained much more constant than a superficial look at a particular year might lead one to believe. Probably the greatest change that took place in the Club's history was the election of lady members, who incidentally did not rush to join at that time, when they were not allowed to use the billiard room with its large bar. This was soon changed and the first and so far only lady 'chairperson' of the Club, Jane Coyle, was elected in 1980. Since then it would be unheard-of for there to be less than two or three ladies on the Council, and the number of lady members has increased considerably.

The history of the Club is littered with famous names, but it must not be forgotten that, in a great many instances, when they first became members they were certainly not famous. There are many new members who one day will achieve the recognition attained by their illustrious predecessors.

Although this is above all a history of the Chelsea Arts Club, it throws an interesting light on the history of certain aspects of British Art from 1891 up to the present time, particularly in respect of personalities and their 'off-duty' hours. Tom Cross must be congratulated on the immense amount of detailed and difficult research which he had to undertake and the fascinating and faithful history of the Chelsea Arts Club that he has produced.

L.S. MICHAEL

'Self-Portrait' by James McNeill Whistler PRBA. The most prominent founder-member and prototype Bohemian.

Acknowledgements

Throughout this project I have received great help and encouragement from many members of the Chelsea Arts Club, most particularly from past Chairmen and senior members. I would like to acknowledge in particular Dudley Winterbottom, Secretary of the Club, who initially conceived the idea of the book, and Bill English, Chairman from 1989 to 1990, who suggested that I write it. I am also indebted to the present Chairman Hugh Gilbert and past Chairmen John Warner, Jane Coyle, Roger McGough, Frederick Deane, and Patrick Hughes. I would like to thank Stanley Ayres, Carel Weight and John Frye Bourne for their help and advice and also the late Ley Kenyon.

In the early stages of this project I was helped by the research undertaken by Jane Averill. I also received considerable help from the staff and resources of the Department of Local Studies of Chelsea Public Library and the archives of the Imperial War Museum, the National Portrait Gallery and the Victoria and Albert Museum. The notes and reference material of Tom Hancock, Chairman from 1962 to 1964 and historian of the Club, were placed at my disposal and were an invaluable source of information.

I am particularly indebted to Bill Michael for help throughout this project and for his kindness in writing an introduction to this book. For an assessment of the financial position of the Club over the years I was greatly helped by Phillip Roberts, Honorary Treasurer, and Richard Maurice, previous Honorary Treasurer. In addition the office staff of the Club have been unfailingly helpful and patient.

For general information relating to early members, I was helped by Peyton Skipwith of the Fine Art Society and the family of Basil Gotto. For information on the New English Art Club I would like to thank Al Weil and Charlotte Halliday. For the use of manuscript notes by 'John the Steward' I am indebted to Mrs D.M. Harvey. For the artists associated with *Punch* I was greatly helped by Amanda-Jane Doran of the *Punch* Library and Archive.

For information on the Arts Balls between the wars, I would like to thank John Rose. For information on H.M. Bateman I am indebted to Mrs Diana Willis and for information on Henry Rushbury to Mrs Julia Ramos. Thanks also to Harold Underwood Thompson for information about his sister 'Anton' and to George Grimm for details relating to his father Stanley Grimm.

Finally and most especially I am grateful to my wife Patricia who has worked closely with me at all stages of this project and who brought the final manuscript to completion.

Tom Cross
1992

Introduction:
A Village of Palaces

Chelsea was Bohemia in London. It cherished its artists and in return they recorded the changes as it developed from a quiet village by the Thames into an important part of the busy metropolis. At first, Chelsea was a fishing village, built on a shelf of pebbles that gave a landing among the marshy river banks. A few cottages clustered around its manor-house and church; orchards and vineyards gave it a rural character and the villagers supplied fish to the Billingsgate Market.

That 'mildest and kindest of men' Sir Thomas More, newly appointed as Henry VIII's Chancellor, bought land by the river where he could enjoy the fresh air, away from the congestion of the City. His spacious house was built of red brick, set around two courtyards, as happy as it was simple and unostentatious. To this educated and studious household came the first, and perhaps the greatest, artist to work in Chelsea – Hans Holbein, who arrived as a refugee from the European wars. For three years he portrayed the household, using the newly invented methods of oil painting, before becoming court painter to Henry VIII. The tragedy of More's execution at the hands of Henry is one of the dark pages of English history. King Henry built a palace nearby, on the site of the old manor-house of Chelsea, supplied with fresh water from a mineral spring in Kensington. During the troubled years of Henry's reign, the royal children were educated there, and throughout the period of the Tudors it remained a royal palace. Five great mansions stood by the river in Tudor times. More's house was rebuilt in 1590 by Sir Robert Cecil and later owned by the Duke of Buckingham. The old manor-house later became Monmouth House. On the river near to the palace lived the Earl of Shrewsbury, for many years the keeper of the imprisoned Mary Queen of Scots, and just west of More's house was a mansion built by Sir Arthur Georges, later passed on to Sir Robert Stanley.

The river was Chelsea's thoroughfare; until the reign of George III, when the King's private road was opened to the public, Church Lane was the only road into Chelsea by coach. The hour's walk into London was a hazardous journey with the danger of footpads on the lonely road. With the new interest in classical principles of architecture and landscape design, Christopher Wren achieved grandeur with a simple, almost monastic effect in the buildings of the Royal Hospital at Chelsea, built to provide a home for some of the many thousands of discharged soldiers who roamed the countryside during the reign of Charles II. It was sadly delayed through lack of finance and took eight years to build.

The topographical artists recorded the spectacle of the river with its great houses and gardens. At the beginning of the eighteenth century the Dutchman Pieter Tillemans, already known in England for his views of

seaports and harbours, painted a panorama of the river that extended from the classical buildings of the Royal Hospital to the Old Church. Joannes Kip made engravings which depicted the building of Beaufort House and the extensive remodelling of its garden layout, based on Italian examples. The same spirit of enquiry led the Apothecaries' Society to choose a plot of fertile land along the river as the site for the Physic Garden. Here they created a great scientific centre in which they gathered together, classified and bred, herbs and medicinal plants from all over the world. Within a few years, this remarkable garden had established connections with botanical explorers from all over the world.

Sir Hans Sloane, eminent physician and astute businessman, left an indelible mark upon Chelsea. In the old manor-house he installed his growing collection of rare objects, flora, fauna and metals, as well as precious antiquities, curiosities and a magnificent library that later formed the basis of the British Museum. He lived in Chelsea for the last ten years of his long life and died in 1753 at the age of eighty-two. His considerable properties, which amounted to more than half of the parish of Chelsea, were inherited by his two daughters and their descendants, the Sloane Stanleys and the Cadogans. Those areas of east Chelsea which bore his name, Sloane Square and Sloane Street, Hans Place and Hans Crescent, were the work of later generations of builders, anxious to satisfy the expanding number of merchants and professional men who added to the wealth of London in the eighteenth and nineteenth centuries.

As the eighteenth century progressed, the rural landscape of Chelsea was covered by new houses and the paddocks and orchards of the royal palaces became encircled. A wide and pleasant road called Cheyne Walk now ran along the Thames and the pleasure boats and barges of the gentry tied up at its many moorings. As late as 1796 a stag hunt through Chelsea ended in Church Lane.

Chelsea retained its reputation for pleasure. Near to the Hospital stood the great house of Ranelagh, the official residence of the Earl of Ranelagh. In 1742, in a blaze of publicity, its huge and ornate gardens were turned into a place of entertainment, with music, fireworks and dancing. A great rotunda was built, a 'pleasure dome' where hundreds could promenade, take refreshments or listen to the great organ. The King had his own house there and took part in the fancy-dress parades, and the young Mozart performed. It remained fashionable throughout the middle years of the eighteenth century, a place for regattas and great dinners. Ranelagh survived the century, rivalled in London only by Vauxhall, but in the year of Trafalgar the great house and the Rotunda were demolished, together with all of the embellishments to its gardens, and not a trace remained.

The great satirists of the eighteenth century, Gillray and Rowlandson, were keen observers of Chelsea frivolity. James Gillray was born and brought up near to the Old Moravian Burial Ground in the King's Road. He became one of the earliest students at the newly established Royal Academy Schools, under Joshua Reynolds, and built his career as a caricaturist upon this sound artistic training. Thomas Rowlandson was born in the same year as Gillray (and as William Blake) and was a fellow student at the Royal Academy; he also trained in France. His searching drawings expose the turbulent years of George III's reign with a highly developed sense of the ridiculous.

Several of that exclusive group of forty original members of the Royal Academy lived and worked in Chelsea. John Baptist Cipriani designed the external decorations of Somerset House and painted the fine decorations of the library and staircase when it was remodelled to house the Royal Academy. Cipriani was closely associated with Francesco Bartolozzi, painter and engraver. They collaborated on a number of artistic enterprises including the design and engraving of the ornate Diploma awarded to all Royal Academicians on their election. Their last collaboration, sadly no longer in existence, was the tomb of Cipriani, designed by Bartolozzi for the Old Burial Ground in King's Road, but destroyed by bombs during the Second World War.

John Varley and Thomas Girtin painted the wide river with cornfields to its edge and a few small houses around the Old Church, dominated by a windmill. Girtin was born in the same year as Turner and both were pupils of the same master. From the first there was rivalry between them: Girtin won early success and some patrons preferred his work to Turner. It was said that 'Turner effected his purpose by industry, Girtin has more genius.' However it soon became apparent that Turner's dedication was more valued; he was elected ARA in 1799 by a large majority, whereas two years later Girtin's candidacy was rejected. Girtin's early death removed him from any further competition, but Turner's much-quoted remark indicates his enduring respect: 'If Tom Girtin had lived I should have starved.'

In the early part of the nineteenth century Chelsea had the appearance of a small country town. Its population was increasing rapidly and building was encroaching almost everywhere. The nursery gardens along the King's Road were replaced by large houses, shops and tradesmen's premises and the handsome houses of Chelsea Square, Carlyle and Paultons Square were erected. Lesser houses without embellishment housed tradesmen and servants. Terraces of small houses crowded between the King's Road and the river, bounded by the spacious grounds of the Royal Hospital to the east and market gardens to the west.

Chelsea's pursuit of pleasure, innocent and otherwise, continued with a further experiment in mass entertainment at Cremorne House, a fine park of eight acres in west Chelsea. In 1831 it was turned into a National Club for Athletics, with instruction in such manly sports as riding, swordplay and rowing, and archery for the ladies. Later it opened as a pleasure-ground with concert room, circus and a large banqueting hall, as well as an American bowling saloon, a Firework Temple, a Chinese pavilion, walks and fountains. In the dancing hall, four thousand dancers could take to the floor and the theatre provided music-hall and comedy. Spectacular feats of tightrope walking across the Thames, balloon ascents and parachute descents were offered, sometimes with disastrous results. Londoners, especially the lower classes, flocked to the scene and the nearby public houses blossomed. By 1875, however, the once-sedate gardens had become so disreputable that they were closed as a public nuisance.

J.M.W. Turner, the greatest painter in England, came secretly to Chelsea in the last years of his life to find peace and tranquillity, away from the glare of public attention. He was known to the watermen as 'Admiral' Booth because of his appearance – short, stumpy and weather-beaten with piercing grey eyes – and also because of the telescope he often carried. He lived at the end of Chelsea Reach in a small house, No. 6

Daw's Place (now 119 Cheyne Walk), leased to Mrs Booth, who had earlier been his landlady in Margate and who had looked after him on his many excursions to the south coast.

Turner had taken English landscape paintings from meagre beginnings into a vision of the sublime. Fame, reputation and great success brought him a fortune, but he had remained solitary and unsociable, alone in a large house in Queen Anne Street, Marylebone, his paintings exhibited in a dusty gallery alongside. To escape, he fled to Chelsea where he enjoyed a few peaceful years of reflection and contemplation. He painted little, mainly working on earlier pictures. From his little house he could watch the river in all of its moods, from sunrise to sunset, its mists and vastness and the romance of its maritime life. On the roof of his narrow three-storied cottage, Turner built a sitting area from which he could spend hours gazing at the spectacle of changing light. Sometimes he would hire a waterman to row him across the river, past the boats of all sizes that crowded its banks. Often the boatman was Charles Greaves, whose sons, Henry and Walter, would serve Whistler in the same way.

The Irishman Daniel Maclise came to Chelsea in the last decade of his turbulent life. He had gained favour at the Academy in the 1840s as an illustrator and portraitist and had become accepted into the fashionable world of literary London. His good looks and his ambition involved him in a number of scandalous episodes – one of which was an adulterous affair with the mistress of Disraeli, the notorious Lady Sykes. He was also a friend and companion of Dickens; his portrait of the author, now in the National Portrait Gallery, is his best-known work. Whilst in Chelsea he was engaged in the mountainous task of painting two great frescoes for the House of Lords: *Wellington and Blücher* and *The Death of Nelson*. He worked at these exacting commissions for eight years, but at the end he was distressed by their impact in the gloomy hall of Westminster and profoundly disappointed with the result.

That other Romantic, John Martin, supported his family 'by pursuing almost every branch of my profession, teaching, painting small oil pictures, glass enamel painting, watercolour drawings, in fact the usual tale of a struggling artist's life.' He illustrated Milton's *Paradise Lost* in 1827; his highly detailed depictions of biblical catastrophe brought him fame and success and the many mezzotints and engravings of these large compositions found a place in many Victorian parlours. For these apoca-lyptic scenes of devastation, Martin studied the skies of Chelsea from the upper rooms of his house. Charles Greaves, who had rowed Turner, gave the same service to Martin, who instructed him 'If there are any good clouds and a good moon, ring my bell.' When the bell rang, Martin would make his sketches from the balcony.

In the middle of the nineteenth century, workshops were built in Chelsea as part of the preparations for the Great Exhibition held in Hyde Park in 1851. These sheds for metalworkers, gilders and other craftsmen, later served the artists of Chelsea as studios for painters and sculptors.

The Pre-Raphaelites had long connections with Chelsea. Holman Hunt had painted his two most popular works, the highly sentimentalized Christ in *The Light of the World* and that moral tale *The Awakened Conscience* in a studio in Prospect Place. Some years later he had a studio in Manresa Road before he moved to join the more prosperous artists of Kensington.

The guiding spirit of the Pre-Raphelite group was Dante Gabriel

Rossetti, the son of a renegade Italian poet who escaped to London. In 1860 Rossetti married Elizabeth Siddal, herself a painter. She became his principal model, but his repeated infidelities and lack of consideration contributed to her death by suicide less than five years after their marriage. Shortly afterwards, Rossetti moved to Tudor House, Cheyne Walk, a handsome but disordered ménage which he shared with various friends – George Meredith was one, the tempestuous Charles Algernon Swinburne another. In his large garden he created a menagerie of animals and birds, various owls, jackdaws, ravens and peacocks, a pet wombat, a racoon, a laughing jackass, a zebra, a variety of ducks and an armadillo, which intruded themselves into neighbouring gardens with alarming results. In the poorly lit studio room overlooking the garden he realized some of his most important paintings, mainly of women in sumptuous and luxurious settings, including *Beata Beatrix*, *Dante's Dream* and *The Blessed Damsel*. Later Rossetti became infatuated with Janey, the young wife of William Morris. Tall and graceful, dark-haired with deep piercing eyes, she became an indispensable model and a visonary object of love. Her departure for Italy and a vicious critical attack upon Rossetti's work precipitated his tendency to paranoia. He became haunted by the memory of his dead wife, and increasingly addicted to drink and chloral. In his last years Rossetti presented a sad spectacle: fat, slovenly and heavily in debt.

The river was changing. The old Battersea Bridge was demolished in 1855 to be replaced by a new iron structure; shortly after this the old wharves between the Church and Battersea Bridge were cleared to make way for the western extension of Cheyne Walk. In 1874 the Embankment was built to protect Chelsea from the ever-present danger of flooding. The landings, boatyards and piers, the old inns and the rickety old buildings along the river that had served the boatmen, the little jetties and the taverns with balconies hanging over the water that were such a feature of the old village disappeared. The river of Whistler and Walter Greaves vanished for all time. The well-to-do left Chelsea and, as Mayfair and Kensington became more fashionable, Chelsea became more easy-going, more Bohemian.

'Cheyne Walk 1872' by Charles Napier Hemy RA. Hemy was a friend of Whistler and Brangwyn. This painting of the river was made shortly before the building of the embankment to protect Chelsea from flooding. The old Church of All Saints can be seen in the background.

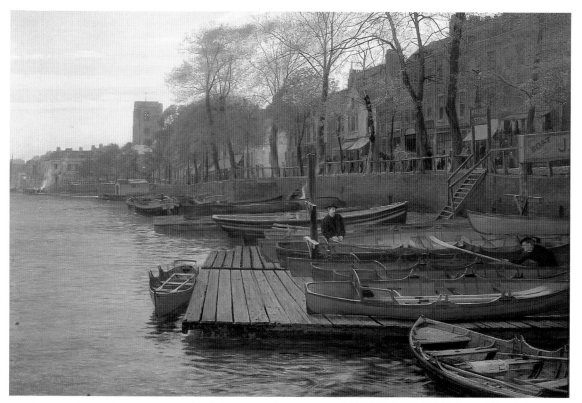

1 The Formation of the Chelsea Arts Club

They were young and this was Chelsea. The artists who formed the Chelsea Arts Club had come to a part of London that retained the air of a village by the river, apart from the great business capital. Many of these young artists, at the start of their careers, had recently returned from Paris. They had sprung from the new middle class that had emerged during the reign of Queen Victoria, with the means to encourage the arts and the leisure to enjoy them. Educated and alert students, they were curious to explore the full dimensions of European art. Their creative urge had remained unfulfilled by their training in England and they were drawn towards the European capitals. Paris remained 'the centre of the world . . . the art school of the world . . . and the art market of the world.'[1] The end of the Franco-Prussian war in 1871 issued in a new period of internationalism; some news of the bitterly contested triumphs of Impressionism had filtered through to London, but it was not these advanced doctrines that influenced the English students. In the teaching studios of Paris or Antwerp they were introduced to the earlier 'Realist' principles of Courbet and Millet, and a training based on the close observation of nature, by teachers who were of a generation before the Impressionists.

To cater for the large numbers of students flocking to the capital, a number of private 'ateliers' were set up in the 1860s and 1870s, run by well-established Salon painters. The Académie Julian, started in 1873 by Rudolphe Julian, became a favourite with foreign students, as did the Académie Suisse, run by a retired model who gave no instruction but offered the freedom to work from the nude. Carolus-Duran's studio was also popular with English-speaking students. The master was a dapper and sophisticated Anglophile, a highly successful portraitist, who emphasized the virtues of direct painting without preliminary drawing, 'search for the mid-tones and work broadly from there.' In the 1870s his most brilliant student was the American John Singer Sargent, already beginning to make a considerable reputation and later to be a leading member of the Chelsea Arts Club.

After their years in Paris or Antwerp, with perhaps summers spent in one of the artist colonies – Pont Aven in Brittany or Gréz-sur-Loing in Normandy – the students returned to London to begin their professional careers. In Chelsea they found a community with the same commitment that they had shared in Paris; studios were available and inexpensive lodgings in the newly built terraces.

That area where the King's Road met Church Street became known as 'The Latin Quarter'. It had hundreds of studios and more were being built. Some were in terraces with Virginia creeper covering the outer walls; others were in large barn-like buildings, down dark corridors or across

timber-yards. The studios of sculptors could be distinguished by their wide coach-house doors, lifting tackle, and the blocks of stone that littered the yard. The largest group were in Manresa Road, then a cul-de-sac, with several groups of large rambling studios linked by courtyards, on its eastern side, backing on to the mortuary and work-house of Arthur Street. Some of these had been built as workshops for the metal workers and other craftsmen who created the Great Exhibition of 1851 in Hyde Park. They stood beside the old burial ground, now no longer used for interments but as an exercise yard for the old women of the Chelsea Workhouse. From the studios the women could be seen wandering behind the iron railings, dressed in their bright red-and-black check shawls, blue cotton dresses and white frilled caps.

On the western side, where the Chelsea Polytechnic was later built, were Merton Villa Studios, a ramshackle group of buildings around a yard, entered by a narrow lane littered with old carts, gradually falling to pieces. Across the lane was a long studio occupied by a sculptor, Thomas Stirling Lee, with a shed containing works in progress and others long past hope of sale. At night a bronze-casting furnace shot a blue flame far above its iron chimney. 'The vague melancholy which broods over a spot of little traffic in a busy neighbourhood made the place seem as far from the respectable houses in the near streets as the artists were in mind from the people of worldly activity or retired bourgeois who occupied them.'[2] Frank Brangwyn worked there for a time as did La Thangue, James Charles and James Jebusa Shannon.

The studios were the workshops of Chelsea: they were not very smart. Any old loft or warehouse could be converted and £40 per year was thought to be a big rent. Trafalgar Studios in Manresa Road were occupied at different times by many well-known names including James Elder Christie, Leslie Ward (known as 'Spy', the *Punch* cartoonist), Frank Brangwyn and Philip Wilson Steer. At Wentworth Studios was the sculptor Havard Thomas and the painter Jacomb-Hood. The Garden studios were a smaller group at the King's Road end, on the site of the Chelsea College. Opposite, in Glebe Place, were some of the first purpose-built studios, thought to be very smart. The Avenue studios in the Fulham Road, where Bohm, Alfred Gilbert and Poynter worked, were originally tradesmen's workshops when the Onslow Gardens Estate was built.

The artists working in this community looked for somewhere to meet, talk, eat and drink. It had to be nearby, for few could afford hansom cabs and the horse-buses that were drawn along the King's Road were notoriously slow. Money was not plentiful and the art-buying public was fickle, but the artists helped one another and optimism could soon be restored by the arrival of a friendly cheque. They were easy to recognize in Chelsea: dress was casual, sometimes disreputable; they went without their collars and smoked clay pipes. 'The man who talked impressively about "Art" and who goes in for silk ties and gold studs, soon removed himself to Hampstead.'[3]

Chelsea lacked the cafés and restaurants that had been the meeting places for the artists in Paris. If they did not cook their lunch over a gas ring in the studio, they would eat at a little ham and beef shop in the King's Road, run by a Dickensian couple. Sometimes they would use an Italian restaurant, Manzoni's, near Carlyle Square. One of the founder-members noted that the owners of Manzoni's heard that a club was proposed and, fearing the loss of their trade, immediately sold out to an

unsuspecting purchaser. The Monaco Restaurant in the King's Road was also a favourite but this, like Manzoni's, tended to close early. In the evening there was even less choice. There were plenty of pubs in Chelsea which served the watermen and the trippers who came in the summer, but they could offer little in the way of wholesome food. One of the most popular of the pubs was the Six Bells in the King's Road, and discussion took place among the artists about hiring a room to use as a meeting-place.

Some time in 1890 a group of friends began to meet more or less regularly in Stirling Lee's large studio after the day's work was done, for conversation, news of artistic events, and the enjoyment of each other's company. In the larger studios, 'at home' evenings were arranged at which some food and drink would be provided and the remainder brought along by the guests, each member in turn acting as host. These convivial evenings were greatly enjoyed and the more prosperous artists helped those in a less fortunate position. However, this made demands upon the working space of the studios and there was talk of how these amenities could be improved.

The first formal meeting that led to the formation of an artists' club was on 30 September 1890 in Stirling Lee's studio. Twenty-two artists were present and they mainly discussed the formation of an exhibiting society for the Chelsea artists. A committee of five, including J.E. Christie, Stirling Lee and Jacomb-Hood, were asked to look further into this. They later proposed that an exhibiting society, to be called 'the Chelsea Art Club', should be created. It was also suggested that an 'Art Union' be formed by which subscribing members were encouraged to purchase paintings or to acquire them by lottery.[4]

A second meeting, at which Whistler was present, took place on 25 October 1890. Still the talk was of an exhibiting society. The American artist, and friend of Whistler, Theodore Wores, proposed that 'A Club be formed of Chelsea artists, under whose auspices an annual exhibition be held.' According to one account of this meeting, one of the artists then

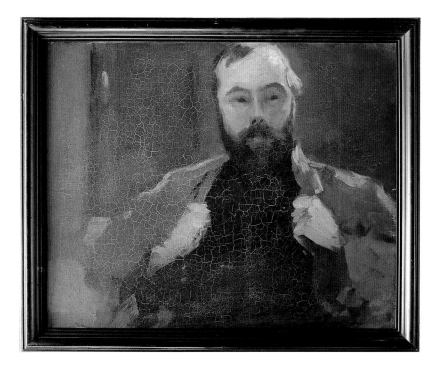

'Portrait of Stirling Lee, 1887', by Philip Wilson Steer NEAC. Stirling Lee was the first Chairman of the Chelsea Arts Club.

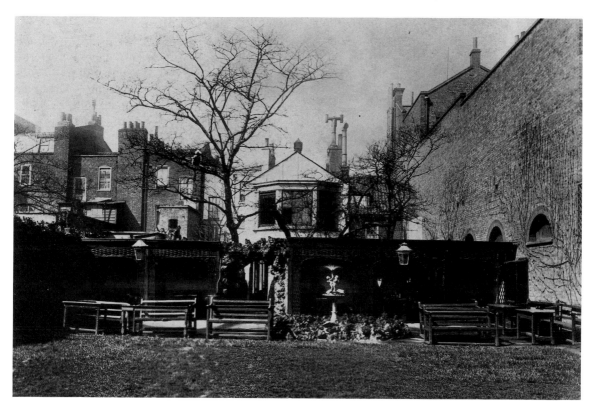

The Garden of the 'Six Bells' at 197 King's Road, Chelsea. A popular meeting place for artists, writers and musicians in the 1880s.

said that what Chelsea needed more than an exhibition was a Club. 'Club, club, club!' shouted everybody, and the exhibition was completely forgotten! Another of the artists, described as 'a Teutonic gentleman', suggested that they should rent a room in the Pier Hotel, which he mispronounced 'Bier'. Whistler rose, in his most dignified and supercilious manner. 'Gentlemen,' he said slowly, 'Gentlemen, let us not start our club in any *beer* hotel – let us start our club *clean*.'[5] At this same meeting it was agreed that the Club should be 'Bohemian in Character'.

A working group was appointed to draw up a scheme for the conduct of the Club, consisting of T. Stirling Lee, who became Chairman, J.E. Christie, Secretary, J. McNeill Whistler, G.P. Jacomb-Hood and Frederick Brown. A list of possible members was prepared, including a number who were not at the meeting, and they were written to. In November 1890 a constitution was agreed:

Rule No. 1 That the Club shall be called the Chelsea Arts Club.
Rule No. 2 That the Club shall consist of professional Architects, Engravers, Painters and Sculptors.
Rule No. 3 That the object of the Club shall be to advance the cause of art by means of exhibitions of works of art, life classes and other kindred means and to promote social intercourse amongst its members.
Rule No. 4 That its affairs shall be managed by a Council of thirteen members with Treasurer and Secretary. Ten of these would be elected by vote and this committee would have the right to choose the remaining three.

At an early meeting it was agreed that musicians be eligible for membership, but this was not acted upon.

The sculptor Thomas Stirling Lee, a friendly and convivial character much respected by his friends, was the prime mover in starting the club. In September 1890 he was elected as the first Chairman with a committee of J.E. Christie (Hon. Secretary), Frank Short, James McNeill Whistler, J.J. Shannon, W. Llewellyn, G.P. Jacomb-Hood (Hon. Treasurer), Hubert

Voss, W. Frith and Conrad Dresler; Fred Brown, E. Lanteri and Albert Toft were added later.[6]

Stirling Lee was a Londoner who trained at the Royal Academy Schools where he was a contemporary of La Thangue and Stanhope Forbes. After four years' study he gained a gold medal and left with a travelling scholarship to Paris. For a year he studied sculpture at the Ecole des Beaux Arts and then in Rome for a further two years. On his return to London, he began to make a reputation as a portrait sculptor. He lived in Chelsea throughout his life; when his Merton Villa studio was demolished in 1891, to make way for the new Chelsea Library, he moved to Vale Walk, off the King's Road, and converted a disused chapel into a studio. He developed the unusual practice of carving directly into the marble from life, without preliminary modelling in clay, treating the stone in an impressionist manner, defining light and shade rather than contour. One of his first important commissions was for a series of decorative panels for the new St George's Hall in Liverpool. The unconventional realism of his nude figures, however, led to a dispute with the City Fathers of Liverpool and his work was suspended. He later carved stone panels for two of the Chapels in Westminster Cathedral and he also worked in silver, designing medals and portraits of great delicacy.

George Percy Jacomb-Hood was a highly gifted painter, illustrator and etcher, and a product of the newly established Slade School. Among his special friends at the Slade were Joseph Benwell Clark and Henry Tuke, also founder-members of the Club. Jacomb-Hood won the Poynter prize at the Slade and a travelling scholarship which took him to Paris, where he and his friends Tuke, Clark and de Glehn (another early member) were students at Laurens' studio. Jacomb-Hood was an outdoor man, a keen horseman, and an early cyclist. In 1889 he worked in Wentworth Studios and later in Tite Street. He was an enthusiastic member of the first Committee and his autobiography, *With Brush and Pencil*, recalls in light-hearted detail the character and appearance of the Club and its early members. He became the Treasurer of the Club and for the first three years was responsible for the book-keeping and for much of the housekeeping and paying the tradesmen's accounts. His cousin Steven Jacomb-Hood became the Club's first honorary solicitor.[7]

Although there was clearly great interest in forming a Club it still had no home. Towards the end of 1890 a suggestion came from one of the members, James Elder Christie, who offered the ground floor and basement of his house at 181 King's Road, a flat-fronted Georgian house with a studio at the back, next door to the newly built Town Hall. On 14 February 1891, the Committee met for the first time in its own clubhouse. Stirling Lee and James Jebusa Shannon put to the meeting that these rooms be taken by the Chelsea Arts Club and this was agreed with only one adverse vote. The formal launch of the Club, with fifty-five members present, took place on 18 March 1891 at 181 King's Road.[8] Soon gas rings were installed, sketchy cooking arrangements were made and suppers were available in the dining-room on Monday evenings. A little later a life-class and a sketch-class were formed.

The Club became a second home for artists who lived nearby. It was an easy 'go as you please' affair, but the Committee kept it alive and solvent. The studio at the back of the building formed a mess-room for meals and the room upstairs was for newspapers, chess and general sociability. Rudimentary furniture was bought, including a long second-hand dining-

table seating at least twenty. This is still in use in the Club, the oak top scrubbed white over the years. Later the Club expanded to the first floor of the building and a second-hand billiard-table was installed in the studio. The members looked after housekeeping and paying the tradesmen's bills, and a man and wife were found to act as steward and cook. The first of these were Mr and Mrs Harvey. Harvey had 'a watery eye and a shaky hand' and the level of his intoxication was of constant interest to members. Ronald Gray recalled that when he asked what he owed for a pot of tea the Steward replied 'One shilling and sixpence' (a West End price). When Gray protested that the price was rather stiff, Harvey answered airily 'All for the good of the Club!'[9] Unfortunately his addiction to whisky got the better of him: he alarmed the members by coming stealthily into the sitting room, locking the door behind him, raising his hand and whispering 'Shh – they are after me!' When he became convinced that he saw hobgoblins dancing and playing on the bell wires in the kitchen, he was removed to an infirmary.

After the departure of the Harveys, a new steward called Myers, a Creole and an extremely good cook, was appointed. His wife, a Scotswoman, was housekeeper. Myers's cooking, in particular his 'Angels on Horseback', became famous and the Monday dining nights were well attended. However Myers, who had been a sailor, was tall and strong and at times gave way to violent passions. On a certain occasion he and his wife came to blows and Myers proceeded to chase her around the Club rooms. One member, a dyspeptic and unsuccessful painter, H.P. Hall, sought to pacify the warring couple and received a powerful blow on the chin. In an even more bizarre episode Carey Elwes, a relation of Simon Elwes, who was sleeping in the Club, reported that he was wakened by screams of 'Murder, Help!' He rushed into the steward's bedroom and found him apparently trying to cut his wife's throat with a razor. How Elwes was able to prevent this wild man from carrying out his murderous intention was never understood, but these incidents were brought to a general meeting on 2 May 1892 and resulted in the Club dismissing a first-class cook and steward. His successor was an indifferent cook and a worse steward.

For a time James Elder Christie retained the studio in the house. He was a jovial and talented Scottish painter of historical subjects, who had trained in London and at the Académie Julian in Paris, where he became friendly with La Thangue and Stirling Lee. Ronald Gray remembered that 'Jimmy' Christie 'suffered a good deal from thirst.' Closing time was not strictly kept and it was common for Christie and some of the others to sit up all night in the Club. 'One morning I chanced to go to the Club early, just as Christie and his friends returned from bathing in the Serpentine after an all-night sitting. J.J. Shannon, who looked cold and miserable, told me that it had all been horrible; Christie was brimming over with good health and smiles as usual.' In 1893 Christie left London for Glasgow, where he became part of that group of realist painters known as 'the Glasgow Boys'. His vigorous paintings, often with children as their subject, became increasingly allegorical. Sickert admired his paintings and called him a primitive.

The most famous artist to be connected with the Club in its early years, indeed one of the best-known men in London, was the American-born James McNeill Whistler. He was considerably older than most of the other founder-members and had established a fearsome reputation. His extra-

ordinary talent, coupled with a blistering wit, had made him a central figure in London and Paris. He was a small man, self-absorbed, witty, with sparkling black eyes, sophisticated and notoriously vain. In the Club he was always impeccably dressed in a full-length frock coat of good cut, worn with white duck trousers in summer, his tall silk hat usually tilted to reveal the white forelock that brushed his dark curls. He wore light patent-leather dancing pumps with square toes, very un-English, with ornaments of bows or rosettes. He was seldom seen without a cane, and never without the monocle, which he used to great effect.

Whistler was born in Massachusetts, USA, and had been taken by his family to Russia at the age of eight, where his father had been appointed to advise on the railway being built by Tsar Nicholas I between St Petersburg and Moscow. Here Whistler began to show an aptitude for drawing and learnt to speak French fluently. After a brief period in the

'Members Present. March 18th, 1891'. A list of those present is Appendix B.

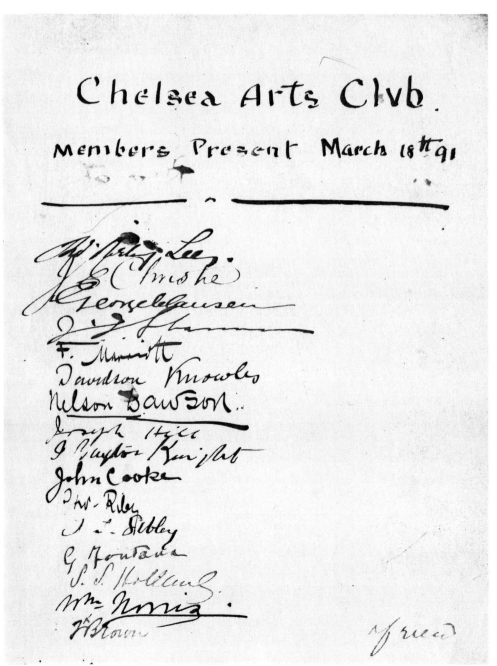

army at West Point, he persuaded his mother to allow him to train as an artist in Paris. At the studio of Gleyre he entered with spirit into the life of the Left Bank. He presented himself as a dandy and dilettante, but he was always a hard worker. He found his subjects in the high life of Parisian society and in the low life of the streets and cafés. He became the prototype 'Bohemian' as described in the novel *Scènes de la Bohème* by Henry Murger, which idealized the romantic life of the Parisian Left Bank, the penurious artists, hack poets and their attendant 'grisettes', models and seamstresses. It was said that Whistler had learnt the book by heart.

Whistler had come to Chelsea almost thirty years earlier when he rented 7 Lindsay Row (now 101 Cheyne Walk), where he lived with his tempestuous mistress Jo Hiffernan. This was also a period of friendship with the ageing Rossetti who lived nearby. Over the years Whistler

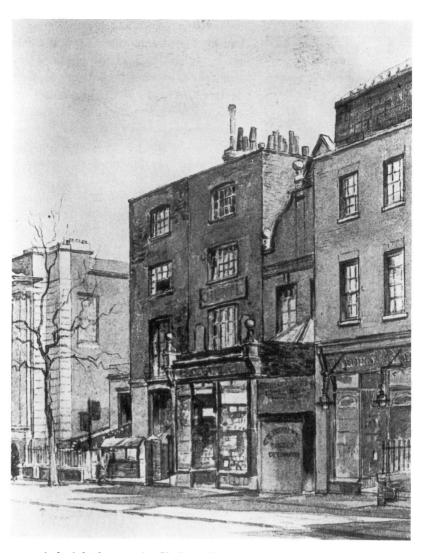

The premises of the first club house at 181 King's Road, Chelsea. Drawing by William E. Fox, made in 1924, shortly before the building of the New Chenil Galleries.

occupied eight houses in Chelsea, living longest at 2 Lindsay Row (96 Cheyne Walk), the east wing of the old Lindsay House, which he moved to in 1867 and occupied for eleven years. During this period Maude Franklyn replaced Jo Hiffernan as his model and mistress.

In the 1870s Whistler was at the height of his powers and produced some of his most important pictures. His work had advanced towards fused atmospheric colour and brevity of detail, to reveal the mood and drama of beauty caught in a fleeting glimpse at dawn or dusk. He had also made important contacts with Degas, Monet and the Impressionist painters, but he suffered a serious setback to his career. John Ruskin had seen a painting by Whistler called *Nocturne in Black and Gold – The Falling Rocket*, an impression of a firework display at Cremorne Gardens, on display in the Grosvenor Gallery. Ruskin, then elderly and almost certainly deranged, objected to the title and to the price asked, which he considered outrageous for a sketch. In his periodical *Fors Clavigera* he wrote 'Sir Coutts Lindsay ought not to have admitted works into the gallery in which the ill-educated conceit of the artist so nearly approached the aspect of wilful imposture. I have seen and heard much of Cockney impudence before now; but never expected to hear a coxcomb ask two hundred guineas for flinging a pot of paint in the public's face.' In a trial that was more remarkable for its misunderstandings than for legal argument, Whistler was successful, but was awarded the derisory

*'James Elder Christie' by
William Barr. J.E. Christie
NEAC was a founder member
of the Chelsea Arts Club. It
was in Christie's studio at
181 King's Road that the Club
had its first premises.*

damages of one farthing. Ruskin, the loser in the case and a wealthy man, had his costs borne by friends and admirers. Whistler received no such assistance and the criticism of his work and his behaviour at the trial angered his patrons. He found himself destitute and in May 1879 he was declared bankrupt. His house in Tite Street, called 'The White House', designed to his own specification and furnished with his superb collection of oriental pottery and objets d'art was dispersed.

Whistler retreated to Venice and did not return to Chelsea until 1881, to a rented flat and studio in Tite Street, where he became friendly with Oscar Wilde. During the period of public rejection Whistler resorted to malignant attacks upon those he blamed for his misfortunes. In his *Ten o'clock Lecture*, delivered in 1885, he heaped condemnation upon those who had offended him or criticised his work, but he also included a number of aphorisms that revealed his honest intentions. In a memorable phrase he stated the argument which later led towards abstraction: 'Nature contains the elements, in colour and form, of all pictures, as the keyboard contains the notes of all music. But the artist is born to pick, to choose, and group with science, these elements, that the result may be beautiful.' In 1890 he published a further diary of personal abuse, entitled *The Gentle Art of Making Enemies*.[10]

Whistler was a born clubman and bon viveur. Before the Chelsea Arts Club was formed he would frequently be seen at the Hogarth Club and at Solferino's, the little restaurant in Rupert Street used by the more educated members of the press. He also had an uneasy membership of the Arts Club in Dover Street. On one occasion, following his bankruptcy, he had been suspended for non-payment of dues. Pleading poverty he had offered a painting instead, but the Secretary of that club, with heavy-handed humour, replied: 'It is not a *Nocturne in Purple* or a *Symphony in Blue and Grey* that we are after, but an *Arrangement in Gold and Silver*.'[11] Whistler's interest in an artists' club for Chelsea may have arisen because of this episode.

Whistler was an obvious choice for chairmanship of the Chelsea Arts Club, but he was notoriously difficult and many members remembered the imperious manner in which he had assumed the Presidency of the Society of English Artists. He was invited to chair the sub-committee concerned with elections and house rules of the Club, which he did with aplomb.

The early years of the Chelsea Arts Club marked Whistler's restored reputation and honour. In November 1891 his portrait of his mother was bought for the Musée du Luxembourg for 4000 frs. In celebration a reception was given at the Chelsea Arts Club on the evening of 19 December 1891. Whistler was presented with a parchment of greetings signed by a hundred members as 'a record of their high appreciation of the distinguished honour that has come to him by the placing of his mother's portrait in the national collection of France.' Whistler replied, with sarcasm, 'It is right at such a time of peace, after the struggle, to bury the hatchet – in the side of the enemy – and leave it there. The congratulations usher in the beginning of my career, for an artist's career always begins tomorrow.' In the following January he was again honoured by the French, who made him an Officer of the Légion d'Honneur, and in April 1892 he moved to Paris. On his departure from the Club he left a number of unpaid bills but his subscription was paid to 1896.

During the first year of its existence the Club kept an attendance book which members signed each day. There were usually about fifteen or twenty members in the Club. Christie, whose studio was on the same premises, was usually the first to arrive. He was followed by the regulars, Davidson Knowles, Fred Pegram, Jacomb-Hood, Graham Petrie, Arthur Black, Nelson Dawson, Alfred Hartley and others. Sunday was poorly attended but Monday, on which dinner was served, was well supported and guests were invited to this. Philip Wilson Steer and Walter Sickert were frequently in the Club, Sickert often accompanied by his friend Sidney Starr. On one occasion, Saturday 2 May 1891, Sickert's distinguished guest was Camille Pissarro, the French Impressionist. In December 1891 Claude Monet visited the Club with Whistler; it was a crowded dining evening and Monet was notably silent. He came again on a later occasion with Sargent and Whistler and in 1899 as a guest of Will Rothenstein.[12]

Special events drew large numbers. Some fifty-six members were present on Wednesday 15 April 1891 to hear 'Mr Whistler's Ten O'Clock', a repeat of the famous lecture that he had given five years earlier in the Prince's Hall, London. Whistler came often to the Club in the evening, usually in a four-wheel cab which he would keep waiting. He was a

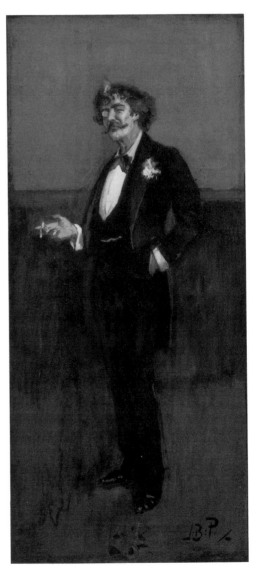

'James Abbott McNeill Whistler' by Sir Bernard Partridge NEAC. Sir Bernard Partridge, the Punch artist, was also a long-time member of the Chelsea Arts Club.

master of the epigram and would usually be surrounded by an admiring group of members and, having scored in conversation, would make his departure at precisely the right moment. On one occasion he was bettered by one of the younger members. James Charles, up from the country, trying to recall a certain year, said 'Do you remember, Whistler, that time you were bankrupt?' Whistler was a little taken aback and remarked to the other men 'This seems to be an extremely frank Club.'

Although the atmosphere of the Club was relaxed and informal, and the members included some of the most advanced and forward-looking of the younger artists in England, the great issues were mostly avoided. As Jacomb-Hood said,

It was a more intimate and convivial life, when membership was smaller and years were fewer, when Whistler was in the habit of strolling round in the evenings after dinner, always charming and amusing and Sargent for a time would come to lunch at the long table. Every now and then we had an evening of music and recitations and story-telling. Jovial, bearded, and rubicund 'Jimmie' Christie, original tenant of the studio, was an inspired declaimer of *Tam o'Shanter* in the true Burns 'doric', and J.J. Shannon would give an imitation of a Canadian skipper reciting *The Boy stood on the Burning Deck*, or tell amusing stories with an American 'twang'.[13]

Dress was varied, sometimes bizarre. Several of the members favoured 'horsey' get-up, wearing a type of coachman's coat with enormous pearl buttons, or riding jackets of florid cut and vigorous checks. Riding breeches and boots were often worn. Others preferred a more continental style, with long dark coats in the winter, white cavalry trousers in the summer with a black or brown bowler, which had mostly replaced the top hat. Those who had spent their formative years in France favoured the beret and smock with baggy blue canvas trousers.

The marine artist Frank Brangwyn was born in Bruges, Belgium, the son of a Welsh architect. His strong sense of design was formed in the workshops of William Morris in Oxford Street, London, making facsimile copies from French tapestries. He took a studio at 4 Wentworth Studios, Manresa Road, in 1887 and was a founder-member of the Club. His early years were battles with poverty and disappointment, and for a time he and his studio companion A.D. McCormack existed on marmalade and a sack of potatoes, until the potatoes went bad. The coffee stall in the King's Road was his restaurant and his only recreation was gunnery drill and training with the Royal Naval Reserve. His patron was the pawnbroker. He told how he tried to pawn one of his pictures – 'I'll lend you thirty bob,' said the pawnbroker. 'Why, man,' the artist exploded, 'the frame alone is worth more than that.' 'It's the frame I'm lending on,' said the pawnbroker. A story that might have been told of many struggling painters.

In spite of such difficulties, and always working, Brangwyn travelled extensively during these years, to most of the European countries as far as Russia and the countries around the Black Sea, to North Africa, Malaya and Japan. He was prodigious in the scale and the quantity of his work, which captured the colour and spectacle of the great ports and the activity of the capital cities. His powerful draughtsmanship and bold sense of design produced some of the most successful mural paintings of the early twentieth century; he later received a knighthood.[14]

With all its free and easy ways, the Club was efficiently run and its finances were carefully supervised by the Hon. Treasurer Jacomb-Hood. It was financially solvent with reserves of £100 in the bank. Membership, which was jealously guarded, was restricted to practising painters,

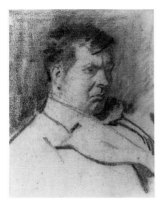

'Sir Frank Brangwyn'. Chalk drawing by Phil May RI, NEAC.

sculptors and architects, the subscription for a town member was two guineas and for a country member one guinea. Preference was given to candidates living in the immediate neighbourhood, 'especially if such candidates be unmarried men in need of the benefits of the Club.' After Christie's departure for Glasgow, the Club was able to acquire the whole of the house, and the bedrooms were available for the use of country members. A number of pictures had been lent by members to decorate the rooms and more were requested; this may be seen as the start of the Club's collection of works of art.

The new Steward and cook, Mr and Mrs West, were fulfilling their duties ably. But the short lease on 181 King's Road was coming towards its end and the future of the Club's premises was under discussion.

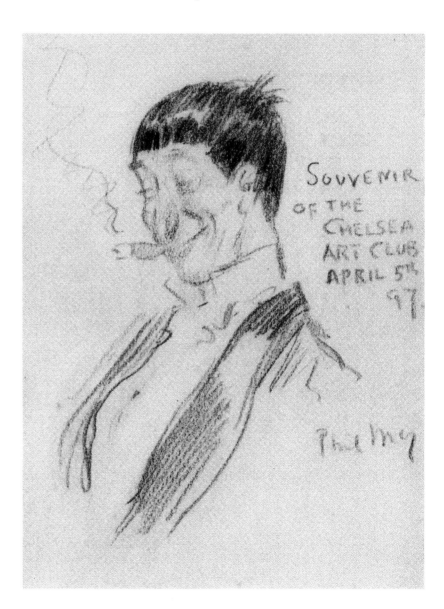

SOUVENIR
OF THE
CHELSEA
ART CLUB
APRIL 5TH
97

Souvenir of the Club, by Phil May.

2 The Move to Church Street

At the beginning of the new century the standing of the Club was high. It had some 150 town and country members, drawn from such diverse bodies as the Royal Academy, the New English Art Club, the International Society of Painters and the Glasgow School. Whistler, Sargent, Edwin Abbey, Alfred Drury, La Thangue and Stirling Lee were prominent members, as were Havard Thomas, William Llewellyn, Frank Short, Frank Brangwyn, Fred Pomeroy and others. As Jacomb-Hood pointed out 'all won much distinction and the terminal letters of RA to their names, in addition to three knighthoods. Not bad for one little Chelsea covert.'[1]

'Chelsea Artists' drawing by Fred Taylor RI.

The camaraderie of the Club was well known and the 'Varnishing Dinners' and 'Smokers' were well attended. Although the premises in the King's Road were cramped, the Club had become an important centre where artists could meet on friendly terms. However it had always been understood that these premises were not permanent and in May 1900 it was agreed to look for a new clubhouse. It was first proposed to take the lease of 42 Carlyle Square and efforts were begun to raise the money from among the members. This scheme was later abandoned, but the loan fund was very useful when a further property became available in Church Street, Chelsea.

With the generous help of Mr Sloane Stanley, one of the principal Chelsea leaseholders, the Club was offered a charming house in Church Street, with small rooms and low ceilings, a remnant of the old Chelsea

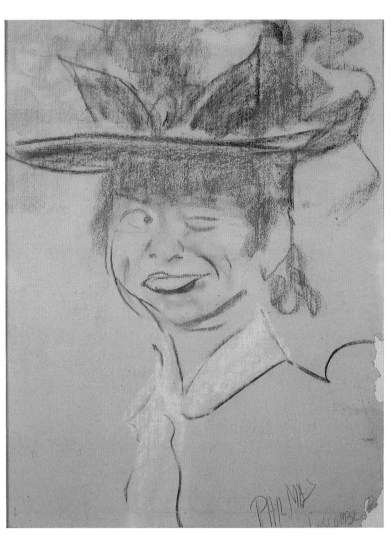

'Laughing and Winking Girl'
by Phil May RI, NEAC.

village. It had originally been two cottages, 143 and 145, to which a large
billiard room (also referred to as a 'gymnasium') had been added. At the
rear was a garden with a velvety bowling green, pergola and gay flower
beds. The two cottages had been built at the end of the eighteenth century
on the edge of the old Chelsea Park, owned by the Sloane Stanley family.
The name they acquired, 'Bolton Lodge', probably came from William
Bolton, an eighteenth-century landowner, who also gave his name to The
Boltons.

In the late nineteenth century Church Street was a working-class area
with grocers, butchers, plumbers and light workshops.[2] There were also
the harness shops and blacksmiths that served the hundreds of horses
that were stabled in the area. In Church Street the London General
Omnibus Co. Ltd. had its stables; towards the river was 'Wright's Dairy', a
long low snow-white cowshed with fifteen or sixteen well-groomed
short-horned cows that supplied fresh milk to the residents. Church
Street was by no means prosperous, many of the smaller eighteenth- and
nineteenth-century houses had become dilapidated and there was con-
siderable overcrowding and poverty. Some had fallen into disrepute. In
1885 it was found that several adjacent houses, 125, 127, 129 and 155
Church Street, were being used as a brothel and a clearing-house for the
white slave trade. Communication had been made between the houses so
that visitors could leave inconspicuously by another entrance. It was
frequented, it was said, by gentlemen from some of the most notable

London clubs and there were rumours that royalty had been known to call![3]

The following notice appeared in the *Westminster Gazette* in October 1901:

THE CHELSEA ARTS CLUB

Most artists, and especially those resident in the 'Latin Quarter' of London – i.e. Chelsea – will be interested to hear that the well-known rendezvous for painters and sculptors in the King's Road, the Chelsea Arts Club, is shortly to take possession of a new and more commodious house ... which will boast greater attractions, besides a lawn, bowling-green, and tennis-ground. It is then proposed to raise the membership to 200, and seeing that Chelsea now accommodates nearly 2,000 devotees of the brush and mallet, this anticipation should be easily realised.

Meanwhile negotiations were taking place with the leaseholder, Mr Sloane Stanley. There was some disagreement about the rent but eventually £85 per year was proposed for a seven-year lease. Mr Stanley was asked if, in view of the substantial sum that the Club was to spend on alterations, he would agree to extend the lease beyond seven years; 'we only number at present one hundred and four town members and it is no small sum of money to be subscribed by our members who are in the pursuit of fickle art and not by any means a wealthy set of men like West End clubs. In the interests of art I think it would be only fair.'[4] Mr Stanley gave way upon this point and, on Christmas Eve 1901, the lease was completed for nine and a half years, expiring 24 June 1911. It was held on behalf of the Club by John Lavery, Gerald Moira, Dermod O'Brian and Arthur S. Haynes.

To cover the cost of alterations it was decided to seek additional contributions to the loan fund that had been started earlier. Within a year a total of £572.16s.1d. was raised. The largest single contribution of £30 was made by John Sargent, then the only Royal Academician among the members and the most prosperous. John Lavery gave £25 and most of the other leading members contributed £10 each. Two architect members, Harrison Townsend and Gilbert Jenkins, were asked to prepare a plan of the alterations and to obtain tenders from builders. The lowest estimate was £530, a considerable amount for the members to find, but with the £500 already raised, plus £50 from reserves, the building work commenced. A new kitchen was created and the 'gymnasium' was enlarged to make a dining-room thirty-five feet by twenty-two. Cloakrooms and a lavatory were installed and electric light was put in all the reception rooms, hallway and passages; no structural alterations were made upstairs. No drawings exist from this time, but it is likely that the two cottages were joined on the road side by a screen wall faced in stucco, with 'Tudor' arched openings and a decorative parapet.

The splendid clubhouse and garden immediately began to attract new members. Proposals to admit ladies on certain days were discussed and small exhibitions of members' work were arranged during the winter months. Finances also improved and in April 1903 the Council were able to begin returning the sums borrowed from members for the building fund, two years later all were repaid.

The Club was now on a stable course, with more joining than leaving each year. A watchman was employed and new furniture was bought from Maples. Income from meals, bedrooms and billiards more than paid the food bills and the wages of the small staff, consisting of the Steward and his wife, a boy, a waiter and a charwoman. Breakfast, lunch, tea and

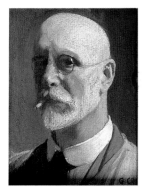

'Self Portrait with Cigarette, 1927' by Sir George Clausen RA, NEAC. Clausen was a founder-member of the Chelsea Arts Club.

dinner were served daily, and the bar stocked a good range of beers, wines and spirits. The House Committee, in charge of day-to-day affairs, was ever vigilant. In October 1904 the Steward George Head was sacked. He had been obtaining fruit and vegetables from local tradesmen on credit and not paying them with the money that he had received. When he was charged with the matter he replied 'This is a private affair.'

There was a remarkable harmony between the Chelsea Arts Club and the newly established 'New English Art Club' which had become the most forward-looking exhibiting society in London. The strongly held opinions formed by the younger artists in Paris, had led them to question the basic assumptions of English art, particularly the pervading chauvinism. Many had seen their work repeatedly rejected by the Royal Academy on the grounds that they were too 'French' and there had been much talk of a new exhibiting society in London, run by painters for painters.[5]

The first meetings which led to the formation of the New English Art Club in 1886, were held in Jacomb-Hood's barn-like studio in Manresa Road, where four years later the Chelsea Club was planned and many of the same artists were present. Ronald Gray, who was a member of both organizations, recalled the personalities: 'Fred Brown – the guide and intransigent type of the revolutionary. The placid Steer listens. George Clausen argues with a gentle persuasive voice and a perpetual cigarette. La Thangue succeeds with caustic and polite irony, whilst the two sculptors 'Tommy' Stirling Lee and Havard Thomas have much to say on the inadequate space given to their profession at the Academy, compared to the Paris Salon. The fair-haired, gay adventurer, Walter Sickert, the beloved disciple of Whistler, with much of the master's wit and sarcasm, added gaiety and mischief to their meetings.'

George Clausen was a founder-member of both the Chelsea Arts Club and NEAC. He was a fine painter of landscape and rural scenes in the classic 'plein-air' style, formed during his time in Paris. By many he was considered to be extreme, both artistically and politically. He painted mostly in the country and when he came to Chelsea he borrowed a studio and adopted rough country airs: 'he would tie his trousers below the knee like a navvy and ask his friends to address him as "Citizen".' Initially Clausen was an active critic of the Royal Academy, but he was brought into the fold by the President, Frederick Leighton, and from that time became a reformer from within. He later became a prominent Academician and Professor of Painting at the Royal Academy Schools.

Encouraged by Clausen the New English Art Club had welcomed as founder-members a number of the painters who were working in Newlyn, Cornwall, and a group of Scottish painters, centred upon Glasgow, later to be called 'the Glasgow Boys'. This provided these two important groups of realist artists with a welcome toehold in the metropolis. The Scottish painters, particularly Guthrie and Lavery, acknowledged the influence of Whistler, although the Cornish group were not so enamoured. Members of both groups became prominent members of the Chelsea Arts Club. James Elder Christie, whose King's Road studio was the Club's first home, was the first to come to London, but he was soon followed by John Lavery, George Henry, E.A. Walton, James Guthrie, W.Y. MacGregor and others.

The artists from Cornwall were less active in the Chelsea Arts Club in those early years. Henry Tuke, the Falmouth painter, was a founder-member, but resigned after two years. The best known of the Newlyn

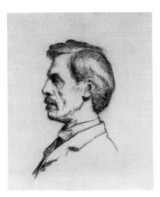

'Frederick Brown' by Philip Wilson Steer NEAC.

artists, and the promoter of the town as an artist's colony, was Stanhope Forbes, who joined the Chelsea Arts Club in 1908.

The Chelsea Arts Club was the regular meeting place for a group of close friends, Frederick Brown, Henry Tonks and Philip Wilson Steer, who together affected the direction of British art at the turn of the century. They had shared a training in France, they had been involved in setting up the New English Art Club and, as teachers at the Slade School, they had a profound effect upon later generations of artists. Brown, Tonks and Steer were also close neighbours in Chelsea; they each lived within easy walking distance of the Club and all were batchelors.

Frederick Brown was a man of great energy and considerable physical presence, spectacled, with greying hair, moustache and chin-tuft. He was endlessly active on selection committees, a great teacher, an organizer, businesslike, scrupulously fair and honest. He was described by D.S. Maccoll as 'the linch-pin or even a driving wheel in successive moments of a fight for the young of his time'.[6] For many years Brown was the Headmaster of the Westminster School of Art, which he developed along the lines of a French 'atelier'. He had played a major part in the creation of the New English Art Club and was largely responsible for the liberal principles of its first constitution. In the Chelsea Arts Club he performed a similar task in drawing up the rules and constitution of the Club and the two documents have the same stamp of authority.

In 1892 Brown succeeded Legros as Professor of the Slade School of Fine Art and, with Steer and Tonks, reconstructed its teaching. His time at the Slade was the period of its greatest vitality: 'a school of drawing was built up such as had never existed in this country.'[7] During the twenty-six years of his Professorship, the Slade became the most prominent art school in England and produced successive generations of fine painters and draughtsmen including Ambrose McEvoy, Augustus John, Albert Rutherston and William Orpen, who in their turn also became important members of the Chelsea Arts Club.

Henry (or 'Harry') Tonks joined the Club in 1891. Two years later he went to teach at the Slade as an assistant to Fred Brown. Up to that time Tonks had been a demonstrator of medical anatomy at the Royal Free Hospital and, already qualified as a surgeon, he could have expected a distinguished medical career. He was, however, fascinated by art and for some years had attended evening classes given by Brown at the Westminster School of Art, where he formed friendships with Steer and John Sargent. The enormous respect that Tonks had for art, together with his delayed start on a professional career, was the basis of the doubts and uncertainties which were to trouble him for the rest of his life. He felt his position as an artist to be permanently in need of justification; for him the production of a painting was a labour requiring a strenuous effort of will and intelligence. In his teaching he professed clarity, economy of means and directness of approach, but his own work often showed painful reworking and uncertainty. Tonks was tall and gaunt with a fierce expression. In the Chelsea Arts Club he had his own preferred corner seat, and he was described by his friend George Moore as 'a herring-gutted figure with a high bridge to his nose'. He held strong opinions, and was an influential and at times an inspirational teacher, but his wit was heavily reinforced with sarcasm, and he was impatient of insufficient effort. As Augustus John said, 'Tonks had a passion for teaching drawing and the Slade was his mistress.'

(From left to right) Fred Brown, Henry Tonks, D.S. Maccoll, Philip Wilson Steer and (front) Walter Sickert by Sir Max Beerbohm NEAC.

Philip Wilson Steer brought prestige to the Club. As George Moore said: 'In all the criticism that I have seen . . . it is admitted that Mr Steer takes a foremost place in what is known as the modern movement.' Steer was the son of a painter from Birkenhead. He studied at the Gloucester School of Art, and in Paris at the Académie Julian and briefly at the Ecole des Beaux Arts, but his failure to pass the newly introduced language test forced him to leave. In his work of the 1890s Steer used free and inventive Impressionist colour. Steer was a creature of contradictions; by nature conservative, conformist and with a dislike of argument, in his paintings he displayed a preference for innovative ideas that were at times revolutionary. He produced some of the most advanced work, strongly influenced by Impressionism, that had been seen in England up to that time. The most adventurous of these paintings – of children playing on the beach at Walberswick – proved difficult even for his friends and admirers. Steer, ever sensitive to the criticism of others, responded to the cautious paternalism of Tonks, Maccoll and others. In his later work the use of strong broken colour gives way to tonal painting, with memories of Constable and Gainsborough.

During his first years in Chelsea, Steer occupied one of the Trafalgar Studios in Manresa Road; he later moved to Maclise Mansions, Addison Road. In 1894 he settled at 109 Cheyne Walk, overlooking Turner's Reach, where he remained until the end of his life. It was a solid late-eighteenth century house in which he found batchelor contentment, looked after by his housekeeper Mrs Raynes, who had been his nurse as a child. His painting studio was a drawing-room on the first floor. He was an inveterate collector, of coins, shells, crystals, Chelsea pottery and bric-a-brac, and of pictures which filled the morning room below. His friend William Rothenstein described him: 'Steer had the wisdom of the slow and steady pulse, disturbed neither by undue ardour nor anger, nor did curiosity for the ways of men, for books, for science, or for the theatre tempt him from his safe ways, a pretty model, a quiet morning painting, a rest after lunch, a little more painting, a ramble around the bric-a-brac shop, and then to bed.'[8]

Steer was a founder-member of the Chelsea Arts Club and for a time he was a member of Council. He guarded his comfort and his privacy and was protected from the world by his admiring friends. In his personal life Steer became increasingly cautious. He had a dread of catching cold. He always wore old-fashioned high collars against draughts, and his excuse for not attending formal dinners was the 'risk' of changing into evening dress. His evening routine at the Club was to close securely all doors and windows on arrival, before settling in his favourite chair, at his favourite table, to play an evening's chess. He always carried a box of fifty cigarettes and when the game was over, and he had smoked all his cigarettes, he would return to Cheyne Walk, usually accompanied by Ronald Gray. These regular evenings at the Club extended over a period of nearly fifty years.

Steer's greatest friend was Ronald Gray, a friendly man with a loud resonant voice. He was also a founder-member of the Chelsea Arts Club and was elected to the Council in 1900. Born in Chelsea, he had studied under Jacomb-Hood and then under Fred Brown at the Westminster School of Art. He spent some time at the Académie Julian in Paris at the same time as Rothenstein. Gray and Steer with one or two other friends from the Club would take summer painting trips to Yorkshire or Walbers-

'Philip Wilson Steer' by Henry Tonks NEAC.

wick. Gray contracted tuberculosis of the knee-joint and for a period he convalesced in Australia. He was re-elected to the Club on his return in 1903 and became again a very supportive member.

Another member of this coterie was the Scottish artist and writer D.S. Maccoll, who had also been a student of Fred Brown's at the Westminster School of Art and was at the Slade School under Legros. He was very active in the formation of the New English Art Club and began to write in support of the new painting from France. In particular, he was drawn into a long and public debate about Degas' painting *The Absinthe Drinkers* when it was shown in London at an exhibition of the International Society in 1893. At this time he was an active member of the Chelsea Arts Club. He later became one of the most brilliant art critics of the time and his prolific writings for the *Spectator* and *Saturday Review* combined literary power with considerable wit. He was the biographer of Steer and he later became Director of the Tate Gallery and Keeper of the Wallace Collection.

Philip Wilson Steer and Walter Sickert were friends and exact contemporaries – both born in 1860, both died in 1942. They probably met in the winter of 1885–6, at a time when Sickert still described himself as 'a pupil of Whistler'. They visited the London music halls together and each drew the dancers and singers. They met regularly and lunched together almost every Sunday. There was a friendly rivalry between them. Sickert sent a telegram to Steer at 143 Church Street, after Steer had sprained an ankle avoiding a taxi in the King's Road. 'Do be careful; I have no desire to be the World's greatest painter!' One day when they were passing a rag-and-bone shop, Sickert remarked: 'That's how I should like my pictures to look.' 'They do,' replied Steer.

Walter Richard Sickert was very active in the Club for the first five years of its existence. Born in Munich, he came from a thoroughly Europeanized artistic background. His father, a Dane from Schleswig-Holstein was a painter and graphic artist; his mother, half English, half Irish, had lived for many years in Dieppe. Before choosing art as a career, Sickert worked as an actor, playing minor parts in provincial touring companies. At the age of nineteen, Sickert met Whistler and was totally overwhelmed by his single-minded enthusiasm for painting. He wrote: 'Such a man! The only painter alive who has first immense genius, then conscientious persistent work striving after his ideal, knowing exactly what he is about and turned aside by no indifference or ridicule.'[9] As a result of this meeting Sickert abandoned his acting career and studied for a few months at the Slade School. Whistler then persuaded Sickert to leave the Slade and work under his direction. For six years Sickert became an apt and willing studio assistant for Whistler and during this time turned into a hard-working professional artist with an additional gift for the written word.

In Chelsea Sickert lived in The Vale, in a house belonging to William de Morgan, the great craftsman potter. As a studio he took a small room at the shabby end of the Embankment near Beaufort Street. William Rothenstein could not understand Sickert's taste for the dingy and squalid. 'I had known many poor studios in Paris, but Walter Sickert's genius for discovering the dreariest house and most forbidding rooms in which to work was a source of wonder and amusement to me. He himself was so fastidious in his person, in his manners, in the choice of his clothes; was he affecting a kind of dandyism 'à rebours'?'[10]

'Walter Richard Sickert' by Philip Wilson Steer NEAC.

'Walter Richard Sickert'.
Caricature by James McNeill
Whistler PRBA.

The young Walter Sickert was a regular attender at the Club, as Basil Gotto recalled: 'In those days Sickert was a very good-looking young man with a quick wit and a kindly twinkle. He was always well groomed and clean-shaven, in strange contrast to the shaggy figure he later became.'[11] Sickert's personality as actor, raconteur, teacher and writer made him a natural leader and before long he found himself centrally involved in art activities in London. By this time he had gained a reputation as the 'enfant terrible' of British art and became deeply involved in the major change of direction in the New English Art Club; he was the prime mover in a break-away group which called itself 'The London Impressionists'.

There was soon to be a cooling of relationships between Sickert and Whistler. In 1897 Whistler appeared as a witness against Sickert in a libel suit brought by Joseph Pennell, an American illustrator and biographer of Whistler, and also a member of the Chelsea Arts Club. Sickert had written an article in the *Saturday Review* on 'Transfer Lithography' in which he asserted that the prints made by Pennell were not true lithographs. Whistler, who appeared for Pennell, referred to Sickert as 'an absolutely unknown authority' and 'an insignificant and irresponsible person'. Soon after this unfortunate incident Sickert left London to live in Dieppe for the next six years, with many expeditions to Paris and Venice. He continued to have contact with his friends but was not seen in the Club for some years. In 1905 he returned to London and his studio in Fitzroy Street became a centre for a circle of friends and younger artists, mostly from the Slade School. These meetings led to a series of informal exhibitions in a storeroom in 19 Fitzroy Street, and later to the formation of the Fitzroy Street Group. Following a particularly notorious murder whch had taken place in Camden Town, Sickert moved his studio there and the group became known as the Camden Town Group. In 1909 Sickert was re-elected to membership of the Chelsea Arts Club, but his participation was much less evident.

From the time of its foundation the sculptor members played an important part in the Club. The first Chairman Stirling Lee was one of England's most prominent sculptors and the two Chairmen during the first years in Church Street, W.S. Frith (Chairman 1901–03) and Frank Lynn-Jenkins (Chairman 1902–03) were both internationally known. They were involved in the establishment of the Royal Society of British Sculptors and both were long-time exhibitors at the Royal Academy.

Another artist who played an important part in setting up the Club in its new premises in Church Street was Francis Derwent Wood, a north-country man from Keswick. Educated in Switzerland, Wood studied first in Germany and then at the Royal College of Art in London. Whilst still a student he became assistant to Legros at the Slade School, until his departure in 1852; Derwent Wood then continued his education at the Royal Academy Schools and later became an assistant to Sir Thomas Brock RA. Derwent Wood became a member of the Chelsea Arts Club in 1898, although at this time he was still the modelling master at Glasgow School of Art. He returned to London in 1901, when he became a member of the Council and a well-known personality in the Club. He had an outgoing manner and a caustic wit, which at times could sting. Alfred Munnings was angered by Derwent Wood's caricatures of him, hung in the billiard room, which he thought were libellous. Wood was very fond of his favourite drink. On one occasion he contracted mumps and this meant isolation for about four weeks. He was very much missed, and the Club steward was of the opinion that the sale of gin and bitters was reduced by about half.

'George Henry RA' by E.A. Rickards FRIBA. The distinguished Scottish artist was Chairman of the Chelsea Arts Club in 1908.

Basil Gotto, an early member and late Chairman, usually walked to the Club with George Henry, whose studio was near his in Glebe Place. Gotto remembered some of those who regularly sat round the large table: 'There was Belcher, Francis Howard and George Lambert, the Australian Academician with the technique of a Rubens and the swagger of a swashbuckler, who sometimes exchanged the stock whip for the boxing gloves.' Havard Thomas, the sculptor, returned from Capri with his black wax statue *Lycidas*, which was unpacked in Gotto's studio and attracted scores of enthusiastic admirers, only to be rejected by the Royal Academy and later acquired by the Tate. Many portrait painters brought their sitters in for luncheon. Paul Maitland was a clever landscape artist, who specialized in depicting the atmosphere of London. He was a hunchback, and sometimes gave vent to spiteful and bitter retorts. One evening a member who had suffered from his tongue, without being able to retaliate, complained that 'the little devil 'ides behind 'is 'ump, and 'its yer!'[12]

Another member was Hollins, a painter from the Midlands. He was quick-tempered, quick-witted and argumentative. Two other members were named Rollins and Collins and it was easy to mix their names. One evening Havard Thomas, seeing Hollins, said in his slow and meticulous way 'I never know if you are Rollins, Collins, or Hollins.' Hollins, very angry, pointed at Thomas and spat out 'Oh, you don't! Well it's a funny coincidence that I never know whether you are Thom-ars, Jack-ars, or Fat-arse.'

From the first there was an enlightened international outlook within the Club. The first notice which invited artists to join was printed in French and English so that it 'might be sent abroad to those who wish to have an opportunity of meeting brother artists in England.' Significantly it was the American artist Theodore Wores who had proposed that the Chelsea artists should have a Club, no doubt based on his memories of the exclusive 'Bohemian Club' in San Francisco of whch he was a member. Theodore Wores had become greatly influenced by Whistler and was treated as a favourite pupil. Whistler's interest in the art of Japan led Wores to visit this still-remote island, and later to live there for three years, to learn its language and to acquire a deep understanding of its

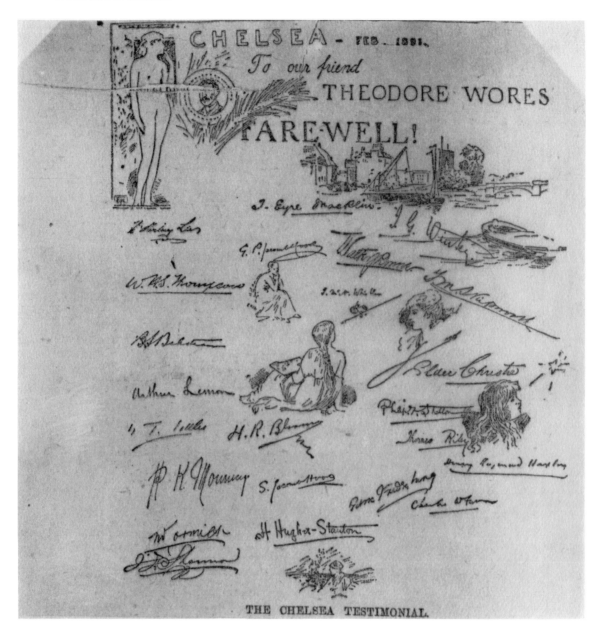

THE CHELSEA TESTIMONIAL.

'To Our Friend Theodore Wores, Farewell'. Testimonial to Theodore Wores, February 1891, signed by the following: J. Eyre Macklin, Thomas Stirling Lee, J.G. Winter, G.P. Jacomb-Hood, Walter J. Donne, W.H.S. Thompson, J. McNeill Whistler, F.M. Skipworth, B.J. Behstern, J. Elder Christie, Arthur Lemon, Philip E. Stretton, T. Little, H.R. Bloom, Thomas Riley, Henry Raymond Huxley, P.K. Mounsey, S. Jacomb-Hood, Patrick Victor Long, Charles W. Furse, A.D. McCormick, H. Hughes-Stanton, J.J. Shannon.

culture. Wores came to Chelsea in 1889 and his exotic paintings of Japan were seen in a number of major galleries. Early in 1891, before his departure to the United States, Wores was given a special farewell dinner by the Club, chaired by Whistler, and on his return he brought messages from four painters from New York who wished to join the Club. This may have led to the later reciprocal arrangement with the Salamagundi Club in New York.

The water-colourist Francis Howard, who had joined the Chelsea Arts Club in 1895, had proposed a scheme of regular 'art congresses' in London, which led to the creation of the 'International Society of Sculptors, Painters and Gravers'. In April 1898 Whistler accepted the invitation to be President, but as he was mostly in Paris, it was the vice-president, the young Irish artist John Lavery, who carried the burden of the Society's affairs and was largely responsible for arranging the first great exhibition. This took place at Prince's Skating Rink, Knightsbridge, and London saw such European giants as Manet, Degas, Fantin-Latour, Puvis de Chavannes and Lautrec. Although the brilliance of that first exhibition was not

maintained, others followed and brought to prominence a number of members of the Chelsea Arts Club including James Jebusa Shannon, William Strang and Lavery's Scottish colleague, James Guthrie.

John Lavery had been born in Belfast in poverty, but from an ancient Irish family. He was orphaned at the age of three and brought up by relations in a succession of poor Irish farms, pawn-shops and tenements. His natural aptitude for drawing won him an apprenticeship to a Glasgow artist and photographer and he received part-time training at Glasgow School of Art. He began to paint at the age of twenty and soon established a reputation in Glasgow for portraiture. The loss of his studio through fire, fortunately insured for £300, gave him the means to travel to London and to train at Heatherlies Art School for a year. This was followed by a period in Paris at Julian's Atelier, and he painted with other English and Irish artists at Gréz-sur-Loing, where the talk was of Bastien-Lepage and plein-air painting. He later confessed this was the happiest time of his life. Lavery became a member of the Chelsea Arts Club in 1894 whilst still living in Glasgow. He had by now established a reputation for portraiture and two years later he moved to London and worked for a year in a studio borrowed from Alfred East. He became the Chairman of the Club in 1917.

It was part of Whistler's vanity to surround himself with acolytes, usually those who presented no challenge to his authority. Walter Greaves was the son of the old boatman who had rowed Turner and the young Whistler on the Thames. He became a pupil and unpaid studio assistant to Whistler and a down-at-heel imitation of the Master. He wore a second-hand, square-cut frock-coat, green with age. His pin-striped trousers were like a concertina, but his boots were always well polished, and his hair oily and black, hanging in locks over his coat collar. It was said that they were done with the same brush and at the same time. On the occasion of a dinner given to Whistler, this shabby imitation led to confusion in the Chelsea Arts Club. A little while before the dinner hour, some of the Committee, who had never met Whistler, saw an elderly man come in with long overcoat and straight-brimmed hat and white gloves. They thought it must be Whistler, received him effusively, and fluttered about him. Then some of the older members arrived and saw he wasn't Whistler and asked him who he was; he said his name was Greaves and he was a pupil and friend of Whistler's. In good part they invited him to the table and insisted on his staying. Then Whistler came, put up his monocle and stared at him, said nothing, and Greaves 'faded away'.[13]

In about 1901 John Lavery urged that such a distinguished artist as Whistler, without whom the Club would not have been formed, should be made an Honorary Member. But he was told it would be the ruin of the Club; Steer and others would resign – they did not want him about the Club. After an angry meeting, Lavery asked Steer point-blank if this was so. Steer, in confusion, said there was a mistake. However Whistler was not elected and Lavery had to be persuaded not to resign. Soon after this Lavery arranged for Whistler to be the guest of a number of members of the Club at a Café Royal Dinner. The afternoon prior to the event Whistler rehearsed to his friend Landor 'a graceful and extraordinarily witty speech', containing the expected sarcastic attacks upon his enemies. But his hosts were so kind and greeted him with such sincere enthusiasm, that Whistler was too deeply touched to go through with the artificial performance. 'His voice was as unsteady as his knees as he rose to acknowledge Lavery's introduction, and his remarks were out of charac-

'J. McNeill Whistler, His Butterfly'.

ter, although greeted with great applause. It took him some time to recover, and his eyes were wet with tears.'

The last years of Whistler's life were spent mostly in London, but he was pursued by illness. In September 1901 he closed his Paris studio, the Atelier Cormon, and in the following year he leased 72 Cheyne Walk, Chelsea. He died there on 17 July 1903 after a heart attack, aged 69. He was buried in Chiswick Cemetery on a grey day; there were no crowds. Three of his six pall-bearers, Sir James Guthrie, John Lavery and Edwin Austin Abbey, were leading members of the Chelsea Arts Club. In 1908 efforts were made to erect a memorial to Whistler in Chelsea, to be designed by Rodin. However the Chelsea Arts Club refused to support the project. The unkind comment of one member was worthy of Whistler himself: 'What has an English club to do with a memorial by a Frenchman to a Yankee in London?'[14] But it was John Sargent who sabotaged the proposal. He wrote: 'I must confess to a real antipathy to the idea of artists erecting monuments to each other the moment they die. It seems to me to have no meaning at all unless it comes from the public and after a lapse of years. I also think that Whistler would have hated the idea. He never was funnier or more sarcastic than on the subject of the monument to Rossetti on Cheyne Walk.'[15]

3 Coming of Age

Among the many vivid individuals in the Club, Augustus John was outstanding. He dominated by force of personality, a strong intelligent head, eyes which fixed his listeners with an intense stare, a deep voice with a slight accent, the rolling phrases of his speech amplified by the expressive use of his hands. He was described as 'a picturesque giant, nearly six feet tall, with a full Christ-like beard, roving eyes and beautiful hands with long nervous fingers. He gave a look of extreme intelligence to everything he did. He was not talkative. He kept himself perfectly still, listening with an absent-minded air, but sometimes his eyes would light up, his whole being came alive and he would speak eloquently in a deep, rumbling Welsh voice.'[1] He delighted in being at the centre of an admiring group and expanded in their presence, but if he felt himself to be provoked he could show alarming rage and he easily came to blows. On other occasions he was equally generous, he could be incredibly hospitable and he was often left to pay the bills at the bar with the only money he possessed.

From his earliest days he had acquired an air of romantic legend. He was born in Tenby, Pembrokeshire, where he grew up in 'boredom and revolt'. Following the early death of his mother and a poor relationship with a distant and isolated father, John developed a fantasy life which found its way into his early drawings. At the age of sixteen he was admitted to the Slade under Brown and Tonks; in the holidays at Tenby, whilst painting his summer composition *The Rape of the Sabine Women*, John went swimming alone and dived onto a submerged rock, seriously injuring his head. After a long recovery he had acquired a new personality, vital, restless and wonderfully talented. In his last years at the Slade he became the most conspicuous of a remarkable group of fellow students, including Ambrose McEvoy, William Orpen and the brothers William and Albert Rothenstein, but always John was the dominating figure.

John left the Slade at the age of twenty and there followed a period of restless years in Paris and Normandy, hard work, portraiture and heavy drinking. This is also the time of his marriage to Ida Nettleship, the beginnings of a sprawling family and a complex knot of relationships. As a model and as a mistress Dorelia entered his life in 1903 and a 'ménage à trois' was created in his rambling home at Matching Green, which served as a base for John's wanderings in Ireland, Dorset and Wales. In his painting he alternates between the lyrical fantasy of his gipsy paintings and portraits of high society.

Augustus John came to Chelsea in 1903 to teach with Orpen at the Chelsea Art School, a private school intended to provide an income for its founders at 4 and 5 Rossetti Studios, Flood Street. It boasted good studios

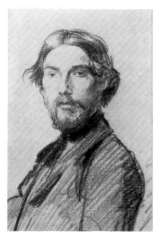

'Self-Portrait' by Augustus John, RA, NEAC.

and was professionally run, with a 'lady superintendent' (in fact Gwen Salmond, an ex-Slade Student) to look after the girls. In the first months of its existence the school took much of John's energy and he used a studio in the school for his own work. Orpen lectured on anatomy, and other 'Sladers' gave occasional teaching. However John soon lost interest, the teaching declined and in the summer of 1907 the school closed. From this time John became a restless and part-time resident of Chelsea, moving from studio to studio with long periods of caravan adventuring abroad.

On his flamboyant application to the Chelsea Arts Club in June 1909, John described himself as 'Welshman, painter and draughtsman'. He was then living at 153 Church Street, a house with a large studio near to the Club, and he was to remain in continuous membership until his death in 1961. He was treated with great respect by the other members, although 'John' the Steward remembered one incident when he had to intervene. This happened when Augustus John was standing in the hall at the entrance to the writing room as Jacob Epstein was leaving with a party of friends. One of the ladies recognised John and said 'Good Evening'. With a typically flamboyant gesture John raised the lady's hand to his lips. Epstein, greatly angered, shouted at him. 'Why do you do that when you know you don't mean it? You are false, and I will pull your bloody beard out.' With great presence of mind, the steward pushed Epstein out of the Club and shut the door, thus averting a threatening situation. He later said: 'Some members said I did wrong to stop the duel but those things are best clipped in the bud.'

Ambrose McEvoy had entered the Slade School at the same time as Augustus John. They became firm friends, but they were physically opposites. Whereas John possessed radiant health and inspiring good looks, McEnvoy was short-sighted with a low 'Phil May' fringe, a cracked voice and a painfully thin body. Nevertheless he fancied himself as a dandy and dressed fashionably, with monocle, dancing pumps and a black suit in the manner of Whistler. As a young boy he had come to know Whistler, for McEvoy's father had been in the Confederate Army and was a friend of Whistler. McEvoy began to exhibit with the NEAC from 1900 onwards, mostly portraits of women, and by the time that he became a member of the Chelsea Arts Club in 1908, he had made a considerable reputation as a portrait artist.

William Orpen also joined the Chelsea Arts Club in 1908. He had been born in Blackrock, County Dublin, the youngest of five children of a successful Protestant solicitor. When he enrolled at the Metropolitan School of Art, Dublin, in 1890, his talent and industry were outstanding and no Irish artist was to repeat his student success. At the Slade Orpen and John were rival geniuses and friends. As John said, 'On the arrival of William Orpen, a new force made itself felt in the school. This Dubliner's industry, combined with his native drollery, soon won him a leading place.'[2]

In appearance Orpen was small, dapper and remarkably ugly, with a long jaw topped by a prominent lower lip and freckles, but his appearance was relieved by intense blue eyes and a profusion of auburn hair. He was incorrigibly interested in gossip and inclined to be garrulous, with an Irish wit and charm. By the turn of the century, Orpen's work was attracting attention at the New English Art Club and at the Carfax Gallery and he was being recognized as a portrait artist of unusual talent. In August 1901, Orpen married Grace Knewstub, sister to Alice Rothenstein

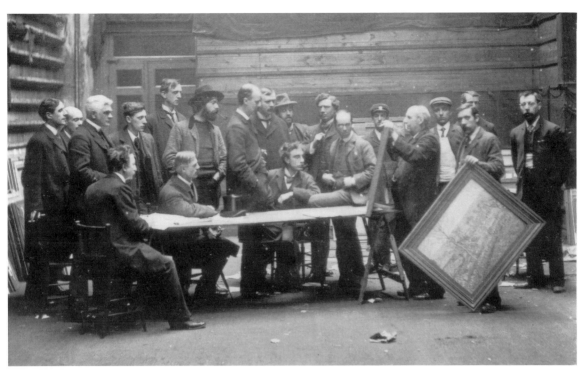

'The Jury of the New English Art Club at the Dudley Gallery in 1904'. Left to right (standing) W. Russell, D. Muirhead, A.W. Rich, A. McEvoy, H. Tonks, A. John, D.S. McColl, P.W. Steer, M. Bone, R. Fry and W. Rothenstein. With the exception of Muirhead and Bone, all were prominent members of the Chelsea Arts Club.

and daughter of John Knewstub, once Rossetti's secretary. Orpen and Will Rothenstein were now brothers-in-law, although they did not become close friends. Orpen moved to Chelsea in 1902, to a small terraced house in Royal Hospital Road. He was a great supporter of the Chelsea Arts Club and became its Chairman shortly after the Great War.

The two remarkable brothers, William and Albert Rothenstein, were each members of the Club. William Rothenstein joined in 1894. He had recently returned from Paris, where he had worked at the Académie Julian and had received encouragement from Degas and Whistler. He had earlier been a student under Legros at the Slade. In Chelsea, Rothenstein was lent a studio in Tite Street by Jacomb-Hood, who was travelling abroad. Michael Field described this borrowed studio and its young tenant. 'Two candles, a great luminous twilight and the curly curls of an artist, chattering incessantly as a bird sings. He is blessed in his poverty, lunching on an egg and some marmalade and then taking a box for *The Second Mrs T[anqueray]*.'[3]

Rothenstein saw the King's Road as 'a shabbier Oxford Street, with its straggling, dirty, stucco mid-century houses and shops'. He recalled the time when the Club was in the King's Road: 'I used to infuriate the older members of the Chelsea Club by passing in front of the windows wearing white gloves and evening clothes. Nor did my conversation annoy them less: for the Chelsea Club was a kind of miniature Arts Club, frequented by cautious candidates for the Academic fold, whose opinions it was a temptation, too rarely resisted, to outrage. No doubt I made myself thoroughly objectionable, and deserved to be unpopular; but I was supposed to be clever, and being irrepressible was indulgently accepted as an *enfant terrible* by most of the older men.'[4] Rothenstein was already a clever talker, with great charm of manner, beaming through huge spectacles with a sweet smile and a gentle yet persuasive voice. With an agile and enquiring mind he dropped naturally into the milieu that included Sickert, Steer, Brown and Tonks. He was also friendly with the more exotic personalities of Max Beerbohm and Aubrey Beardsley.

*'William Rothenstein' by John
Singer Sargent RA.
Lithograph.*

Although a close friend to many artists, to whom he was generous and helpful, Rothenstein was not a popular man. He worked through others and preferred to offer advice and direction – not always appreciated. He was also very sensitive to criticism, a trait shared with Whistler, and because of this he was often hurt. Additionally he was uncomfortably aware of his Jewishness and his ugly appearance – he was once described as 'a dark monkey-like creature'. With increasing responsibilities in the world of art and education, he gradually abandoned painting in favour of art politics.

William Rothenstein's younger brother Albert (who changed his name to Rutherston at the time of the First World War), was a member of the Chelsea Arts Club from 1904 to 1907. He had also been a student at the Slade School and on a visit to France he became friendly with Sickert in Dieppe. Albert became a member of the New English Art Club in 1902 and in the two years following he made several short visits to France, where his friendship with Sickert developed. He spent much of his career in teaching and later became Ruskin Master of Drawing at Oxford.

To a somewhat anarchic Club, the portrait painters brought a measure of social respectability. In Edwardian days a proficient portraitist in London could expect to live well. If his work was admired at the Academy he was invited into society and commissions followed. In Chelsea their studio-houses stood distinctively among the Victorian terraces. Well-to-do sitters would ring the bell at an imposing mansion of red brick, the door would be opened by a dignified butler and he or she would be shown up into a splendid studio lit by a north light. Some of the most elegant of these were built in Tite Street (named after the architect Sir William Tite) and it was there that Whistler had built, but barely used, his 'White House' and Sargent had his studio.

John Singer Sargent joined the Chelsea Arts Club in June 1894 and was to remain a member for life. Born in America of prosperous parents, his youth had been spent in continuous movement between the European capital cities and spas, in search of a suitable climate for his mother's delicate health, and his education had been in museums and galleries among his fellow expatriates. As a youthful virtuoso in paint, he studied first in Florence and then in Paris at the atelier of Carolus-Duran, a highly successful portraitist. His teacher emphasized the virtues of direct painting without preliminary drawing, and John Sargent was a receptive pupil.

In the late 1870s Sargent had begun to establish a reputation in Paris, but after the stormy reception given to his portrait *Madame Gautreau* at the Paris Salon of 1884 he decided to settle in London. In that summer, while staying with friends, Sargent painted a glowing vision of two little girls in an English garden, lit by Japanese lanterns. This painting entitled *Carnation, Lily, Lily, Rose* was a *tour de force* of Impressionist painting and it was to provide a standard for decorous modernism. The exotic atmosphere, glowing colour and free inventive handling singled it out when it was exhibited at Burlington House; the attention it received confirmed Sargent's decision to remain in England. The move to London was a decisive step for, as a supporter of Impressionism and a friend of Monet, Sargent remained a controversial figure, viewed with the suspicion that the English art world reserved for all things French. He joined the New English Art Club at its foundation and exhibited his most advanced work there; with Steer and Sickert he was in the van of the avant-garde movement – 'an apostle of the "dab and spot" school', as the *Art Journal*

referred to him. But it was his portraits of the highest ranks of American and British society, shown mainly in the Royal Academy, that built his reputation as the most brilliant realist painter and later the most glamorous portraitist of the Edwardian era.

Sargent came to live at 13 (now 33) Tite Street, a fine studio house previously occupied by Whistler. At first he occupied the studio on the upper floor, but later he also acquired the ground-floor flat with its studio and narrow hallway leading to a bedroom and dining-room. Some years later the adjoining property became available and he combined the two. In 1894, the year in which Sargent joined the Chelsea Arts Club, he was also elected an Associate of the Royal Academy, the first of the original group of New English artists to breach the Royal Academy defences. As a portrait painter he was now pre-eminent, yet he founded no school, attracted no followers, nor did he collect disciples around him like Whistler. In manner he was diffident and inarticulate. He disliked talking about art and had a horror of theories.

In the Club he could be at ease: 'In the middle of the day, or the evening, he was often seen eating at the Chelsea Arts Club, where in a studio that served as a messroom he would meet the other painters frequenting the district. The family-style service, waiters carrying dishes of vegetables around the single long table at which all sat, produced a singularly pleasant atmosphere. It was a friendly place at which he could relax, eating the table d'hôte dinner with a litre of wine while the chef prepared an additional steak for him. Upstairs in the then very modest quarters of the Club was a room for newspapers which he never read, tables for the chess he particularly enjoyed, and a general sociability. He was a jovial companion at the Club, spreading good cheer and considered rather lightheaded by those unfamiliar with his brand of idle banter.'[5]

When the Club was in its simple premises in the King's Road Sargent had difficulty in satisfying his prodigious appetite. He complained that he could not get enough to eat so he often preferred the Hans Crescent Hotel, where he could order from a table d'hôte menu of several courses. After the move to 143 Church Street the choice of food was greater. Sargent would eat large portions of all that was available, but he was known to say as he rose from the table 'Well I think I'll go now to the Ritz for something to eat.'

In appearance Sargent was large and formidable, stout with protuberant blue eyes and a florid complexion. He dressed well but formally; there was little of the artist about his appearance or his manner. In private conversation among his friends he could be charming and witty, but he grew uneasy on formal occasions, pacing about like a caged animal; his speech was jerky and inarticulate and he groped the air as he sought for words. Sargent's greatest horror was to be asked to speak in public; probably for this reason he refused to be considered for the Presidency of the Royal Academy when this was suggested.

When a move was afoot to give a dinner to Wilson Steer, Rothenstein asked Sargent to act as Chairman. He replied

My dear Rothenstein,

I will be delighted to join you in doing honour to Steer, and I note the 21st – let me know where the dinner is to be and at what time. My only misgiving is that if there are to be speeches, (and I scent them in the air) one might be expected from me, and I am utterly incapable of saying a word. I dare say that this is a recognised fact by this time and I need not fear being asked.

Yours sincerely, John S. Sargent.

'John Singer Sargent' by Sir Max Beerbohm NEAC.

At the dinner, however, Sargent was asked to propose a toast, a request which appeared to paralyse him. Rising, bug-eyed and purple, he clutched the edge of the table and, in explosive little bursts, amidst much throat-clearing and embarrassed silence, one word at a time came forth. It never approached any sort of syntax or sense, and each piece was greeted by wild roars of approval and applause. In the general tumult the nature of the toast was lost, though Will Rothenstein recorded it as 'I rise to propose the health of our guest.'[6]

One of Sargent's close friends and a fellow member of the Chelsea Arts Club was Edwin Austin Abbey, also an American living in London. Edwin Abbey was a fine draughtsman who had produced meticulous pen and ink drawings for Austin Dobson's poems and had illustrated a number of Shakespeare's plays. Jacomb-Hood described him as 'a most lovable and delightful man, with a dry, quaint way of saying things, with a roguish look from gleaming, spectacled eyes and a smile which was almost a grin, showing a sparkle of gold in a tooth.'[7] Sargent and Abbey were invited to decorate the upper landing of the Boston Public Library with a series of murals. This work was to occupy them over the next twenty-five years and Sargent regarded the murals as his major contribution to contemporary art.

That other Anglo-American portrait painter, James Jebusa Shannon, was a founder-member of the Club, a friend of Frank Brangwyn and a neighbour in Merton Villa Studios. He was urbane and elegant and an accomplished raconteur at the Club's 'Smoking Evenings'. He was also a fearsome entertainer at the annual Christmas parties for children, with his friend Cole playing the part of a ventriloquist's dummy. He also helped to establish the Arts Ball at the Albert Hall. Born in Auburn, New York, Shannon had spent some years in Canada before coming to London. He was a founder-member of the New English Art Club and a frequent exhibitor at the Royal Academy. Shannon's portraits of the leading figures of the day were painted with bravura and dash and he was coupled with Furse and Lavery as part of the 'Slashing School'. In 1910, the year in which he became Chairman of the Chelsea Arts Club, he also became President of the Royal Society of Portrait Painters. He received a knighthood in 1922, the year before his death.

Charles Wellington Furse was a man of sporting tastes and a member of the Club throughout the 1890s. He was a friend of Sargent, from whom he said he 'got a lot of tips' and his portraits of women and family groups display the same sleek luxury. In his best-known work Furse took his sitters into the fresh surroundings of heath and mountain; his equestrian portrait group *The Return from the Ride*, shown at the Academy in 1903, was described as 'the herald of the new age'. This success was followed in the next year by an even more imposing masterpiece *Diana of the Uplands*, 'as fine a piece of open-air portraiture as England has ever produced.' Sadly this achievement was not to be built upon. The painting was completed in 1904, the year of Furse's death from tuberculosis, which he had fought since early youth.

In the early years members had an uneasy relationship with the Royal Academy and were wary of its pernicious influence. However as time passed its attractions became irresistible for many. Those who were drawn into the Academy in the first twenty years of the Club's existence included John Singer Sargent, the first to be elected ARA in 1894, followed by George Clausen, Edwin Austin Abbey and James Jebusa Shannon in

'Professor Shannon and his wonderful talking figure, "Blow it out Cole." ' James Jebusa Shannon and Philip Cole in their ventriloquist act, popular at children's Christmas parties at the Club.

successive years. La Thangue, Alfred East, Arnesby Brown and Frank Brangwyn soon followed. In 1907 George Henry was elected ARA; he was followed in 1910 by William Orpen and Derwent Wood and, in 1911, by David Young Cameron, Mark Fisher, John Lavery and Charles Shannon. It was seriously believed among London artists that to become an RA you should first join the Chelsea Arts Club. There are however some interesting omissions. The Impressionist faction of the New English Art Club resisted all attempts by the Academy to lure them into membership. As William Rothenstein recalled: 'Many of my friends, Frederick Brown especially, for Brown was a grim Ironside, a sort of Fifth Monarchy man, held the narrow door of the New English Art Club to be the only gate to Heaven.' Steer also remained true to his beliefs and never joined; Augustus John, who had not exhibited with the Academy, accepted an invitation to membership in 1921. (He resigned in 1938 but was reinstated in 1940.) Sickert held out until 1924 and he too resigned in 1935.

The more prominent members of the Club were associated with that network of small galleries that had blossomed in London and were prepared to show experimental work. The Carfax gallery in Bury Street, St. James's, was opened in the 1890s by John Fothergill, with William Rothenstein as adviser. Up to 1906 Steer and his friends exhibited only at the New English Art Club and the Chenil Galleries in Chelsea, which had opened in May 1906 on the site of the original Chelsea Arts Club in the King's Road. John Lavery and others exhibited at William Marchant's Goupil Gallery with a policy 'to represent the modern school in England'.

If the surface of Edwardian art appeared serene, there were strong currents that would soon break through. In 1905 *The Studio* magazine could say 'England's artistic outlook was never so full of splendid promise as it is today.' However even the revolutionaries now appeared complacent and those who had been so adventurous in the formation of the New English Art Club had abandoned their youthful fervour and become noticeably reactionary. Two years later, *The Studio* saw only cosy domesticity. 'That the whole of modern art is affected by the somnolence and a drowsy indication to let things stay as they are, is one of the most dispiriting peculiarities of the artists of the present day.'[8]

In the summer of 1910, an important exhibition at the Whitechapel Art Gallery, 'Twenty Years of British Art', contained the work of many leading members of the Chelsea Arts Club, including Clausen, Condor, Forbes, Fry, Guthrie, Hornel, John, Lavery, La Thangue, Orpen, Roussel, Sargent, Steer and Stott. However more radical influences were at work and soon a tide was running that would carry away many assumptions and break many reputations. To a bewildered audience modernism was first presented. In that same summer an exhibition of 'Post-Impressionist Painting' took place at the Brighton City Art Gallery, entitled 'Modern French Artists'. This was followed by a more ambitious exhibition, 'Manet and the Post-Impressionists', held at the Grafton Galleries, London, from November 1910 to January 1911. Both of these exhibitions had been organized by Roger Fry and showed, for the first time in England, the range and depth of work of late Impressionism and of Post-Impressionism. In October 1912, a second 'Post-Impressionist Exhibition' was held which included French painters of even more advanced views, including Braque, Picasso and Matisse, plus some of the most experimental of the young English painters – Spencer Gore, Stanley Spencer, Vanessa Bell, Duncan Grant and Wyndham Lewis. The Chelsea artists were notably absent.

One of the 'spoof' drawings for 'Septule and the Racinistes' by H.M. Bateman.

Led by Tonks, Steer and Maccoll, the 'old guard' of the NEAC felt themselves isolated and were fiercely critical. Augustus John, who had been regarded as the 'heir apparent', did not exhibit in either of Roger Fry's exhibitions and by 1912 found himself in the rearguard of British art. The attention given to the avant-garde by students at the Slade School led Tonks to wail 'What a brood I have raised up!': he advised them to stay away from Fry's exhibition for fear of contamination. Steer developed a loathing for Cézanne, his 'toppling jugs, botched-bashed apples, bodiless clothes, muddled perspectives and the rest, thought to illustrate the cubical nature of the sphere, the generosity of colour and other brown profundities.' In a private joke, Steer and Tonks avoided the continual use of Cézanne's name by calling him 'Mr Harris'.

The Club's response to these perilous artistic times was to arrange a 'spoof' exhibition in December 1910, entitled 'Septule and the Racinistes'. This hoax was the brain-child of the new Chairman, James Jebusa Shannon, who prepared a handsome catalogue which described an imaginary group of artists, 'the Racinistes': 'that brave band of fighters who gathered around Quinite Septule after his flight from Paris, and formed the little artists' colony at Châteaudun.' Shannon claimed these revolutionaries were responsible for forming the great artistic principles that were the basis of Impressionism and Post-Impressonism. He described the work of the various members of the group who gathered round the leader, including Charles Turletin 'whose uncompromising independence had closed to him the gates of all public exhibitions.' His companions were men of 'brilliant genius' such as Schulfin, Rotton, Gaga, Aspic and others, who variously shot themselves, went mad, died in convulsions from 'the poisonous exhalation of certain pigments of his own invention', or destroyed themselves with drugs.

A small exhibition was arranged in the Club of joke drawings and paintings, executed by H.M. Bateman and others, which caricatured the styles of Cubism, Fauvism, etc. One was signed 'Henri-Matisse' and other abstracts were given classical titles such as *Adam and Eve* or *Venus and Cupid*. A private view was held for critics and their friends at which the elegant Shannon passed off the whole proceedings with his usual urbanity and the members enjoyed the joke hugely.

It was during Shannon's Chairmanship that the Club had as its guest the distinguished writer Arnold Bennett. He recorded these events of Friday 1 February 1910:

Dinner at the Chelsea Arts Club. Room, long, low. Billiard-room. Rules and cues still hanging on the walls. Some men in elegant evening-dress; some in fair ditto, some in smoking jackets, some in morning coats, some in lounge suits. Frampton in the last, with rough hair. Shannon, in chair, très élégant.

New ventilation put in roof for this banquet. Ventilation bad. Dinner sound. Service mediocre. Man on my right who grumbled at most things.

Caricatures, drawings and paintings round walls. Whitish walls. No elegance of furniture. The whole place rather like a studio.

Shannon's speech good. When replies began, 'il commençait de se dégager' an atmosphere of brotherly love. You might have thought that success in an artistic career depended chiefly on help from fellow-artists. It grew almost maudlin. Enormous log-rolling, not principally as great artists, but as true friends, etc. Notoriously untrue, of course.

Stanhope Forbes and George Henry made good speeches, but even these far from free of the log-rolling. Piling it on thick.

Note that the points of my speech that raised laughs were that I had bought pictures by members, that Orpen was a child, and that each member of the Club

'Portrait of a Member' by George Belcher RA.

who was made ARA was a hatchet buried in the ribs of the enemy.

Enormous applause of younger ARA's, Derwent Wood and Orpen. When I mentioned Foster (Club organizer) in my speech, they called for a speech from him afterwards. A very strong man. He went out. Several tried to drag him into the room but could not. They say the Club owes everything to him.

After regular speeches, comic speech read by Cavaliere Formili, interrupted by an arranged suffragette invasion. Political opinions of majority seen at once. Invaders in costume, also policeman. One put his legs down hole in roof.

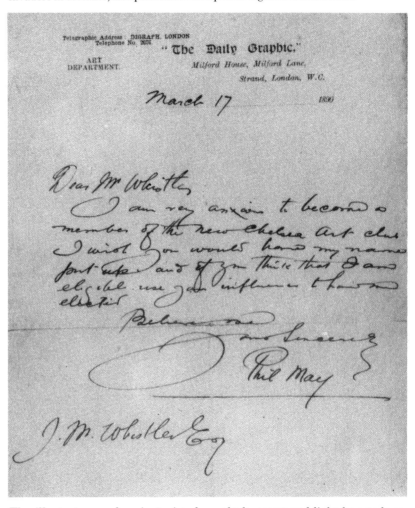

Phil May. Application to the Chelsea Arts Club, 17 March 1896.

The illustrators and caricaturists brought humour and light-heartedness to the Club. In the 1880s and 1890s new processes of photo-engraving had replaced the older methods of line-block reproduction. These new techniques led to an enormous increase in the number of illustrated books and magazines and brought a new public, eager for the latest joke or topical illustrations.

When Phil May joined the Club in July 1891, he was one of the most prominent artists in London. He had an astonishing skill, drawing on the humour of the slums, a world of guttersnipes, drunken charwomen and bookmakers. It was a world he knew well, for he had grown up as a cheerful urchin in Leeds. At one point he was reduced to begging in the London streets, but he always continued to draw. He married at twenty-one and was rescued from the gutter by his courageous wife who never ceased to believe in him. He worked for a time in Australia on the *Sydney Bulletin*, an experience which restored his health and brought him to public attention. On his return to London his sparkling drawings for *The Graphic* and later for *Punch* brought him solid success.

Phil May, the greatest English cartoonist, was one of the true Bohemians. He was very small, he looked like a stable lad, and his face was deadly pale except for a red, bulbous nose. In the club he was rarely seen without a drink in his hand. He said to Jacomb-Hood 'You see this nose of mine? I wish I now had all the money it's cost me to colour it.' He was sociable but reflective and somewhat distant, at least until he had started drinking – then he could be garrulous and frequently became involved in bizarre episodes. To the end of his days he remained a spendthrift and his heavy drinking killed him early; he died in 1903, at the age of thirty-nine, of cirrhosis of the liver. At the time of his death he weighed only five stones.[9]

Max Beerbohm was of the same generation as Phil May and Aubrey Beardsley but, unlike them, Beerbohm was from the upper class, educated at Charterhouse and already a celebrity at Oxford as an undergraduate. He was briefly a member of the Club in the 1890s. At this time he was still a dilettante and teaching himself to draw. He soon mastered an expressive and highly personal use of line that became a surgical instrument in his hands.

There was a link between the Chelsea Arts Club and the London Sketch Club, which had its beginnings over the same problem that had occupied the Chelsea artists – how to provide a good hot supper for its members. Phil May, Cecil Aldin, Frank Hart, Hughes Stanton, H.M. Bateman and Terrick Williams were members of both Clubs. At the London Sketch Club, it was a tradition for members to make caricature drawings of each other, a habit that came over to the Chelsea Arts Club: menus, tablecloths and shirt cuffs served as drawing surfaces. In the Chelsea Arts Club, the illustrators of *Punch* formed a somewhat separate group. In their work they tended towards a conservative view, drawing on the styles of a decade before. Club members who regularly drew for *Punch* included Cecil Aldin the hunting artist, George Belcher, Lewis Baumer, Fred Pegram and F.H. Townsend. A number of these formed a sketching group that met in the Club several times a week to draw from the model.

F.H. Townsend was a shy and kindly man, considerate to others. He drew like an angel: there is little fantasy in his realistic drawings of contemporary events, but much gentle fun and sympathy for the fine social distinctions of Edwardian England. In 1905 he became the first Art Editor of *Punch* and favoured those who, like himself, could draw well, rather than those who relied on comic invention. Townsend's brother-in-law, Fred Pegram, also a founder-member of the Club and later a prominent Council Member, was Townsend's equal as a naturalistic draftsman, but with a more restrained style. He invented a popular advert of the day, the sylph-like 'Kodak' girl with the stripy dress.

Bernard Partridge was one of the most staunch and reliable of the *Punch* draftsmen. In 1910 he became the principal cartoonist for the magazine and continued to illustrate it until his death in 1945. Partridge's work for *Punch* spans fifty years of social comment and political satire, but it is in the Edwardian era, when he describes the world of London society, of swells, formal clothes and grand dinner-parties that he is at his finest. He was entirely absorbed in his work, and highly professional; his meticulous drawings were always delivered on time and he was never wrong about a costume or a uniform. There was a theatricality about his work, perhaps influenced by his early choice of a stage career: he was in the first production of Shaw's *Arms and the Man* under his stage name

'In the Soup' by F.H. Townsend. Cover for Punch.

'Bernard Gould'. He had also trained with an architect and with a firm of stained-glass designers. Partridge lived near the Club in Church Street and became a member in 1894. Always courteous, if a little pompous, as befitted the son of a President of the Royal College of Surgeons, his weighty presence brought dignity to the more rumbustious proceedings and he soon took on the role of a grand old man. He enjoyed living in style; it was said that his elaborate dinner parties were the longest in London. The knighthood that he received in 1925 came naturally to him.

The Club thrived on anecdote and incident and one of the wittiest observers was H.M. Bateman, who was put up for membership by Frank Hart in August 1910. Bateman was already well known from his cartoons in the *Tatler*, the *Bystander* and other magazines. He had found a way of drawing that was indisputably his own, in which the characters became actors in his own private theatre, expressing their foibles and emotions through gesture and hilarious incident. In his own words he 'went mad on paper.' To study character and exaggeration he would sit in front of a mirror and twist his face and body into the strange shapes that he required, a performance that usually took place in private. He also frequented the music halls and doted on the eccentricities of Little Titch and Harry Tate. He was very fond of boxing, which he practised, and he became a keen tap dancer. He bought a wooden dancing mat and a pair of wood-soled shoes and became adept in the 'buck and wing' dance. From time to time he would give impromptu demonstrations to the startled members of the Club. Just after the Great War he lived and worked in a room in Chelsea. Alfred Munnings, who occupied the room below, recalled: 'Each morning, as I worked, I would hear H.M. Bateman in the studio above doing his step-dance; pit-a-pat, pit-a-pat, it went on. Oh damn the fellow.'[10]

Bateman's most popular cartoons, which appeared over many years, were *The Man who...* – a series which shows an wholly innocent individual performing various socially unacceptable acts, such as *Lighting a cigar before the Royal Toast*, to the shock and horror of his audience. In common with many of his fellow members, Bateman was a declared reactionary and detested 'modern art'. In 1910, at the time of Roger Fry's exhibition of Post-Impressionism, he made comic cartoons of the paintings for the 'spoof' exhibition arranged in the Club. He was particularly incensed by Matisse, Picasso and the Cubists; in one of his best-known drawings, *Brother Brushes*, he poked fun at the excesses of Vorticism.[11]

Although naturally retiring and somewhat shy, Bateman produced many perceptive cartoons of other members; he also made a great many illustrations for dinner menus and he illustrated a brief history of the Club written by Graham Petrie. On a number of occasions he made comic designs for the Chelsea Arts Club Balls, including the Armistice Ball of 1919. It was at the Ball of 1925 that he met his wife-to-be, Brenda Collison Wier, who was related to Harry Collison, an early member of the Club. For many years the Chelsea Arts Club was an oasis where he could relax in the company of fellow artists and away from the publicity that had come with his success. His marriage in September 1926 and his subsequent move to Reigate ended his close connection with the Club, but he continued his membership until his old age, resigning with regret in 1958.

Although the world of art was proving troublesome, and there was rumbling in Central Europe, Edwardian values appeared to be enduring. The Club had made considerable profits on the first of the Arts Balls,

subscriptions had remained low and the Club now appeared to be distinctly prosperous, with £1000 on deposit and regular payments made to the building fund. Stirling Lee, the true founder of the Club, and a moving spirit in the early years, was re-elected to the Chairmanship in 1911 and, in the few years that remained to him, he again steered the Club through some of its most difficult decisions.

The Club had now reached its maturity and a grand celebration dinner was arranged for 18 March 1912 to mark the twenty-first anniversary of its formation. Appropriately Stirling Lee was in the Chair and the event was a spectacular success. Thirty-one out of the sixty-five founder-members were able to attend, and eighteen out of the fifty-two original members. There were some apologies: Walter Sickert wrote 'I am tied by my L.C.C. class on Monday' and a number of the country members, including Henry Tuke in Falmouth and Moffat Lindner and Alfred Hartley in St Ives, were unable to make the long journey. In proposing the health of the Officers of the Club, F.R. Fowke, the Honorary Treasurer, told the dinner party 'How the swindle is worked.' He explained that on joining the Club he had believed that artists are not men of business, 'their souls are for ever soaring into empyrean of aesthetic ideal and they know little of and care less for filthy luker and its manipulation.' But there was now evidence of progress, due, he felt, to exceptional men whose artistic gifts were combined with financial and administrative ability.

At the instigation of the sculptor Basil Gotto, the Club arranged a competition, open to all Chelsea artists, to decorate the main hall of the Chelsea Town Hall with four panels of Chelsea celebrities, together with allegorical figures to represent art, literature, politics, religion and science, pictured against a background of the river. Basil Gotto had broached the idea to Sir Christopher Head, the Mayor of Chelsea, at a dinner party with Sargent, Derwent Wood, and other prominent club members. 'We decided that the painters should receive £250 for each of the larger panels, and £100 for the smaller ones. The Mayor at once expressed himself willing to contribute the cost of one large panel, and we broke up just before mid-night. Having parted with my guests, I went out to post a letter in Oakley Street, and encountered Mr Horniman, the tea king, who was on a like errand. "Horniman," I said, "I want £250 from you." "What for?" he asked. I explained and he immediately complied.'[12]

The competition attracted a great deal of attention. John Sargent, Philip Wilson Steer and the architect E.A. Rickards were judges and the murals were satisfactorily completed in 1912. However two years later, after heated discussion in the Council Chamber, the Borough Council decided that one of the murals, that of literature, was offensive and should be removed because it included a portrait of Oscar Wilde (it also contained portraits of Thomas Carlyle and T.S. Eliot). Councillor Wright had made the objection that 'Chelsea Town Hall was not built for the exhibition of such people.' Other Council members objected to the picture on artistic grounds. Basil Gotto was greatly incensed; in an angry letter to the press he complained: 'that the Borough Council should now decide "on artistic grounds" to remove any of the panels by artists chosen under the scheme, which they themselves definitely sanctioned, seems to us incomprehensible, and we desire most emphatically to protest against any such arbitrary action on their part.'[13] The controversy rumbled on for some time, but because of the outbreak of war this contentious resolution was not carried out and the portraits remained.

In 1913 the City of Bradford invited the Chelsea Arts Club to arrange an exhibition of members' work in the Cartwright Hall, Bradford. Basil Gotto went to Bradford to hang the exhibition and he was pleased with the result, but somewhat overwhelmed by the opening ceremony, with the Mayor and Aldermen in full regalia, red carpet, reporters, photographers and speeches to which he responded on behalf of the Club. He was very nervous, very brief and very bad. He was then told that a banquet had been arranged and was asked to present an account of his expenses from door to door. Embarrassed, he explained that his visit was but a poor expression of the thanks which the Club already owed to Bradford for such a splendid exhibition. 'Mr Gotto,' replied the Curator in a round Yorkshire accent, 'Bradford is rich. Bradford can afford to pay the expenses of the visitors whom it wishes to welcome.' After this, his only regret was that he had bought a third-class return.

As the end of the decade approached, it was again necessary to extend the lease of the Club and, after negotiation with the Sloane Stanley Estate, a new lease was agreed to commence on 24 June 1911 for twenty-one years, at a rent of £110 per annum for the first five years and £130 per annum for the remainder of the term. In the lease document it was prohibited for the premises 'to be used for the purpose of any trade or business whatsoever or as a brothel, private madhouse or receptacle for lunatics or insane persons.'

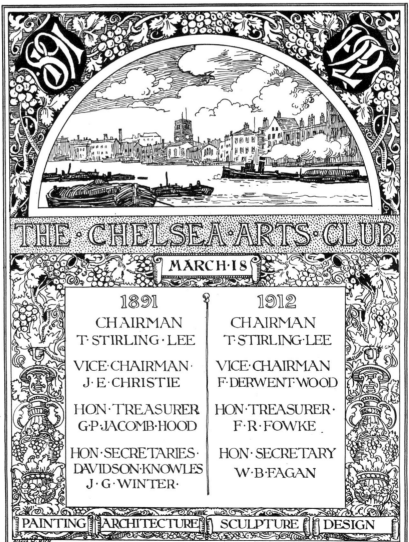

The Bi-Centenary Dinner Programme, 18 March 1912, by Alfred Rich NEAC.

'The Beggarman' by Basil Gotto NPS. The bronze sculpture which is one of Gotto's principal works now stands in the garden of the Chelsea Arts Club. Basil Gotto was Chairman of the Club from 1913 to 1915.

Well before the expiry of this lease, the Club found itself to be in possession of considerable capital, as a result of the success of the Annual Arts Balls. In order to put this to good use, Sherwood Foster again approached Colonel Sloane Stanley to ask if the freehold of the premises could be purchased or, if this was not possible, a long lease could be arranged, the longer the better. Foster put to him that 'this proposal is of the utmost importance to the artists who live in and are associated with Chelsea. Many of them are very poor, and it has always been the policy of the Council of the Club to keep charges and subscriptions down, and not to exclude any artist with the necessary qualification on account of poverty. . . . The Chelsea Arts Club is known to artists all over the world, and its permanence in the eyes of artists is almost a matter of national importance.'[14]

His appeal was successful and after some negotiation a new lease was agreed in June 1914, just a few weeks before the outbreak of the Great War. The lease was to run for sixty years, to 1974, and the sum paid was £2225, plus a ground rent of £30 per annum. Most of this could be found from the funds of the Club, but £900 was borrowed from the Bank at 4½% interest. The lease was held for the club by Edward Moira, Basil Gotto, Captain Adrian Jones, Sherwood Foster, Frank Baxter and James Jebusa Shannon.

The greater use of the Club and its new-found prosperity was putting considerable strain upon the old clubhouse and it was clear that further improvements were urgently needed. The sleeping arrangements were inadequate for the growing numbers of resident staff and the dining-room and other parts of the accommodation were in a poor state of repair.

In 1908 the architect Gilbert Jenkins, who had made the earlier alterations to the Club, had been asked to suggest further improvements. However his somewhat modest ideas were not to the liking of the ambitious Committee and Jenkins resigned. A more adventurous architect member, L. Rome Guthrie, was asked to take over the scheme. He constructed a new dining-room by joining the old reading and writing rooms. (This is the present large dining-room of the Club.) A new lounge was created by closing the old members' entrance and joining together two small pantries. (This became the present small dining-room.) A new entrance hall was made and a new kitchen was provided by building over part of the yard.

This was not to be the end of the changes. The Building Committee now had additional funds at its disposal and, in a series of improvements made between 1908 and 1910, it was decided to enlarge the billiard room in order to accommodate a second billiard table. To make it even more spacious the roof was raised by three feet and a gallery was added. The room was further improved by the addition of a handsome bay window entering onto the garden. A ventilation system was installed and two fireplaces were provided in the room. However a central heating system was said by the architect to 'present many difficulties'.

Money now appeared to be plentiful and the Club proposed even more ambitious building schemes. In 1913 a considerable amount of time and energy was spent in preparing an elaborate scheme for rebuilding the entire premises. The architect L. Rome Guthrie sketched out a design to add a third storey to the main building. This would have given the Club a large new dining-room, a new kitchen and an enlarged library on the ground floor, and a total of sixteen bedrooms, including servants' rooms,

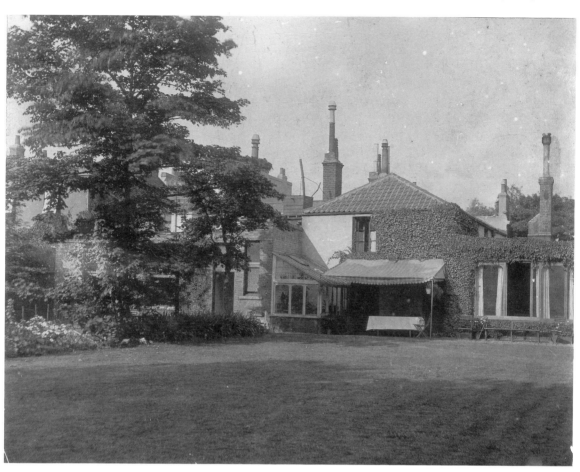

The Garden of the Club before the alterations of 1908–10.

above. The cost of this ambitious proposal he estimated as in excess of £3000, a sum which horrified the Council. A Special General Meeting of the Club was called on 25 June 1913 to consider this important matter. However, although the members were anxious to insure the permanence of the Club they felt that this building scheme would absorb a large portion of their capital without bringing additional profit. It was eventually agreed to recommend one of the less ambitious schemes, which would give the Club a servants hall, plus three additional bedrooms, bathroom and WC over the billiard room. The cost of this, with repairs to the kitchen and additional furniture, totalled £800. Soon any further ideas of improving the building were swept away in the emergency of the Great War and it would be some years before improvements to the clubhouse were again discussed.

Artists Go To War

In August 1914 the long peace of Europe ended. No one in England could foresee the crippling effect that the conflict would have upon the social fabric of the nation. War was envisaged as a military matter in which speedy and decisive battles would be fought and a dictated peace would soon follow. Within a month the Germans had marched through Belgium and reached the line of the Marne in France; but there they stayed. By November there was a line of trenches running across French soil from Switzerland to the sea.

The peace of Chelsea was shattered. Dora Coats, who lived in Glebe Place wrote: 'Never shall I forget how suddenly Chelsea seemed to become an armed camp. Soldiers were bivouacked in Ranelagh Gardens and the Royal Hospital grounds. Army motor lorries were rattling noisily along the normerly quiet Embankment, and those hot nights we lay awake listening to the heavy rumble of laden troop-trains, all night long, slowly steaming out of Victoria Station. It was a heart-breaking sight to see the young men of all ranks going up the steps of Chelsea Town Hall to enlist.'[1] Members of the Chelsea Arts Club took part in a patriotic concert in Chelsea Town Hall. The programme announced 'At this War Crisis it is your duty to attend.' Patriotic songs, musical recitations and sentimental ballads were followed by an auction of members' work, each sale accompanied by a mighty thump on a big drum.

Derwent Wood, supported by several leading members, wrote formally to the Council, proposing that a Chelsea Arts Club Corps be formed, and sought the sanction of the War Office for this; he hoped for at least one hundred members. He was sure that 'the Club would be proud to have made such an effort in the present crisis.' When Alfred Munnings came to London from Cornwall at the outbreak of war, he found fellow members of the Chelsea Arts Club who had already joined the Artists' Rifles, solemnly drilling with broomsticks in the garden. He went to the nearest recruiting station in Chelsea but, to his surprise, he was rejected from the Yeomanry because of his blind eye and returned to Hampshire to paint hop-pickers.

The older artists, too old for active service, helped as best they could. They turned their studios into light workshops, or they patrolled the streets as special constables, prepared to cope with every emergency. The landscape painter Arthur Black was sent to France to make hand and foot splints for the wounded. William Dickson was also too old for the Army, but being a good mechanic he turned his studio in the King's Road into a workshop and for three years devoted all his time to making fine parts for the sights of field guns. Westley Manning, known as 'Black' Manning, was a member of Council. He was not known for his generosity: in his notes,

'Drawing of a Member' by Henry Poole RA. Chairman of the Club in 1915.

the Steward recorded that 'Mr Manning bought a drink one night, I have never known him do such a thing before or since.'[2] Being too old for active service, Manning adopted a wounded soldier, but this did not turn out well. After being nursed back to health his charge disappeared and was probably shot as a deserter.

There was a great feeling of support for the Belgian people, who had suffered so terribly under the German occupation. Many practical offers of help were made, such as the use of empty houses to house refugees, gifts of food, coal and furniture; more than two hundred Belgian civilians and wounded soldiers were accommodated in Chelsea. John Lavery and William de Glehn organized support within the Club and membership was given to Belgian artists. The Club's assistance to the Belgians was later commemorated by the gift of a bronze head by the well-known Belgian sculptor Victor Rousseau, inscribed with the names of all the Belgian artists who enjoyed the Club's hospitality. This was presented by the Belgian Ambassador at a dinner given by the Club in February 1926.

"The Immediate Need Fund"

For Refugee Belgian Artists in Great Britain.

A French Speaking Committee has been formed at the Chelsea Arts Club for the relief of the Refugee Belgian Artists in Great Britain.

A 5/- fund has been started and subscriptions are earnestly needed to help those who are destitute.

Subscriptions to be sent to—

W. G. von GLEHN,

Hon. Treasurer,

73, Cheyne Walk,

Chelsea.

Tel.—Kensington 1516.

or as many 5/s as possible !

Support for Refugee Belgian Artists.

In the early days of the war the Commandant of the Third London General Hospital made an impassioned plea in the bar of the Club for help with the medical services. As a consequence some thirty members joined the Royal Army Medical Corps. Many of these enlisted very early in 1914 and stayed, although past military age, until the end of the War. When Derwent Wood joined the RAMC in 1915, he was the first sculptor to be recruited into the army to practise his art. He helped the wounded

'The Third London General Hospital, Wandsworth'. Some members of Hut VI, (left to right) Fullwood, Wood, Pirie, Ware, Fagan, Grant, Stott. Postcard from W.B. Fagan, 7 July 1915.

and disfigured in the field, by making silver masks for the facial wounds department. Noel Irving, who was too old for active service, joined the RAMC and became editor of the *Third London General Hospital Gazette*, which counted amongst its contributors many members of the Chelsea Arts Club. Others drove ambulances or served as stretcher-bearers for the Red Cross throughout the war in France, Belgium, Italy and the Balkans.

Henry Tonks combined his medical experience with his artistic skills in an extraordinary way. At the beginning of the war, Tonks, then fifty-nine, served in England as a volunteer hospital orderly, but by January 1915 he was in France; the following year he was made a lieutenant in the RAMC. He became interested in the recording of facial surgery cases and began to visit the Cambridge Military Hospital, where Sir Harold Gillies had developed techniques of skin grafting to repair the faces of men disfigured by bullets, shell-fire or burns. Tonks worked with Gillies in the operating theatre, recording operations, and made a series of remarkable pastel drawings of severely wounded soldiers. In the last year of the war Tonks was appointed a war artist. He agreed to tackle a medical subject and, after much indecision, left for France in June 1918 in the company of John Singer Sargent. Tonks's task was to paint a field dressing station for propaganda purposes. With the war still at its height he worked on studies in an advanced dressing station near the front line, although with typical self-depreciation he wrote 'anybody less suited to be a special artist probably does not exist.' 'However,' he went on, 'I pride myself that it gives a reasonable account of modern war surgery . . . I used to make such notes as I could of actual wounded men and I think most of what I saw is based on actual fact.'[3]

Gaps were appearing in the Club as members were called into the Armed Forces. Of the 319 members, 74 were serving with the Colours by 1916. They were all made honorary members and their subscription was waived. Their photographs were exhibited in the Club and food parcels were sent to them at the Front. As far as possible the Club tried to proceed with its normal affairs, but attendance was down and income was reduced. There was concern that members would not find employment as artists and it was agreed to put on a cheap lunch, at one shilling instead of

'Pay Day' by J.H. Dowd.

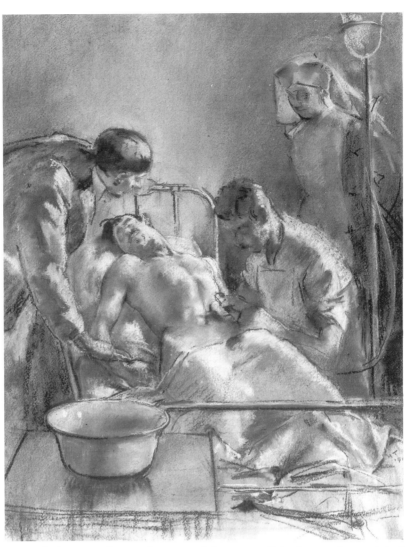

'Surgeon Performing an Operation' by Henry Tonks NEAC.

one and sixpence. It was also agreed that any artist who was in receipt of help from the Artists' Benevolent Fund should be allowed three months' credit for meals. Although every economy was being made, the Club was running at a certain loss. Because of the lack of young men, the red-coated waiters were replaced by waitresses, the cost of wines and spirits was raised, great economy was made in the use of coal and electric light and the Club closed at 11 p.m.

The war fever upset that sense of international friendship that was so characteristic of the Club. A number of members became concerned that the Steward, whose name was Heinrich Grohne, was German or a German sympathizer. Grohne had an English wife, called Mabel, who acted as stewardess; she was a 'cordon bleu' cook, who had studied under Escoffier. They were both valuable servants to the Club and it was agreed that it would be wrong to dismiss them. However matters were taken out of the Club's hands.

The Chairman took the advice of the police who made a search of the Steward's belongings. Grohne was found to be a German and was interned at Alexandra Palace. There was a happy sequel to this, however, for the Club owed Grohne back wages, which were given to him in golden sovereigns, and he was able to keep these with him during his time in prison, stored in a biscuit barrel. When he was finally released he and his wife were able to buy a small hotel in Germany with these savings.

'John the Steward': Albert Edward Smith.

At the Annual General Meeting of 1916 a new rule was introduced; 'candidates for ordinary membership may be of any nationality other than German, Austrian, Turkish or Bulgarian, in addition to having a bona-fide qualification in the graphic arts.' It was also decided that no Germans or Austrians were to be employed in the Club.

The next Steward was a young man called Albert William Smith, who, for no good reason, was immediately christened 'John the Steward'. He was then about twenty-four years old, courteous and well-spoken, and had trained as a servant. His young wife Ellen Mayne became stewardess. 'John' soon became a Club institution. He recalled the casual atmosphere of the Club on his first days, shortly before war began:

I arrived this morning, 2nd April 1914, at the Club, on Good Friday above all days a suitable day to come to the Club. Most of the members were away, being holiday time, so I did not see many the first day. . . . On Monday most of the members came back and dinner seemed a strange affair after private service. I thought what a strange lot of people to be sure. Members 'lazed' on the table, swore a bit, and had not brushed their hair, but it is easy to fall into line. I mean there was no need to be embarrassed. Mr Robert Fowler came in on the Saturday afternoon, and seeing that I was new, started showing me a few card tricks. Mr George Coats came in and in his well-modulated voice asked me my name, etc. At that time he was Chairman of the House Committee. The Annual Dinner followed on the 27th, a pleasant affair; English ribs of beef from Smithfield Market at 9d a pound, quite different from the 'War meat'. We managed to finish the clearing away by 2 a.m.[4]

Together the Steward and stewardess ran the Club and gave great personal attention to the members. Their duties were comprehensive, overseeing everything from the kitchen and other staff to the wine cellar and tradesmen. After Arts Balls or Club dinners they could be on duty in the bar until 4 a.m. and then be required to prepare 120 breakfasts before the last guests left. 'John' was a keen observer of the members. He greatly admired their way of life, he enjoyed their successes and commiserated with their disappointments. He wrote his reminiscences in two journals, parts of which are quoted in this book. He describes a Club which is boisterous, outgoing and friendly; yet, at a time of war, tensions were high, fierce disagreements could occur and members not infrequently came to blows:

On Monday night the Club gave a dinner to Bill Baynes, and a riotous affair it was. 'Bill' drank innumerable pints of beer, and sloe gin. After dinner the company went into the billiard room, where singing and a general carousel took place. One member happened to say that any person serving in France must be lousy. Bill Baynes instantly let down his trousers, pulled up his shirt and said 'Look at this and see if I am lousy,' which they did do. Afterwards they patrolled the billiard room, headed by 'Bill', singing 'Ribs of beef and b—y great lumps of Duff'. This went on until 2 o'clock and then they dispersed as best they could. On the following day 'Bill' returned to France. Mr Bell went to Victoria with him, and Mr Lambert followed them and arrived just before the train started, and jumped over the barrier to wish 'God Speed' to poor Sergeant Baynes; and that was the last we saw of him, as he was blown up by a shell three weeks afterwards. But he is often spoken about by his friends here.

Although many of the men were away, the Club was at its liveliest, there was constant coming and going of members on home leave, or others calling in between portrait commissions of the military. George Lambert told terrific stories, and Derwent Wood, with biting sarcasm, helped to keep the place in an uproar. 'John the Steward' appeared never to sleep; no matter what time a member turned up, he was always ready to minister to their needs. H.M. Bateman borrowed pyjamas from him more

than once, and others used his razor, boots and other civilian apparel as a matter of course.

Those members who had remained in London were greatly in awe of the returning servicemen. H.A. Hogg had seen action in France and was seriously wounded in the thigh. On his first leave he impressed other members sitting around the fire with tales of soldiering. One rather impressionable member asked him what he did if a military policemen crossed his path. 'Oh,' said Hogg, 'you just stick your bayonet in their guts and if a Tommy pinches anything belonging to you, bash in his jaw.' On his return to France the Club Steward accompanied him to Victoria Station at 5.30 a.m., to help carry a gramophone and records, two turkeys, two bottles of whisky, two bottles of bass to drink on the train, a pair of boots that reached to the knee and various other articles. With a muffler around his neck, big boots and a great-coat he looked like a poacher. On a later leave he was at the Club when the air-raids were on. Alfred Munnings said to him 'Hogg, I hope there is a raid tonight so you can see what the Club is like in one. The girls run about cackling and the place is like a bloody farmyard.'

Philip Wilson Steer was in the Special Constabulary for a short time; later he was recruited as a war artist. He was asked to paint Dover Harbour for the Navy, but found this uncomfortable. Steer's requirements while painting (as listed by his friend Philip Connard) were: (1) Shelter from the wind (his fear of draughts was notorious). (2) Proximity to a lavatory. (3) Shade from the sun. (4) Protection from children. (5) A suitable subject. These were not easily satisfied; he found his hotel accommodation depressing and when he started to paint in watercolour 'some blighter comes up and wants to see my permit, which is very upsetting just in the middle of laying in a wash!' To add to his difficulties he found that 'ships and boats have a habit of moving unexpectedly and after spending much time and labour in putting one in, one finds one has got it in the wrong place.'

Steer's friends showed more resilence. Ronald Gray, who was by no means robust, was enlisted into the RNVR Anti-Aircraft Services and worked on various gun-sites around London for the duration of the war. Philip Connard was attached to a cruiser squadron painting sea pictures. He had previously been a Captain in the Royal Artillery and was a poor sailor. However he was admired for 'the plucky way that he stuck to his work in all weathers, in spite of frequent journeys to the ship's side to "discharge cargo"'. He found the Navy's suspicion of civilians and the obstructive bureaucracy made it difficult to work; however he was able to record the surrender of the Turkish ships and the opening of the Dardanelles. George Clausen, by now aged sixty-six and a respected member of the Royal Academy, was commissioned to paint scenes in the munitions factories. He produced one large oil, *In the Gun Factory at Woolwich Arsenal*. Such war artist commissions were paid at a standard rate – £300 for a single picture of large size and £150 for smaller sizes.[5]

In the early days of the war Albert Fullwood and Robert Heyworth were drawing near the sea-front when a coastguard came up and demanded to know what they were doing, since sketching out-of-doors was against wartime regulations. Heyworth showed a sketch of Putney Church to prove he was an artist, but the coastguard said 'How do I know this is Putney Church, to me it looks like a plan of a fortification?' He asked Fullwood for a passport and Fullwood said he had none, so the coastguard tugged at his beard to see if it was false.

'Philip Connard' by a member.

In pre-war days Cecil Wilson considered himself to be the best-dressed member of the Club. He would wear a check suit, high collar and 'horsy' tie, white bowler hat and long cuffs. He joined in the ranks, but before he embarked for France he had been made up to Captain. He proved to be a particularly efficient transport officer and was involved in the operations of the Somme and Loos. In Macedonia he suffered great hardship because of the intense cold and lack of food, but he was there until April 1919 and was one of the last to leave Bataoum before the Bolsheviks took possession.

H.M. Bateman had made an attempt to join the army but, after a brief period of training, he contracted rheumatic fever and was invalided out. During his recovery he was in the Third London General Hospital, Wandsworth, where he found a number of friends from Chelsea. He decorated the recreation room with several cartoons, one of which was Sgt. Derwent Wood fixing a splint to a straffed microbe. He was later

'The Recruit Who Took to it Kindly' by H.M. Bateman.
Punch, *17 January 1917.*

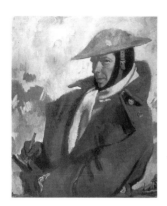

'Self-Portrait' by Sir William Orpen RA, NEAC.

commissioned to make drawings for the War Office. On one occasion in France when he visited a training camp at St Pol, the commanding officer, Colonel Campbell, rushed out to the car in great excitement. 'Bateman,' he cried. 'You are the spirit of the Bayonet.' Bateman was flabbergasted, for he had already been thrown out of the army as unfit. He found that a comic drawing that he had made for *Punch* of men in action with the bayonet, called *The recruit who took it kindly*, was being used as an example for training practice.[6]

William Orpen, Augustus John and John Sargent were the biggest names among the war artists. Some of the earliest commissions of the war were offered by the Canadian Government, as part of a scheme that had been pursued with great energy by Lord Beaverbrook, and Orpen was one of the first major painters to be appointed. During his early months in France he was remarkably unproductive; he objected to being treated like a child, expected to show his work each day and to hear it criticized by philistine army officers in terms which outraged him. He spent much time quarrelling with the authorities who thought he was 'Irish and artistic'. Orpen was later appointed as an official war artist to the British Government in January 1917 and was still in France well into 1920.

Augustus John had been saved from the rigours of active service by an ailment he described as 'Housemaid's knee'. He applied for a war artist appointment in June 1917, but the terms that were offered by the British did not meet his requirements and he too was attracted by the Canadians, who offered a major's commission with full pay. He came to France in January 1918 to the area around Vimy and cut a dashing figure. He was the only bearded officer in the Army except for the King, for whom he was frequently mistaken. John greatly enjoyed the attention that he was given, but he was sent home in disgrace for knocking down a fellow officer. Nevertheless, his reputation was such that the British authorities later approached him with a request for a special commission for a large canvas depicting *The Junction of Our Line with the French*. However John produced nothing of value from his time as a war artist; he had little feeling for the hard facts of warfare, he was drinking heavily and subject to fits of depression and the picture was never even started. He wrote 'When out at the front, I admire things unreasonably and conduct myself with the instinctive tact which is the mark of a moral traitor.'

The most ambitious picture to come from the Western front, and one of the most powerful, was John Sargent's *Gassed*. A subject had been suggested to him by the War Office – the cooperation between American and British troops – and for an American living in London this appeared to be appropriate. It was suggested that this should be a 'super-picture', designed, like John's, to be hung in a hall of remembrance, to be 20 ft. long by 9 ft. high. With a personal letter from Lloyd George, Sargent received VIP treatment. He arrived in France in July 1918 and was given good accommodation with the Guards division on the Somme. He made many sketches, working under a large white umbrella – later camouflaged – and was taken on occasional joy-rides in a tank. However he had difficulty in finding a subject of sufficient gravity and importance to fill the large canvas, without it looking, he said, 'like an illustrated-paper kind of subject'. Eventually Sargent chose to paint a scene that he had witnessed at Le-Bac-du-Sud on the road to Arras, where a temporary dressing station has been set up to relieve the suffering of hundreds of men who had been temporarily blinded by mustard-gas. When finally

'Alfred Munnings' by Fred Pegram RI. The black eye and bandaged hand are perhaps souvenirs of the Armistice celebrations.

completed, this haunting painting was a tribute to the sufferings of the serving soldier and a strong statement of opposition to war: it justly became one of the most famous of the war pictures.

Several of the portrait artists were employed as artists for the Navy, including John Lavery, Ambrose McEvoy and Glynn Philpot. Philpot was asked to paint portraits in oils of the Admirals; this he agreed at £100 per portrait, one sixth of his usual fee. In spite of the problems of arranging sittings he managed to complete four of them, including Admiral Jellicoe, the most senior. Ambrose McEvoy, who more usually produced atmospheric reveries of beautiful women, undertook the task of painting those officers and men of the Navy and Marines who had received the Victoria Cross and he completed portraits from life of seven VCs. Unfortunately the reconstruction of likenesses from photographs of those killed in action proved to be beyond his capacity and none of these was successfully finished.

John Lavery worked in the cold waters of Scapa Flow in the Orkneys. In the bitter cold he painted in an electrified suit taken from a German airman and produced a quartet of canvasses which expressed the impossible conditions endured by the men of the Grand Fleet. He also worked from British airships on sea patrol. He wrote: 'Escorting convoys and painting from "blimps" . . . I felt nothing of the stark reality, losing sight of my fellow men being blown to pieces in submarines, or slowly choking to death in mud. I saw only new beauties of colour and design.'[3]

'Better Times' by C. Lovat Fraser, 14th Durham Light Infantry in Flanders.

Artist members served at all levels, from private solders and naval seamen to high-ranking officers, and they were present at some of the most bloody engagements of this punishing war. The fighting soldiers, who suffered most, included many of the younger men whose artistic reputations were yet to be made. Adrian Klein was twenty-six when he entered the service as a private; in France his life was narrowly saved on Hill 60 when he was wounded on night patrol in the thigh and forearm, partly paralysing his right hand. F.C.B. Cadell was a private in the Royal Scots Highland Regiment; he fought on the Somme and at Arras where he was wounded in the arm, was then commissioned as an officer in the Argyll and Sutherland Highlanders, returned to the Front and was again wounded at Buyancy. C. Lovat Fraser was twenty-nine in 1914 when he entered the Durham Light Infantry as a second lieutenant; he was at the battles of Loos, Ploegsteert, Armentières, and Ypres. He was wounded and suffered from shell shock in 1916 and later was seconded to the War Office; he was invalided out in 1918.

Some did not return. Their deaths in action were a small part of that tragic tide that swept away so many of the young men of England. Campbell Lindsay Smith was with the Gordon Highlanders as a second lieutenant and was reported missing in France in 1915. Gerald Chowne had enlisted as a private in 1914, but died of his wounds as a captain on the Balkan Front and was buried in Salonika. Brian Hatton was a lieutenant in the Queen's Own Worcestershire Hussars: he enlisted as a trooper in 1914 and was commissioned in 1915. He fought in the Dardanelles and Egyptian campaigns and was killed on active service in Egypt in April 1916. Charles Orchardson, the son of the portrait painter, Sir William Quiller Orchardson RA, joined the Camel Cavalry as a trooper in August 1914. In Egypt he was awarded the Military Cross, but died there of his wounds in 1917. William Hammond Smith went to France in April 1915 with the New Army, fought at Ypres and on the Somme and was

'Barnard Lintott in the Fullness of his Development' by G. Bateman.

involved in continuous action in France until his death near Roeux in April 1917. Shortly before the war ended, James Halley, second lieutenant in the Royal Engineers, was shot and killed by a sniper on the banks of the Scheldt where he and another officer had crawled to prospect for bridging the river. He had previously been wounded at Arras in 1917.

The painter Edward Barnard Lintott, who always cut a dashing figure, found an appropriate niche in the diplomatic service as a cipher and language specialist and became secretary to the Ambassador at St Petersburg during the last three months of the old Russian regime; he was the last diplomat to be presented to the Tsar. He remained in Russia during Kerensky's rule and lived for a year under 'Bolshevik misrule and murder'. Back in London he lived at the Club and was promptly nick-named 'Bolshi'. He was still at the Foreign Office and frequently worked late, often returning at 2 a.m.; his breakfast time was normally 11 a.m. One morning, as Mr Lintott arrived, one of the waitresses said to another: 'Hello, here comes the eleven o'clock bird.' Lintott complained to the steward 'Tell the girls I am not a bird at all, but a member of the Club.'

The painter Frederick Mulock became a censor and later remembered one letter from a sailor to his mother. This is all the letter contained: 'Dear Mother, this war is a bugger. P.S. Tell Auntie.'

Into the autumn of 1918 the war dragged on. But, at last, on 9 November, the Kaiser abdicated and two days later the German delega-tion signed the Armistice. In the Club the celebrations were furious. On Armistice Day Alfred Munnings arranged a dinner for which he decorated the billiard room. This was an uproarious affair with speeches and frequent interruptions for his own recitations and songs: his rendering of 'The Raven' was interrupted by squalling cats on the roof and curses from Munnings. Later in that week, as the Steward recalled:

We had a dance and when it was officially over some of the members induced the pianist to stay and they plied him with whisky. He was hopelessly drunk, so drunk he could not get off his seat, but still he played dance music. At 7 o'clock we laid him to rest on the sofa with flowers around him and he was snoring terrifically. He awoke at 5 p.m. and had two poached eggs on toast and rushed off to play at some church.

On another 'jovial night' during Armistice week, Alfred Munnings brought Paul Konody to the Club; Algernon Talmage and Charles Simpson were also there. 'John' the Steward recorded the celebrations:

They were all slightly inebriated and, about midnight, Mr Simpson started to wrestle with Mr Talmage and threw him. Then he threw Mr Konody and went for Mr Munnings and they both got locked in each other's arms and went to the ground and in two minutes were fighting like Kilkenny cats. I remember seeing Mr Munnings aiming a blow at Mr Simpson and missing him, and his fist struck the coal scuttle and broke a bone in his hand. This was in splints for a month. Then he had another scrap with Mr Farrell, but Mr Farrell struck him first.

Colonel John Cameron presided at the Peace Dinner. As the Steward remembered: 'Col. Cameron was very strict; some members were whis-pering during a speech and he jumped to his feet and said in broad Scotch "Will you shut up with your row down the room there?" After dinner, when the speeches were over about midnight, I saw him with his arm around a maid, and when he saw me he said, "You know John, you'll have to get a bit of discipline in this place."' Cameron was already forty-seven years old when he entered the army as a second lieutenant in 1915. He rose rapidly and took part in many of the major battles, Ypres, Passchen-

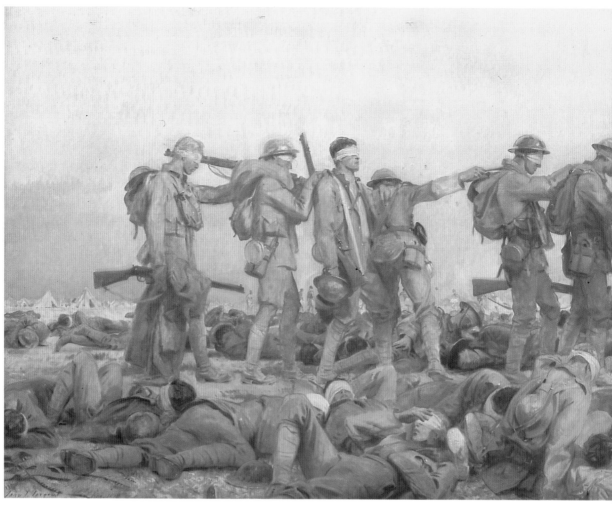

'Gassed' by John Singer Sargent RA.

daele, the first and second battles of the Somme and Armentières. He had a narrow escape in the trenches when a frenzied soldier rushed at him with a rifle and bayonet; he managed to beat him off and disarm him in a none-too-gentle fashion. Cameron was twice wounded, demobilized with the rank of lieutenant colonel and awarded the Military Cross and the Distinguished Service Order.[7]

In the spring of 1917 Orpen had been sent to France under the newly started War Artists Scheme and invited to make a major contribution to the establishment of a National War Museum as 'a memorial record of the effort and sacrifice of the men and women of the Empire'. Working in the rear of the fighting armies, he recorded the aftermath of the battles of the Somme, and the great battles of Arras, Messines, Passchendaele and Cambrai. Unlike most other war artists, who were employed only for short periods of time, Orpen was continuously in France from 1917 to 1919, recording the scenes of battle and the proximity of the serving soldiers to death. In June 1918 Orpen was knighted 'for services in connection with the war'. But it was after hostilities had ceased that Orpen painted his most remarkable war paintings. As the official artist at the Versailles Peace conference, he painted three large paintings of the signing of the Peace Treaty. He wrote: 'The fighting man, alive, and those who fought and died – all the people who made the Peace Conference possible – were being forgotten, the "frocks" reigned supreme.'[5] In two of these paintings, the frock-coated leaders and delegates appear at the bottom of the canvas, dominated by the florid architecture of the Palace of

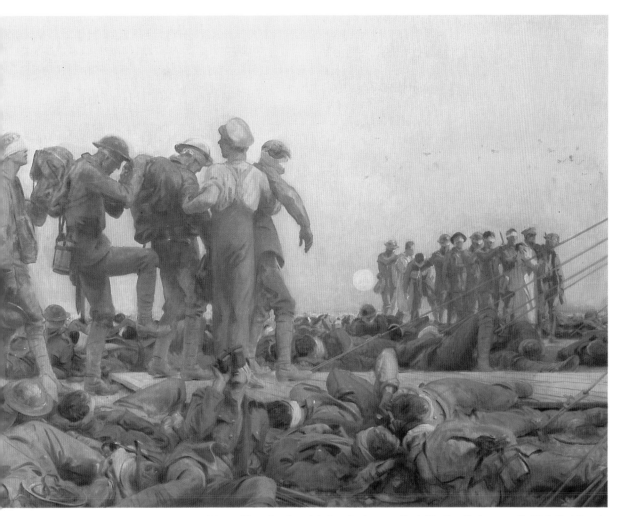

Versailles. In the third painting, called *To the Unknown British Soldier in France*, no figures appear; only the flag-draped coffin stands alone in a marble hallway.

The Club was by now under the Chairmanship of the figure-painter Fred Lutyens, a regular exhibitor at the principal London galleries from 1890 onwards. He had become a member in 1911 and was soon on the Council, becoming Treasurer in 1915. Lutyens came from a remarkable family of eleven sons and three daughters. Their father, Captain Charles Lutyens, had applied his life equally to painting and hunting and had become a close friend of Sir Edwin Landseer, sharing his studio. All the children were talented, but the best-known was Fred's younger brother Edwin Lutyens, soon to become the most celebrated architect in England and President of the Royal Academy.[8] At the time of Fred Lutyens's Chairmanship, his brother Edwin achieved prominence through the subtle perfection of his hastily prepared design for the Cenotaph in Whitehall, which became the symbolic focus for the Peace celebrations. In July 1919 members of the Club took part in those most solemn celebrations in Whitehall that officially marked the Peace. A permanent monument in stone, which closely followed the design of this temporary structure, was put in place for the second anniversary of the Armistice on 11 November 1920.

Eighteen months after the Armistice the memory of war was still very vivid. The Chairman of the House Committee reminded the members 'in 1914 we had certain members here that we shall never see again.' A

subscription of 5s. was raised from each member and a stone was set into the outside wall of the billiard room, bearing the names of the fallen. The competition for the design was won by the sculptor Leonard Jennings, who had himself served in France and Belgium from 1916 to 1919. The memorial reads:

REMEMBRANCE

The following members of the Club were killed in the Great War
1914–18
Philip H. Baynes, Percy F. Gethin, Brian Hatton, J.W.M. Halley,
C.Q. Orchardson, Campbell Lindsay Smith

IN THE MEMORY OF ALL MEN

5 The Chelsea Arts Balls

In the early days of the Club the artists of Chelsea had brought back from Paris memories of the great 'Quatz' Arts' Balls, in which the artists, musicians and people of the theatre had celebrated 'Mardi Gras', Shrove Tuesday, the last day of the Lent Carnival. For some years Stirling Lee and his friends arranged parties in Chelsea when the artists of Trafalgar and Wentworth studios opened their studios. Jacomb-Hood remembered one such fancy-dress party, arranged by the Manresa Road artists on 15 February 1887. 'Our studios were cleared and thrown open – luckily the night was fine and warm – dancing was in my studio, supper in Skipworth's next door, another was the gentlemen's cloakroom, while the ladies had a fourth. In the following years we repeated the affair at the Chelsea Town Hall, but they lacked a little of the abandon and informality of the first.'[1] In the early 1900s the Club began to arrange annual fancy-dress parties in the newly-built and elegant Chelsea Town Hall. Although small in scale compared to what came later, these parties attracted attention that carried beyond Chelsea and encouraged the Club to be more ambitious.

Under the Chairmanship of Captain Adrian Jones, the Club decided to hold a Ball in London which would rival those of Paris or Rome. When this was discussed a member asked 'Are we lacking in the necessary wit, fancy and daring in this Club?' The first of these great fancy-dress Balls was held at the Royal Opera House, Covent Garden, in 1908. There was a considerable financial risk, for the booking cost of the Opera House was then £300 and a deposit of £60 was required. However the Ball was a great success. The Royal Opera House was filled to capacity and the papers were full of the 'Chelsea Arts Club Ball', attended by a huge gathering of artists, art students and guests. Tickets, including supper, were half a guinea, boxes from five to eight guineas, all the tickets were sold and all the boxes taken, and a profit of £450 was made for the Club. In the following year a second ball was held, and an even greater profit, this time of £850, was made.

These first balls at the Royal Opera House had been arranged by George Sherwood Foster, then Chairman of the House Committee. His flair and organizing abilities were outstanding and he was to make the Annual Arts Balls internationally famous as the greatest costume ball in the world and a centrepiece in London's social season. In addition to the artists and their friends they attracted many celebrities, socialities, leading actors and actresses. Encouraged by their success, in an even more ambitious venture, Sherwood Foster decided to book the Albert Hall for the Ball of 1910.

On Mardi Gras 1910, the first of the Chelsea Arts Balls took place at the

Invitation to the First Carnival Ball held on 15 February 1887 at the Wentworth Studios in Manresa Road. These studios were occupied by William Llewellyn (later President of the Royal Academy), Alfred Hartley, F.W. Pomeroy, Frank Markham Skipworth, G.P. Jacomb-Hood, Frank Brangwyn and Frank Short. Others who were present included P. Wilson Steer, Stirling Lee, J.J. Shannon and Albert Toft.

Albert Hall. The interior was wonderfully rich and exuberant. The whole of the great dome space glowed with the light of thousands of gas jets, and the newly installed 'Limelights' played upon the swirling and glittering crowd below. The three tiers of boxes were ideal for small parties, while the corridors and galleries gave space for strolling and conversation, and for food and drink. One of the greatest advantages was the unrivalled 'Great Floor'. Some years earlier the authorities had decided to use the Hall for large meetings and, against much opposition from seat and box holders, a floor had been constructed to cover the whole of the amphitheatre. This parquet floor was prefabricated, made in sections and supported by hundreds of foot-thick wooden supports, each one numbered and bolted into position with rods and ties. It stretched some fifteen feet above the arena and provided the largest dancing space in the world, offering sixteen thousand square feet in area, about three times as large as that of Covent Garden.[2]

The newspapers were ecstatic. The *Illustrated London News* described it as the 'greatest fancy-dress ball ever held in London, four thousand dancers on the floor of the Albert Hall'. Costumes were *de rigueur*. The *Westminster Gazette* excitedly described the scene: 'The Follies in their caps and bells jostled Dutch peasants, the sabres of comic-opera warriors rattled, elephants, giraffes, and "Teddy bears" uttered deafening cries, Halley's Comet dashed into a Red Indian, Joan of Arc was tossed hither and thither in the eddies of the whirling tide of dancers, and many brave knight lost either a helmet or a gauntlet.'

London society had risen to the occasion. 'The white-eyed Kaffir was Sir Herbert Tom O'Flynn, Miss Viola Tree was disguised as a ballad in E flat and Mr Arthur Aplin, the novelist, as Chantecler.' Derwent Wood, the sculptor, was in the character of Richard III; Mr Charles Cook as Charles the First, and Miss Decima Charteris as Queen Victoria before her

George Sherwood Foster, 'The Genius Behind the Chelsea Arts Ball', by James H. Dowd.

Below are some of the 4300 artists and their friends who attended the Chelsea Arts Club costume ball at the Albert Hall. It was the largest fancy-dress ball ever held in England.

accession. Lady Constance Stuart-Richardson came as a cowboy; John Hassall, 'the well-known artist', appeared in Cingalese costume and Mrs Rudolph Helwag appeared as a Sioux chieftainess, carried in a litter by two genuine Sioux Indians. More casually, Mr and Mrs Soutten dressed as French students, in velvet suits with beret and artist's smock. Even the band of a hundred performers were all in costume.

Many of the artists had designed their own costumes, and went to elaborate lengths for effect. 'Chantecler', the crowing cockerel, was in full plume of black and orange feathers, but as he continued to strut from one end of the hall to another, he soon showed signs of fatigue, for the fine costume made it impossible to sit down. A baby mammoth, big for his age, was in the charge of an Indian driver; there were scores of red devils, Hamlets, Romeos, Juliets and Toreadors. For those of less imagination, 'Venetian Capes' worn over evening dress were considered sufficient, but few were worn.

In order to find partners in the vast space of the ballroom, signs were set up to serve as meeting-places around the floor. Dancers would arrange to meet at 'the Mad Hatter', 'the Teddy Bear' or 'the Irish Pig'. These were accompanied by topical illustrations provided by members of the Club: 'the Teddy Bear' showed Teddy Roosevelt hunting in an African swamp, 'the Irish Pig' showed Mr Asquith and Mr Balfour being whipped by John Redmond, the Irish leader. George Belcher, the *Punch* artist surpassed himself with a sign depicting a drunken waiter vainly trying to draw a cork from a soda-water syphon. It was entitled 'Athlete struggling with a syphon', and it bore an uncanny resemblance to the sculpture by Lord Leighton recently exhibited at the Tate Gallery *Athlete Struggling with a Python*!

Although it was not known at the time, John Singer Sargent played a critical part in the decision to move the Chelsea Arts Balls to the Royal Albert Hall. In a confidential discussion with Sherwood Foster, Sargent

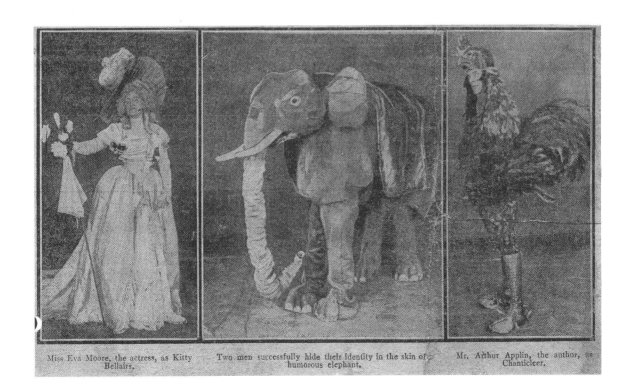

Miss Eva Moore, the actress, as Kitty Bellairs. Two men successfully hide their identity in the skin of a humorous elephant. Mr. Arthur Applin, the author, as Chanticleer.

offered personally to carry any loss which might occur. However such precautions were not necessary, for the Ball made a very healthy profit of £1400. The members' first thought was to help those who were in financial distress, for this was a time of hardship. After some discussion it was agreed to give £250 to the Artists' General Benevolent Institution and £150 to the Artists' Annuity Fund for Widows and Orphans. This substantial support of artists' charities continued throughout the life of the Arts Balls.[3]

In the following year the success was repeated, and even greater crowds came. Extra efforts had been made to accommodate the dancers by building a dozen additional boxes across the stage. Finding one's partner was still a problem, so a dance list, picked out in coloured lights and suspended above the orchestra, helped partners to identify the dance on the card. In the body of the hall were hung illuminated names of towns in England and abroad, so that partners could find each other in the confusion.

For the Ball of 1912 the decorations were in the capable hands of the sculptor Derwent Wood, the architect Professor G. Moira and the painter E.A. Rickards, all currently members of Council. Captain Adrian Jones, who was fond of martial music, suggested that a military band play at the Ball, but he was overruled and the more light-hearted 'Corelli Windeatts Band' was engaged. Mr Windeatts dedicated his waltz 'Artists' Revels' to the Club. A catering contractor, looking for further trade, offered to engage an artist member to paint a portrait of Sherwood Foster, provided that the Club would write to him stating that they were 'quite satisfied with the catering on the occasion of the Club Ball, at the Albert Hall in 1912.' This offer was unhesitatingly refused by the Council.

By now the Ball was a proven success and big business. Sherwood Foster was firmly in control and it had been agreed that he receive 20% of the profits; other directors received expenses only. However the affairs of the Ball were inextricably mixed with those of the Club and run from an office on the Club's premises. Although the first two balls had made substantial profits, members were uncertain about their financial liabilities if times changed. Some doubted whether running 'society entertainments' was their proper function, and felt that the publicity that the Balls received was in danger of swamping the main functions of the Club.

In November 1912 a General Meeting of the Club agreed to form a private company, called 'Chelsea Arts Ball Limited', to take over the management of the Annual Ball. This was intended to release the members from any financial responsibility and yet keep the Ball in the hands of the Club. The only shareholders were the elected members of Council, who would hold shares on behalf of the Club. No dividends would be paid but all profits were to be given to the Club. The Company was incorporated in December 1912 with a capital of £500. Initially three Directors were appointed, Sherwood Foster, who became Managing Director, Frank Lynn Jenkins and Henry Poole.

With these improved business arrangements, the Balls continued to grow in popularity. There was now a great demand for tickets, priced at two guineas, with boxes on the Grand Tier fetching as much as twelve guineas. Such was the demand that a ballot for tickets was held for the 'Mardi-Gras' Ball of 1913. However with the threat of war in 1914, ticket sales were slow. At the outbreak of war the Balls ceased. However it was hoped to restart them as soon as times allowed. Sherwood Foster said that

Dance card for the Ball of 1920 by Claude A. Shepperson ARA.

he hoped that when the war was over the Balls would be as much of the rage as ever, and from what he had heard the men were dancing away in France whenever they could get a chance.

As the Armistice was signed, England celebrated and continued to celebrate. After the first days of intoxicating triumph, thoughts turned to the joys of the future: for the Club this meant the revival of the Arts Ball, but there were inevitable delays. Although Sherwood Foster was able to bring his considerable experience to the task of recreating the complex arrangements of the pre-war years, an office and staff had to be found and all of the important decisions on theme and decorations had to be made. In the post-war euphoria, Victory Balls, Peace Balls, and Service Balls all jostled for the use of the Albert Hall. Sherwood Foster, who sensed the possibilities, hired the Albert Hall for the whole of July 1919 and put in the Great Floor at his own expense for a number of balls, dinners and similar events.

The first Chelsea Arts Ball to be held after the war was on 12 March 1919. In addition to this a New Year's Eve Ball was held at the end of the year – they immediately recovered their gaiety. They were a light-hearted frolic and greatly enjoyed, yet they retained the formal dignity of the Edwardian age and were conducted with great decorum. The first post-war Ball was given in aid of the British Empire Service League. This meant that the invitations were associated with H.R.H. the Prince of Wales, as Patron of the League. A special Ball Committee was formed with H.R.H. Princess Arthur of Connaught as Chairman and Lady Rodney as Vice-Chairman, supported by such notable socialites as Lady Londonderry, Lady Cunard, Lady Plymouth, Lady Gladstone and Gladys Cooper. At the Ball artists and students mingled with the titled and famous, society hostesses would gather their own parties and foreign ambassadors would bring their guests. It was important to be there and to be seen. Tickets were snapped up months beforehand, and groups came from all over the British Isles and from Europe and the United States. Sherwood Foster wrote: 'Since its inception, the Chelsea Arts Ball has been one of the things which have lived in the minds of thousands. Year by year, British men and women register the feelings inspired by this function in letters sent home to friends from Central Africa, Egypt, China, India, America, the Antipodes and the most distant outposts of the Empire. Quite common are such remarks as the following, written from South of the Soudan: "By the time this letter reaches you, you will be thinking about the Chelsea Arts Ball. I have the date marked on my calendar and shall be with you in spirit." '

On the whole the Balls were orderly affairs and well managed. Club members acted as stewards, but as the evening wore on and their spirits rose, they were assisted by a group of paid stewards, ususally commissionaires or ex-soldiers employed to keep a firm hand on proceedings. They were dressed as Beefeaters, and placed under the direction of a senior member of the Club. Alfonso Toft frequently had this responsibility. 'To see Alfonso Toft at his best one ought to go to the Chelsea Arts Ball and see him dressed as an Admiral. At the Ball he is Commanding Officer of the Beefeaters and any male dancer in evening dress is instantly ordered off the floor. If he has the temerity to refuse Mr Toft's request, at a snap of the fingers he is hurled off the floor by Mr Toft's slaves.'[4]

After the war the costs of everything, food, salaries, decorations, had risen, but so had profits. Whereas the company had spent nearly £6000 in

1914 in presenting the Ball and had made a profit of less than £2000, in the post-war period the Ball cost more than £10,000 to put on, and the profits rose to more than £5000 by 1920. However this plateau of success was not always maintained. As the euphoria of the peace celebration years evaporated and the economic climate worsened, so the profits levelled off. In 1921, for the first time, the Ball made a loss, albeit small, of £302. However the Ball Company had good reserves and investments and it had increased the share capital from £500 to £1000. A major effort was made to improve the administration and, with economies in decorations and a drive to sell more tickets, a profit of £1600 was made in the following year.

For some years the Club could not decide between the merits of a 'Mardi Gras' Ball held at the end of February, and a New Year's Ball. When the ball was held on New Year's Eve it coincided with many family parties; it was also necessary to pay much more to the musicians, but over the years it became apparent that the New Year's party was the most enjoyed and New Year's Eve of 1922 was welcomed with a 'Hogmanay Ball'. Up to this time themes had not been used, although fancy dress was always *de rigueur*. However for 1926, following the much discussed excavations of the Tomb of Tutankhamun, which had taken place three years earlier, it was decided that an 'Egyptian' theme be used. Howard Carter, the archaeologist in charge of those excavations, agreed to advise on the decorations. He had become a national figure and he was also a distinguished painter, and the brother of a Club member, William Carter. Howard Carter worked with Frank Brangwyn to create an exotic setting in the Egyptian style, set with screens and hanging lamps. In later years considerable care was taken about the choice of theme, which focussed the attention of the revellers and became an eagerly discussed part of the festivities. Such exotic themes as 'Noah's Ark', 'Arabian Nights' and 'Sun Worship' of the 1920s gave way to the more modern 'Speed', 'The Naked Truth' and 'Physical Perfection' of the 1930s.

The most successful celebration of the inter-war years, and also the most controversial, was the Ball of New Year's Eve 1924. The Club had been approached by the popular magazine *The Bystander* which wanted to hold a public and well-publicized celebration of its 'coming of age'. The magazine offered to organize some special features, including a series of 'stunts' and 'the World's Biggest Birthday Cake' which was opened at midnight and produced gifts and prizes, Cadbury's chocolates for the ladies and Abdullah cigarettes for the men. At the 'Bystander' Ball, the Clandon-West Orchestra played a programme of lively one-steps waltzes and foxtrots, including 'When You and I were Twenty-One' and 'Just a Little Twilight Song', especially written for the occasion. The elaborate souvenir programme included letters of congratulation from some leading personalities of the day including the famous barrister, Sir Edward Marshall-Hall, Sir Gerald du Maurier and Mr Winston Churchill.[5]

The bands were big; they had to be – a hundred performers was not unusual – for in the days before electric amplification they had to be heard over the feet of three or four thousand dancers on the floor. The singers struggled to make themselves heard; some used megaphones to make their voices travel. Four or five bands were usually on hand during the evening and they played continuously from 10 p.m. to 5.30 a.m.

In spite of the enjoyment of the occasion there was considerable criticism from members about this involvement with the press. As Derwent Wood put it: 'The Club has been in my opinion rather

The Bystander Ball of 1924. Cover of the Souvenir Programme.

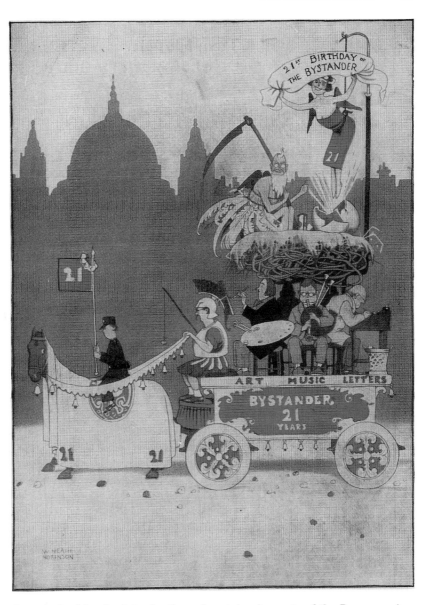

'21st Birthday of the Bystander', 1924, by W. Heath Robinson.

besmirched by the introduction of certain elements of the Press coming in, that is to say little tiny efforts on the part of linotypers who make fortunes by printing the efforts which are sold in the Press, in the street. . . . Today I am told that the Club no longer exists, that the 'Bystander' is the element who runs the Club as a Board.'[6]

There were also problems over the Ball for 1927. The theme was 'Merrie England' and the sculptor Henry Poole RA and the architect Leslie Bucknell agreed to prepare a centrepiece of a roundabout, peopled with characters from English history. Labour troubles, however, interfered with the setting-up of the complex three-dimensional tableau. In an effort to reduce costs the Ball committee executed the backcloth and other decorations themselves, with help from other members of the Club. At the last minute, William Orpen agreed to supervise the decorations, but this was less than satisfactory and it was thought better in future to leave the making of the decorations to professionals, with the artists acting as designers.

The Ball was remarkably unlucky with its elephants. There had been disaster in 1926 when a life-size model of an elephant had collapsed and the damage to the parquet floor amounted to £475. In 1929 the theme

'Noah's Ark' again required an elephant (preferably two, but this was beyond the wildest dreams) and arrangements were made with Bertram Mills Circus for a live elephant to appear as part of the great parade. However this time the efficient administration failed and at the last minute this exotic project was cancelled. The architect of the Albert Hall explained to his Council, 'I calculated that the weight of the elephant's foot would approximate to the breaking weight of the floor and had therefore reluctantly but firmly to veto the proposal, which I learned only by the merest chance.' Following this the Hall introduced a new standing order – no live animals – and a long wrangle took place between the Club and Bertram Mills Circus over who should pay for the non-existent elephant.

The Albert Hall was being modernized. The replacement of the Great Floor had been discussed for some years. It had stood a lot of pounding from the feet of revellers and in 1929 a new floor was installed by Benjamin Edgington, manufacturers of structural steel work. With metal beams and braces and a more scientifically devised system of construction, it could be stored more easily and erected more quickly. The acoustics of the Hall were noriously bad, but it was noticed that they were always better at the Arts Balls than at orchestral occasions, for the hall was decorated with flags and streamers and the band was on a high stage. Electrical amplification had now been installed and the great organ was rebuilt. The volume of sound was enormous. It was described by the *Musical Times*: 'The noise was like a colossal harmonium in a nightmare, well beyond the number of decibels that the human ear can stand without pain.'

By 1930 plans were being made to celebrate the twenty-first anniversary of the Arts Balls with a great 'Coming of Age Ball', but there were again problems. The principal London art schools prepared 'stunts', large tableaux mounted on the chassis of lorries that were drawn into the hall. Each was decorated with an elaborate setting related to the theme, with students as living sculptures. These were planned well beforehand and students submitted drawings for the Club to approve. There was great competition to have their ideas accepted, as boxes for the Ball were given to the three schools who were judged to have made the best designs. In the previous year some of the art students had got out of hand and a group of rowdies had smashed the tableaux before they even started their journey round the floor. Only one, a giraffe, managed to enter the 'Noah's Ark' amidst fierce fighting. The newspapers the following day were full of condemnation, with banner headlines 'Chaos at Chelsea Art Ball' and 'Many injured', as indeed there were. Although Club members felt that this incident had been greatly exaggerated, it left an uncomfortable memory; a meeting was held of the Arts Schools and the riot act was read. To prevent such scenes from occurring in future, members of the Harlequins Rugby Club were offered free tickets to the Ball with full authority to throw out any offenders.

By good management the costs of the Ball had not increased between 1919 and 1929. When all the payments had been made to the Albert Hall, to the caterers, for decorations, costumes, bands and attendants this amounted to £4500 in 1919. By 1929 the same services cost just over £4000. What was more erratic was the public. The love of party-going in London in the early 1920s was less certain.

The prices of tickets were raised, first to 30 shillings and then to two

guineas, but it was sometimes difficult to sell enough to cover expenses and there were years when only a very small profit was made, and even, in 1921 and 1927, a loss. However in spite of gloomy predictions, the 'Coming of Age Ball' was a great success and made a profit of £1000.

Among the younger members of the Club there remained a feeling that all was not well. They were critical of the way in which the Ball Company was managed and questioned its relationship to the Club. This led to serious misunderstandings which almost terminated the Balls. Even the Club Chairman, the architect Percy Tubbs, did not know how Sherwood Foster, the Managing Director of the Ball Company, was paid or how much. In order to clarify the situation Tubbs proposed that the members of the Council should become shareholders of the Ball Company with the right to investigate its affairs.

This proposal was badly received by members of the Board of the Ball Company. They felt themselves to be quite distinct from the Club, and not under its control, and saw these proposals as a criticism and an attack upon their independence. So incensed were they that proceedings were begun to wind up the company and notices were sent out for a General Meeting to consider voluntary liquidation. The situation was further complicated by the fact that Sherwood Foster was abroad and was not expected back for about two months. It was eventually agreed to postpone discussion until his return.

Matters came to a head at a General Meeting of the Club in November 1930. Percy Tubbs gave the members a history lesson on the relationship between the Club and the Balls. He emphasized the independence of the Ball Company and read out the memorandum of 1912 which described its formation. He then told them to what extent the Club was dependent upon the Balls. 'Since the first Ball at the Albert Hall in 1912, until 1929, the Club had received just under twenty thousand pounds from the Ball Company (cheers), an average of £1923 per ball (cheers). Without this help it is hard to see how the Club could have survived.' The meeting ended happily when it was suggested that Sherwood Foster, upon whom so much of the success of the Balls was due, should have his portrait painted by Sir William Orpen. Orpen immediately agreed to do this and refused a fee, suggesting that it be given to artists' charities.

The Ball was known world-wide, eagerly awaited as the party of the year, but its preparation and planning required months of effort. The Hall booking had to be made and the theme of the Ball decided. Discussions and meetings took place with the many firms and organizations that would supply materials and services. With three tiers of boxes, plus the revellers in the hall and the further 1500 spectators in the galleries, about 6000 tickets had to be sold.

With the theme agreed, artists were invited to design the decorations. There was considerable prestige in this and the most notable of the artist members acted as designers, including, in the 1930s, Augustus John, William Orpen, Cecil King and T.C. Dugdale. Professional help from scenic artists was required to paint the great backcloth, which was some 144 ft. across by 65 ft. deep. In the early days, Vladimir Polunin, the Russian-born theatrical designer and painter, was responsible for this. He had settled in London prior to World War One and taught stage design at the Slade School; with his students, he enlarged the artists' designs to this vast scale and at the same time managed to convey the spontaneity and even the texture of their designs. In later years Alexander Bilibin, who

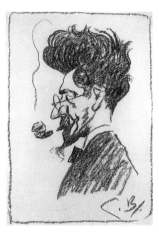

'Vladimir Polunin' by George Belcher RA. Polunin was the artist and designer who painted the huge backcloths for the Balls.

was the chief scene-painter for Two Cities Films, took over the same task.

A special feature of the decorations was the centrepiece. This was usually designed by a sculptor and it was the opportunity for an elaborate three-dimensional fantasy. It was often made to revolve or was decorated with groups of suitably costumed figures and guarded by the most active young stewards to prevent revellers climbing on it. Other decorations were made up by Barkers of Kensington and Benjamin Edgington the tent firm. Lighting was a special problem. The Hall was now lit by electricity and Strand Electric, the stage lighting experts, provided an elaborate lighting plan with special effects from floodlights and spotlights of many changing colours.

As in earlier years several bands were required for the evening, but now the bands were not quite as large, for sound amplification was used. The big dance orchestras were popular: Ambrose and His Band, Jack Hilton, the Embassy Band, or Jack Harris's Band, with lighter music from the Charles Ferrier Accordion Band. Always there were the stirring marches of a good military band and the pipes and drums of one of the Scottish regiments. By the end of the decade, the Ball was regularly filmed by Gaumont British News and Pathé News and rushed to the cinemas to be seen on New Year's Day. It also became a feature of the BBC's New Year's Eve celebrations. A description of the scene was broadcast on the 'National' programme in the early evening and after midnight the 'Empire' programme came back to the Albert Hall to join in the celebrations.

'Sun Worship', a design for a 'Persian sun-God' with a Bull Figurehead. One of the stunts for the Ball of 1934. Drawing by John Rose. John Rose was a student at Portsmouth Municipal School of Art, the only provincial school to be invited to take part in the Ball.

A full supper menu was provided by the Mayfair Catering Company with a buffet serving 400 revellers at a time. With so many to feed, dancers were advised in the programme that 'you will be studying your comfort by supping early.' The cost of the buffet was included in the ticket, washed down with Perrier Jouet 1917 Champagne at 22/6 a bottle or a 1924 St Julian Claret at 7/6. At the end of the dancing, breakfast was

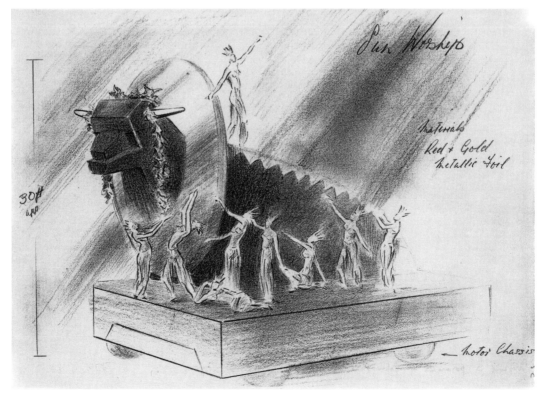

served to the party-goers but, for the more discerning, special 'after the Ball' breakfasts were also on offer from 3 a.m. at the Hyde Park Hotel and other nearby hotels at a cost of 3/6d.

There was much back-scenes activity before the Ball. The 'stunts' had been made in the Art Schools during the Christmas vacation – carpentry, painting and the making of costumes. Every part had to be numbered for re-assembly at the Hall and conveyed on the day of the Ball by furniture van, whilst the students followed by coach. A student of Portsmouth College of Art, the only provincial Art School to take part, remembered the occasion when the theme was 'Noah's Ark'. 'On arrival about 11.45 a.m. and after a break for sandwiches, work started on assembling the float which proceeded until about 7 p.m. – then to the dressing room to fit our costumes ready for the start of festivities at 10 p.m. . . . I encountered Augustus John in paint-stained smock feverishly putting finishing touches to his magnificent 'back drop' which covered the entire height and width of the organ. He was slightly inebriated, I think he had a small 'bottle of cheer' accompanying his other bottles of turps, linseed etc. . . . We produced an undulating snake some 40ft. long, the male students having to get inside its body, the female students steering it towards the slipway of a gigantic Noah's Ark at the end of the Hall.'

The most ambitious float constructed by the Portsmouth students was in 1934, with the theme 'Sun Worship'. 'This was some 30ft. high, mounted on a base approximately 14ft. by 8ft. bolted to a motor chassis. The three-tier edifice was surmounted by a bull's head emerging from a dazzling metallic gold sun, the various maiden sun worshippers being decoratively placed on the tiers – a dizzy height for the girl on the very top . . . as midnight arrived an enormous stork with flapping wings flew on wires from one end of the hall to the other carrying a *real* baby in its beak. The baby was quite placid and not at all frightened. If that baby is still alive today he can boast of having flown the Albert Hall 'in one'.'[7]

Although the wine flowed freely there was no evident unpleasantness or aggressive behaviour. Those that were inebriated were either happily merry or 'out for the count'. Neither was there any nudity, although on one occasion a float by the producers of 'Vat 69' consisted of a huge polished vat with a benevolent monk and a lovely girl dressed as a Bacchante who toasted everyone vigorously with upraised glass. During the tour of the hall her only shoulder-strap broke leaving her beautiful torso revealed in the glare of the spotlights. On another occasion a wicked-looking clown darted among the dancers, snipping the shoulder-straps of the ladies, much to their consternation and to the amusement of everyone else.

The Ball had a dreamlike quality, a world of make-believe, romance and carnival. Entering the hall was to be part of a gyrating world of colour and movement, the beat of the music magnified by the great dome of the roof. On the vast dance floor, the rich and famous in expensive glittering costumes, Madame Pompadours, Cleopatras, Centurions and Caesars, contrasted with the home-made fantasies of artists and students. Well-known stars were there, Jessie Matthews, Sonnie Hale, Tom Walls, Evelyn Laye and hosts of others; many had come straight from the theatre complete with make-up. On one occasion Gracie Fields was carried to the stage shoulder-high and persuaded to sing 'Sally'. Popular favourites such as Cole Porter's 'Begin the Begine' and 'Night and Day' were played at the Ball for the first time and then requested time and time again, and bottles

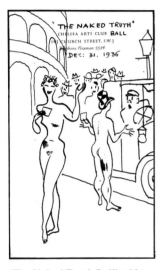

'The Naked Truth Ball', 1936, by A.R. Thomson RA.

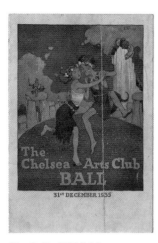

*The Ball of 1935. Menu cover
by W. Heath Robinson.*

of whisky offered to Jack Harris and his Band stood along the whole
length of the stage.

Away from the dance floor, leading off the corridors, were numerous
sitting-out rooms, comfortably furnished with settees and easy chairs and
a photographic studio was set up to record the fancy dress of the
party-goers. There was even a stage costumier who would hire fancy
dress to those that needed it. In the gallery, onlookers could watch the
scenes of revelry below.

The Ball reached its climax at midnight. Some four to five minutes
before, the Pipe Major entered the arena followed by the pipes and drums
of one of the famous Scottish Regiments and everybody followed, stamp-
ing their feet. The five massed bands assembled on the stage and then all
was silent as the great crowd waited for the chimes of Big Ben at
midnight; as these died away searchlights swept the arena, and in a flood
of colour 100,000 balloons were released from the dome. At the same
instant the Great Albert Hall organ, the Scottish pipers and the five
massed bands would burst out with 'Auld Lang Syne'; the multitude on
the floor of the Hall and in the boxes and the gallery linked arms and
joined in the singing. After this spectacular celebration, the floats would
be brought in and then the dancing would continue. Breakfast was served
in the hall at 5 a.m. as an end to the festivities.

At the end of the long evening, with the bandstand empty, the party-
goers would slowly collect their outdoor clothes in preparation for their
return to the real world. Police would courteously rouse the sleeping and
assist those who had difficulty in standing. Crowds of revellers, still in
their fancy dress, jostled good-humouredly for taxis and cars, and the
Evening Standard newsboys did a brisk trade with souvenir copies of the
paper, already carrying photos of the Ball. Artists and their friends would
wander through Kensington and Chelsea in the early morning light to
their homes and studios, and a few of the hardiest would assemble at the
Club for a further breakfast and to discuss the night's events.

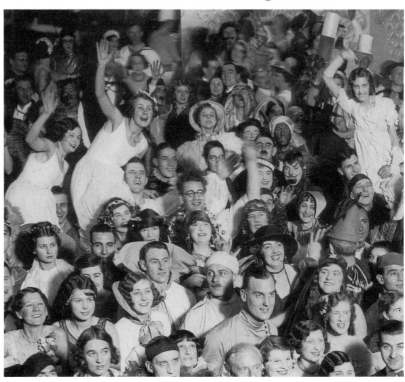

*'Primavera', the Ball of 1938.
The revellers await the entry of
the 'stunts'.*

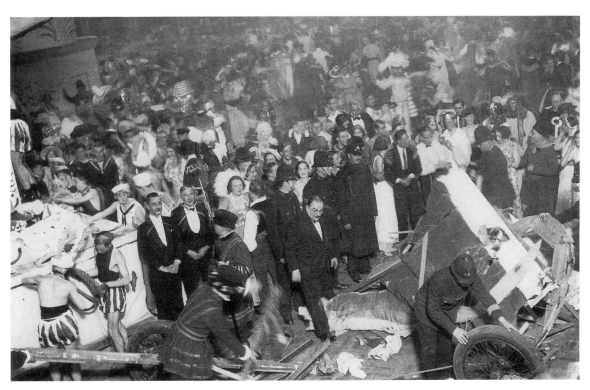

The wreckage of the stunts is inspected by G. Sherwood Foster (centre).

LET'S GO TO THE CHELSEA ARTS BALL

Let's revel on New Year's Eve.

There's a magic land
Where the colour's grand
It's a land of make-believe
LET'S GO TO THE CHELSEA ARTS BALL
Let's revel on New Year's Eve,

There's a note of spring
There's the cutest swing
It's a sight you can't conceive
LET'S GO TO THE CHELSEA ARTS BALL
Let's revel on New Year's Eve

There are artists
There are sculptors
And models not a few
There are pipers
There are pageants
And dancing the long night through.

It's a world apart
It's the world of art
Where magic colours weave
LET'S GO TO THE CHELSEA ARTS BALL
Let's revel on New Year's Eve.

W.R. Maxwell Foster, 1937

6 The Nineteen-Twenties

As the wounds of war slowly healed, the Club settled into its peace-time existence. By the 1920s many members of the Club had stepped into positions of considerable influence. D.S. Maccoll had obtained control of the Tate Gallery, C.J. Holmes was appointed Director of the National Gallery and William Rothenstein became head of the Royal College of Art. There was a continuing struggle for power between the New English Art Club and the Royal Academy, but by 1922 about half of the members of the Academy were former exhibitors of the New English Art Club, and many of the new Academicians were members of the Chelsea Arts Club. The critic Frank Rutter asked 'Has the New English Art Club captured the Royal Academy, or has the Academy captured the New English Art Club?' The Royal Academy had grown to resemble the New English Art Club at the turn of the century and much of the work was trite reworking of earlier 'New English' themes. The outstanding characteristic of the artistic life of this time is that time had stood still.

The Chairmen of the Club in these first years of the 1920s were mostly establishment figures. John Lavery, once the rebellious young friend of Whistler, was now Sir John Lavery, and one of England's most successful society portrait artists. He became Chairman in 1920 and was followed in 1921 by the landscape and portrait painter Alexander Jamieson, known as 'Sandy'. Algernon Talmage became Chairman in 1922, the year he was elected to the Royal Academy. He was then a well-known painter of landscapes described as 'honest as Constable', clearly stated with a strong instinct for broad skies subordinated to the overall colour of the day. Talmage had joined the Club in 1906, whilst living in St Ives, Cornwall. In the following year, when returning from a painting trip to Picardy, he stopped in London for a few days. He became entranced by the sight of the city, particularly at dusk and in the early mornings and he began to paint it with a poetry inspired by Whistler. These pictures formed the basis of his successful first one-man exhibition at the Goupil Gallery, London, in 1909, which established his reputation, and he came to live in Chelsea. In 1918 he was an official war artist to the Canadian Government, and painted many dead or wounded horses on the battlefield. After the war pastoral landscapes were again his main theme.

In spite of the respectability of its more distinguished members, the Club still contained extraordinary characters. Alfred Munnings (later Sir Alfred Munnings PRA) was unconventional even by the standards of the Club. He had a raffish air and an unshakeable confidence in his own abilities. He dressed like a horse-coper in a black and white check suit, set off by a yellow scarf, and judging by his tap-room manners and his extremely free conversation, had no idea that conventions of any kind

'Sir John Lavery' by Sir Bernard Partridge RI, NEAC.

existed. He possessed great vitality and magnetism, but he was also short-tempered, outspoken and quick to take offence. He was elected to the Club on 14 April 1913, while living in Lamorna, Cornwall. In support Philip Baynes, soon to be a victim of the war, spoke warmly of his paintings of horses and said that 'he is a clubbable chap and has never been in prison to my knowledge.'[1]

Munnings was born of East Anglian farming stock and brought up in Suffolk, the son of a prosperous miller at Mendham. At the mill and on the nearby farms there were always horses and he had a genius for their representation. For six years he was apprenticed as a lithographic artist with Page Bros. of Norwich, with evening instruction at Norwich School of Art. He then returned to his home village and began to paint with enthusiasm in a studio converted from a carpenter's shop. During this period he lost the sight of his right eye, pierced by a briar when he was lifting a dog over a fence, and after a long period of convalescence he had to make one eye do the work of two. With his work regularly exhibited at the Royal Academy he built a reputation as a 'native painter'. He would set off for weeks at a time in a blue-painted caravan, on painting expeditions to the Ringland Hills in Norfolk and the Waverney valley in Suffolk, with a string of seven or eight nondescript horses and a donkey, his man Bob in charge of the procession and a gypsy boy, called Shrimp, who acted as his principal model. Until the outbreak of the Great War Munnings was closely identified with that group of painters who lived and worked in the Lamorna valley, near Newlyn in Cornwall, but his last months in Lamorna were clouded by the tragic suicide of his young wife.

Unable to enlist because of the loss of his eye, Munnings worked in a cavalry remount centre, until in 1918 he was sent to France as an official war artist attached to the Canadian Cavalry Brigade. Under difficult and often dangerous conditions he painted the horses and the men close to enemy lines. A portrait of General Seely, commander of the Brigade, was painted 3500 yards from the German positions. The painting later attracted great attention and set a pattern for equestrian portraits that assured Munnings a ready source of income from this time, and took him into the great houses of the rich. In January 1919 an exhibition of paintings by British and Canadian artists, telling the story of Canada at war, was held in London and later in New York, Montreal and Toronto. It was dominated by forty-five pictures by Alfred Munnings, in which he described the wartime partnership of horse and man. Within a few weeks of the first showing Munnings was elected an Associate of the Royal Academy.[2]

Munnings's behaviour in the Club was frequently outrageous. H.M. Bateman recalled one occasion at the dinner table when the talk was of baldness. 'Butter is good for baldness,' said Munnings in a loud voice and, seizing a large pat of butter from the table, he demonstrated by rubbing it liberally into his hair. He then replaced the butter in the dish with a slap, much to the astonishment of members. He was usually surrounded by a jovial crowd at the bar or in the dining-room and loved to shock with an impressive range of bad language, acquired from his acquaintances on the hunting field: he was often at the centre of acrimonious exchanges. In January 1920 a special meeting of the Council was called to discuss a number of complaints made against him. It was said that he had used foul language, had frequently entered the staff quarters, and two waitresses had refused to serve him. On one occasion, when Munnings could not get through on the phone, he used such abusive language to one of the

'A Frank Self-Portrait' by Sir Alfred Munnings PRA.

waitresses that the staff threatened to leave. At that time the rules did not allow Munnings to appear before the Council, but in his defence it was said that he was swearing at the telephone and not at the waitress. In spite of a written apology and strong support from his friends, Munnings was expelled from the Club.

Soon after this Munnings married for the second time, to a divorcee Mrs Violet MacBride, a plain woman who, like Munnings, regarded dogs and horses as her only true friends. They lived at 96 Chelsea Park Gardens and at Castle House near Dedham on the Suffolk border, where Munnings took his small stud of horses. Munnings took his suspension from the Club with equanimity. He transferred his activities, and his retinue of admirers, to the Café Royal and he was later elected to the Garrick Club.

In December 1924 Cecil King attempted to reinstate him as a member, but in spite of considerable support the Council were not prepared to re-open the matter. As a consequence a number of leading members of the Club resigned, including Derwent Wood, Major O. Bernard and Munnings's friends from Cornwall, Julius Olsson and Algernon Talmage (at that time Talmage was a Trustee of the Club). In the following year Munnings was proposed as an honorary member. At the Annual General Meeting the Chairman, Sherwood Foster, attempted to be fair to both sides. 'You have to take into consideration that Mr Munnings is an abnormal man. He achieved tremendous success which turned his head. He was surrounded at the time by men who perhaps encouraged him and he was unable to keep control of himself. . . . I gather he was entirely beyond control and a damn nuisance.' He continued: 'However, Mr Munnings is an astonishingly clever painter and the sort of man we should have in the Club. What happened was five years ago. He was certainly pretty bad but that will never occur again as he is more settled, five years older, married and lives in the country, and if re-elected probably would not use the Club very much.' Munnings was not re-elected on that occasion, but became a member again in the 1930s.

The greatest difficulty facing many artists returning after the war was to find studio accommodation. The speculators were moving in and rents had increased drastically. In 1920 the Cadogan Estates sold off a considerable amount of property in order to erect two great convalescent homes in Chelsea as part of a scheme for extending the hospital zone of West London. With the disappearance of the ancient artist studios in Manresa Road, this considerably altered the artistic landscape.

'*G.C. Jennis' 1921 by A.R. Thomson RA. Jennis's habit of drawing in cafés led to the capture of Dr Crippen.*

Augustus John protested publicly about this destruction of property. 'Surely a better place for the convalescent homes that are being proposed would be out in the country,' he argued. The magazine *The Builder* was less sympathetic, suggesting that 'the "Artists' Quarter" of Chelsea' should be transferred wholesale to some suburban spot 'where the artists could obtain a certain isolation combined with the advantage of a cooperative stores, club and recreation facilities.'[3] The Arts League of Service spoke in support of the artists: 'To look after our sick is undoubtedly an ethical duty (though it is questionable if the heart of a city is the best place for a convalescent home), but, we may well ask, why should this be done at the expense of the artist? . . . Instead of destroying studios, we should be building them, and rather than make of the heart of Chelsea a hospital area, we should like to see it developing into a true artists' quarter.'[4] The Arts League put forward a scheme to erect new studios for artists and flats

'for literary men and women' and it was suggested that 'artists who have established their position will be willing to take a practical interest in the scheme by endowing studios, and nominating tenants, in the same way as hospital beds are endowed.'[5] Sadly these well-intentioned schemes did not materialize.

By 1924 it was feared that all the artists had left Chelsea. *The Star* complained

Real honest to goodness artists cannot get studios in Chelsea today. They are all snapped up by these new invaders, the moneyed dilettanti who love to ape the ways of the Bohemian, to dress in bizarre colours, with barbaric jewellery, big earrings, crimson bedknobs, clashing necklaces of strange stones, jazz frocks and cushions borrowed from the Russian Ballet, and pseudo culture stolen from anywhere.[6]

'Artistic people' were now occupying the Chelsea studios and the artists themselves were being driven out into the heights of Hampstead or Bedford Park. A few who had stayed in Chelsea had opened galleries or antique shops along the King's Road and Chelsea was simply crawling with tea shops. The cartoonist 'Low' was of the opinion that the tea shops were run by artists and their wives, 'hounded from their homes by the new school of studio small-talkers.' He recognized them because they were all so long and thin. 'Art,' he said, 'tends to make one like that, and these people have given up the profession just before starvation sets in.' He described the newcomers:

Plump women much too well nourished to be living on art, dressed in primary colours, bobbed and shingled, smoking cigarettes in holders like young walking sticks, sprawling on the sofas and showing much too much calf in the real artistic manner, and broadcasting their views on anything that cropped up, from Chiaroscuro to Charles Chaplin.

One ambitious enterprise, in which the Club was much involved, was the development of the Chenil Galleries into Chelsea's art centre. The Chenil Galleries in the King's Road had long-established links with the Club. It had started in 1905 when it took over the premises formerly occupied by the Club. It was financed by Orpen, who persuaded Jack Knewstub to run it as a shop selling canvas, paints and artists' equipment, with an etching workshop and two exhibition galleries upstairs. These were part of the original dining-room and billiard room which, it was said, owed its scheme of decoration to Whistler. In the early years the artists who exhibited there were almost all members of the Club, McEvoy, Lavery, Rothenstein, Orpen and predominantly Augustus John. At the rear there was a large studio that John often used and William Orpen worked in the next-door building.

Knewstub, the manager, felt that what Chelsea needed was 'A Temple for all the Arts', which would enhance the artistic life of London. There were six long picture galleries and a domed sculpture hall on the ground floor. The longest gallery, capable of seating 300 people, was also intended for musical recitals. On the floor above was a first-class restaurant with a 'silver grill' and two large studios which were to become an art school. Later it was planned to include a small repertory theatre. Augustus John laid the foundation stone of 'The New Chenil Galleries' on 25 October 1924, although the promoters were still looking for capital to complete this ambitious scheme. In his spirited address John appealed for help.

In the name of Truth, Goodness and Beauty we ask in this great enterprise for the

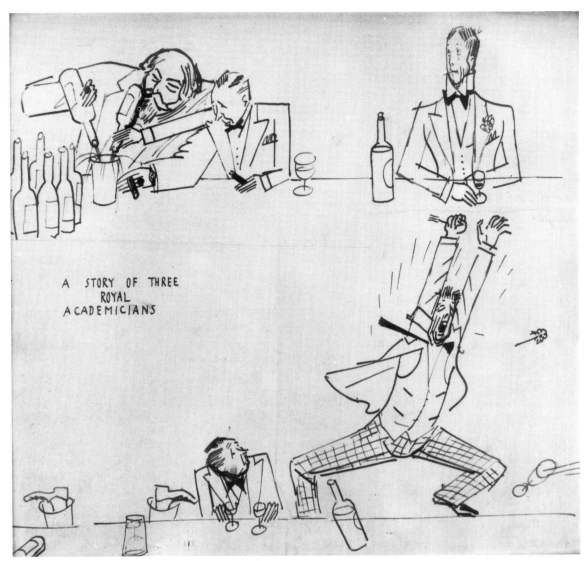

A STORY OF THREE
ROYAL
ACADEMICIANS

*'A Story of Three
Academicians' by A.R.
Thomson RA. They are
Augustus John, Sir William
Orpen and Alfred Munnings.*

moral and practical support, not only of poets, painters, and writers, but of that of the general public also, and we ask this in no servile spirit, but in the proud consciousness that artists – as artists had ever done – could and would give back more, far more than they could ever hope to receive at the hands of any man.

In December 1924 Knewstub invited the Club to arrange the first exhibition. There was a mixed reception from the members, for it was known that the Chenil was out to make money from the gallery and some felt that the prestige of the Club was at stake. Sherwood Foster, as Chairman, gave his opinion that 'this is not an exhibiting Club, it is a social Club and the question of organising an exhibition is outside the constitution.' However it was agreed to go ahead and twelve of the best-known artist members acted as selectors for the first exhibition, which took place in June 1925 under the title 'Present-Day British Art'. Sadly this ambitious concept had only a short life. A year later, after an exhibition by Gwen John, the gallery went bankrupt.

One of the well-known Club regulars in these years between the wars was Philip Wilson Steer and many stories were told about his eccentric foibles. He came into the Club one Sunday morning and walked into the dining-room where there were armchairs and a good fire. There was only one other member in the room and Steer said 'Good morning, how are

*Philip Wilson Steer,
photographed in the garden of
the Club in the 1930s.*

you?' The member replied 'Oh, I have got a bad cold.' 'Then I will wish you good morning,' said Steer and left the Club.

Steer's love of privacy was sorely tried on one occasion when he came to the Club as usual. At this time the Club was in Church Street and regularly gave a children's party near to Christmas. Steer rang the door-bell, saw confetti and streamers on the floor and said to the steward 'Damn, I forgot about the party.' He went into the writing room to have a gin and bitters, hoping to be away from the crowd, when suddenly a group of children burst into the room and played ring-a-roses around him. Steer finished his gin and bitters and hurriedly left the Club. On another occasion, when invited to join a charabanc party to the Derby, Steer refused and said 'No, I'm not fond of having a little rattle in my hand.' Steer had his own sense of humour, ingenuous and a little wry. When asked his opinion about some matter in the Club, he replied 'There's something in it – as the burglar said when he put his hand into the night commode.' More famously, when he received the Order of Merit, the highest distinction given to an artist of his time, he showed this to his friend Henry Tonks with the disarming enquiry 'Have you received one of these?'

Throughout the 1920s there was discussion over the inadequacies of the Club's premises. In 1922 a Building Committee had been formed to look into this but, after labouring for some months, they merely agreed to spend £363 on necessary repairs and to buy a new boiler for the kitchen. However there appeared to be an opportunity to acquire the next-door property, for many years occupied by Captain Adrian Jones, who had been Chairman of the Club in 1905. Captain Jones had lived there for thirty years and had built a large studio in the garden, in which his monumental sculptures had been made; his lease still had seven years to run, but his application for an extension had been refused.

Horseman, horse surgeon, soldier and artist, Captain Adrian Jones was a truly Victorian figure and one of the most respected members of the Club. In the 1870s and 1880s he had served in the army as a veterinary officer. He became a Captain in the Royal Horse Artillery and served with distinction in a number of the African campaigns. Being fond of animals, he began to model them and studied art under the sculptor Charles Bell Birch. As a serving soldier Captain Jones exhibited small maquettes of animals at the Royal Academy. He found the subject for his sculpture in human and animal action and for one of his earliest groups, which portrayed the slaughter of a buffalo, he 'borrowed' as his model a North American Indian brave from Colonel 'Buffalo Bill' Cody's Wild West Show. In 1891 Jones left the army and moved to 147 Church Street (later to be known as 'Adrian House') next door to the Club. He was now intent on producing statuary on a monumental scale and he erected a large studio in the garden.

Captain Jones had already met Whistler, whom he admired, and he became an incongruous companion of Phil May, who sought his company for drinking bouts, as Jones's reputation for sobriety reassured May's wife. Jones also formed a friendship with Wilson Steer. On one occasion he showed Steer a number of paintings that he had done in South Africa. Steer looked at them for quite a long time without making any comment and eventually the impatient Captain asked for his opinion. Steer's typically evasive reply was 'I've never been in South Africa.'

Jones was a fighter and firmly committed to his sculpture, but because of his lack of academic training, he had difficult relationships with the Royal Academy. He met resistance from Sir Frederick Leighton, the President, when he exhibited an over-life-size sculpture of three plunging horses in 1892, and he was attacked by the press for his use of 'ghosts', that is assistants who contributed more to the work than the sculptor himself, an accusation that he fiercely denied. He nevertheless continued to make memorial sculpture on the largest scale. At the Royal Academy he exhibited a classical group of a four-horsed chariot driven by an Assyrian. This vigorous piece caught the attention of the Prince of Wales (later King Edward VII) who stated that he would like to see a monumental 'Quadriga', such as this, on top of the archway on Constitution Hill. Somewhat bewildered by the scale of this possible commission, Adrian Jones was discussing it in the Club. There was no shortage of advice. He was told 'So and so is good at animal figures, he can help you' 'and that chap over there has got time on his hands at the moment, he can give you a hand.'

The commission for the great 'Quadriga' was finally granted in 1907. It took the form of the figure of 'Peace', descending upon the 'Chariot of War', drawn by four plunging horses. Each figure was several times life

'Quadriga' by Captain Adrian Jones. One of the great decorative sculptures of London, which surmounts the arch designed by Decimus Burton on Constitution Hill.

size, as it had to be large enough to be impressive from the top of the archway designed by Decimus Burton at Hyde Park Corner, sixty feet above the swirling traffic. This sculpture was made in the studio at 147 Church Street and throughout the summer of 1907, King Edward VII was a regular visitor to see the great work as it reached completion. Jones worked with a team of assistants; a photograph shows the sculptor and one of his helpers taking tea in the plaster mould of one of the horses. The whole sculpture could not be assembled in the studio, but individual figures were built there and taken to the caster's workshop. At the completion of this vast work Jones suffered a great disappointment, for no opening ceremony took place. This was due, he believed, to the earlier displeasure of the Royal Academy; for the same reason he was not offered membership of the Academy.[7]

At a special meeting of the Club in December 1924 the members were told that the ground landlord, Mr Sloane Stanley, was willing to offer the lease of 147 Church Street to the Club. Unfortunately this matter was not well handled as Captain Jones had not been consulted. The Chairman, with some hesitation, said that Captain Jones should be compensated for the loss of his lease and he suggested a sum of £1400. Captain Jones, who was now in his seventy-ninth year, was present at this meeting and saw this as an attempt by the Club to take over his house and studio. 'I think that this is about the worst form that I have ever come across in this Club,' he exploded. 'You and the people with you are simply going to force me to leave my house. To bring it up at a meeting with your own members, without allowing me to say that I will even sell! I am not prepared to sell. I am not going to be forced to do anything by any of you!' In a hasty attempt to smooth matters the Chairman agreed to talk to Captain Jones after the meeting. However it was later decided that the Club would not benefit financially by the additional premises and the matter was not pursued.

Captain Jones continued in membership to the end of his life and he was a familiar figure in the Club, with his navy-blue campaign cloak, scarlet-lined, flung over his shoulders. He still played snooker regularly, although he admitted that he was not too good at the long shots. His ninetieth birthday was celebrated by the Club with a marvellous party. Aware that he had felt let down by the lack of the recognition that he deserved for the 'Quadriga' at Hyde Park Corner, some well-meaning members obtained a letter of congratulation from King George V, which pleased the old man greatly.

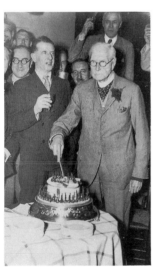

Captain Adrian Jones cuts his 90th birthday cake in the Club, with Bill Adams (to his right) and other members of the Club, February 1935.

After working on the paintings of the Peace Conference in Paris, William Orpen returned to London in 1920. He became a Royal Academician in that year, and in 1921 was re-elected to the Chelsea Arts Club. He was frequently seen in the Club where he was known as 'Orp' and he entered spiritedly into its affairs. The sculptor Roland Bevan remembered him as 'like a natty little City gent', while Orpen referred to himself, in a letter to Tonks, as 'just a happy little fat man'. Orpen became an active member of the House Committee and made efforts to improve the standard of the food. To test the persistent criticisms of the meat served in the Club, William Orpen offered to send a leg of lamb and a piece of beef from his own butcher, to be served without informing members, and opinions to be asked for later. He also made a gift of General Haig's map of the First World War battlefields, as well as a number of books. One of his gifts which produced great excitement was a ping-pong table, with net, bat

William Orpen, 'Working in his own way, a commission for a portrait', by Sir Max Beerbohm NEAC.

and a hundred balls. A games committee was organized and each Monday during the winter months an 'American Tournament' took place in the loggia.

Sir William Orpen RA became Chairman of the Chelsea Arts Club in 1930. He was by then nearing the end of a tumultuous life, which had included great success and prestige, but which had also brought him much pain and suffering. He was then England's most popular painter and a national figure, possessed with fame, success and wealth, but with a disastrous personal life. He was the British artist who earned the greatest income from his work: in 1929 for example, he earned £54,725, the equivalent of half a million in present terms, of which four fifths came from portraiture, mainly painted from photographs. His appointments book was a 'who's who' of titled ladies and gentlemen, actors and actresses, members of the Bar, Parliament and the professions.

During the last years of his life Orpen was estranged from his wife and increasingly dependent upon his clubs. He was a close friend of the architect Duncan Tate and in 1920 acquired 3 South Bolton Gardens and with his help transformed the two houses into a palatial establishment, with studios and reception rooms. Tate also had a difficult marriage and the two men spent a great deal of time in the Club bar, drinking heavily. In 1931, William Orpen became Chairman, but by this time he was already suffering from his final illness, and had difficulty in working; even portrait commissions came to a halt. In September 1931 he died, probably of alcoholic poisoning, aged fifty-three.

A threat to the privacy of the Club came in the summer of 1922, with a move to bring clubs into line with the licensing regulations for public houses. Members were alarmed by the pressure that had been mounted by the Temperance Party and the Temperance Council of Christian Churches and bills were before Parliament which would limit the 'inalienable right' of clubs to serve their members when and how they liked, a right never previously challenged. This teetotal crusade was seen as part of the Prohibition movement that had recently swept America. The

tactics were the same in both countries: clubs were denounced as pest-houses and plague spots and put under police supervision. Members were very concerned about these threats to their liberty, and the Chelsea Arts Club joined with other gentlemen's clubs in London to form a 'Clubs Protection Committee', however licencing was introduced and a greater degree of order was subsequently maintained.

The post-war years found a Club that had suffered sadly from the effects of war. A 'war boom' was spoken of; prices went rapidly up as did wages and services. The prices of all commodities were at least double what they were in 'the good old times'. Throughout the 1920s, there were complaints over the mismanagement of the Club. It was felt that the men who built the Club were being 'frozen out' and many younger artists could not afford to join. Sir William Orpen, writing from the Hotel Majestic in Paris, was incensed to hear that he had been asked to pay the same £4 subscription twice. He wrote 'Dear Sir, What is the meaning of this, if notices have been sent out twice, I suggest that an apology should be sent in each case, as it would show damned bad management.'

Every year since 1910 the Club had been in deficit on its trading, but as ever the Club had been saved from disaster by the profits of the Ball, which over recent years had averaged £350 a year. After the war, the reinstated Arts Ball again came to the rescue, and in 1921 made a substantial profit of £4749, most of which came to the Club. When Sherwood Foster announced this welcome news at the Annual General Meeting in May 1920 he was greeted with prolonged applause and said, as he handed over the cheque, 'if any of you gentlemen want to see a cheque for £4000, now is your chance.' The Club had now come to depend upon the Annual Arts Ball to subsidize its losses.

In 1925 with a new Council under the chairmanship of Terrick Williams, the real financial problems remained unsolved. The Council struggled to manage its affairs, but it also continued to spend more than its members were prepared to pay. In 1925 a motion to increase the subscription from £2.10s.0d. to £4.0s.0d. for town members was defeated by the members at the AGM, although later agreed. There were 450 members, but nearly a quarter had paid no subscription for two years or more; some had continued as members for four or five years without paying any subscriptions.

The Club now had a large staff, three men and nine women, but in the post-war world domestic servants were hard to come by. When one of the favourite waitresses, Peggy, was married in January 1922, she was given two pounds as a wedding present, about two weeks' wages. Officially familiarity was not encouraged and members were not allowed to buy drinks for the staff. The Club closed at 11.30 p.m. and those members who still propped up the bar at midnight were supposedly reported to the Council, but these rules were not enforced. Colonel Watts, the part-time Secretary, was asked to look into reductions in staff. He suggested that central heating would ease the labour of fire lighting in all of the public rooms, but this was considered too expensive. Even the measure of whisky was seized upon as an economy: thirty-two portions to the bottle were now served, instead of the previous twenty.

It was decided that professional management was needed and in the summer of 1924 a new broom, Colonel Hely, was appointed as full-time Club Secretary. This was a new appointment intended to put the affairs of the Club on a more business-like basis. He set about matters with a will.

During the summer holiday the Club was thoroughly turned out; attics and cellars were cleared, seldom-opened cupboards discharged their contents and every room was cleaned. Even the library bookcases were emptied. All of the Club's pictures were cleaned and a place found for everything . For the first time an office was organized in the Club.

This active ex-soldier discovered much that was wanting; the book-keeping system needed radical improvement, cash received in the bar was not strictly accounted for and the 'chit' system by which members signed for drinks and meals was described as 'unique to the Club'. It was not unusual for the signatures 'Leonardo da Vinci' and 'Michelangelo' to turn up on the chits. The collection of subscriptions was woefully inadequate, some £500 was owing from members and there was not even an up-to-date list of their names and addresses. A large stock of wines, many of pre-war vintage but representing unproductive capital, had accumulated and Colonel Hely suggested that this be sold off, even at a loss.

The main problem was that of the staff. There was an easy-going familiarity between them and the members and too much responsibility was placed on the Steward. Colonel Hely was of the opinion that 'such responsibility was far too heavy to be placed upon the shoulders of a man who, although admirably equipped for the duties of a valet or possibly Head Waiter, certainly lacks both the training and the temperament for the very complicated and exacting duties of a Manager.' However the good Colonel had reckoned without the membership and he soon ran into problems with the House Committee who were accustomed to directing staff. This, he complained, 'entirely prevented me from carrying out the duties which in all other men's social clubs were recognised as the exclusive duties of the Secretary.'

Colonel Hely was tactfully reminded that the Chelsea Arts Club was unlike any other Club. It had its own traditions and atmosphere and until he had thoroughly absorbed it he would not be expected to make any drastic alterations; in particular he was advised to continue to give the staff their allowance for breakfast and not to make such rigorous inspections of the cleaning arrangements. He was also accused of an overbearing manner with the servants. These skirmishes resulted in a major confrontation in which the House Committee and members joined against Colonel Hely. When his first six-month appointment was completed, the Colonel handed in his resignation and the Club adopted less war-like tactics.

Soon afterwards, a more diplomatic Secretary, Captain Collier, was appointed. However he was no more successful than the Colonel, for within three months he was dismissed for insobriety. With a feeling of some relief the Club reverted to more familiar arrangements, with the Steward doing much of the Club's management and the burden of decisions being taken by the House Committee.

Staff worked an average of sixty hours per week on a rota of fifty-four hours one week and sixty-six the next. Three maids shared the bedroom at the end of the corridor at the front and the Steward and his wife were next door. The kitchen staff shared one of the smaller rooms. The kitchen was far from satisfactory and in April 1930 a small explosion happened in the gas oven, and the kitchen maid was burnt on her hands and face. This happened to the cook again later in the year and a doctor had to be called. But conditions were improving; by 1923 electric light was installed in the

DINNER

SOUP

1 Vegetable.

FISH

Fried Fillet of Whiting.
Grilled Herring & Mustard Sauce

HOT JOINTS

Roast Leg of Lamb.
Steak & Kidney Pudding.

COLD MEATS

Ham. Lamb. Beef.
Brawn.

VEGETABLES

Roast & Boiled Potatoes,
Sprouts + Turnip.

SWEETS

Queens Pudding,
Figs, Apples. Prunes

FRUIT CHEESE

COFFEE

Rice Pudding, Cream.

*'Cecil King at Saffron Walden'
by J.K. Kirby NEAC.*

staff rooms and in 1929 it was agreed that the Steward and Stewardess should have two evenings, or one afternoon and one evening, a week off. Their joint salary was £3 per week and the head waitress was paid 25s per week.

Each week between five and six hundred meals were served in the Club, but almost half of them were to the staff. Food was plain, nursery food preferred. Dinner was 2/6d. and the menus was Soup, English Beef or Fish, followed by a substantial pudding, or, in the summer, Salads, Veal and Sweetbreads. Crumpets for tea were 1d. with Chivers Marmalade and Pourports Jam. On the Club wine list a good Claret or Burgundy sold at 2/9d. per bottle. The Club Champagne was 11/6 and Whisky 7d. per glass. The Annual Dinner of 1929, at which the special guest was Philip Wilson Steer, cost 5/- and consisted of Creme Soup, Fried Sole, Roast Chicken and Ham, with Bread Sauce, or Roast Leg of Lamb, with Mint Sauce, Mashed and Baked Potatoes, French Beans, Trifle, Dessert, Biscuits, Cheese and Coffee.

The painter Cecil King was a lively member who joined the Club in 1914. He was then in the army and helped to create the London Division Cyclist Company. Later he was transferred to the Admiralty and worked in a special camouflage section called the 'Dazzle Department and Interpretation'. During these years he stayed at the Club, for here he could get hot baths on a Sunday. He later became the official painter to the Royal Thames Yacht Club. He had many connections with Chelsea, for his grandfather Charles Keep had earlier owned the house on Chelsea Reach which had been leased to Turner. In the early 1920s he was an active member of the House Committee, Secretary to the Club and a witty observer of its ways.

In 1922 he gently guyed the Club in a lengthy poem entitled 'An Epic of the House Committee' – the following is a short extract:

In a cosy little corner fitted tastefully with books,
Which nobody can ever find (though no one ever looks),
A cosy seat of government accommodates the hub
Round which resolves the bus'ness of a cosy little club,
And on a Tuesday evening, if ever you should dare
To shove your nose inside the door you'll see them sitting there
As solemn as a row of solemn judges on a bench,
Sipping comfy little glasses full of comfy gin and French.

There the House Committee ponders, as a House Committee should,
On all kinds of new expediments for the other members' good –
And they keep important records and they dabble in accounts
And they vote the public money up to fabulous amounts.
There they ponder on the frailty of their frailer fellow folk,
Making ponderous decisions – House Committees never joke –
Taking devastating action to the limit of their powers,
And the minutes that they write will often occupy them hours. . . .

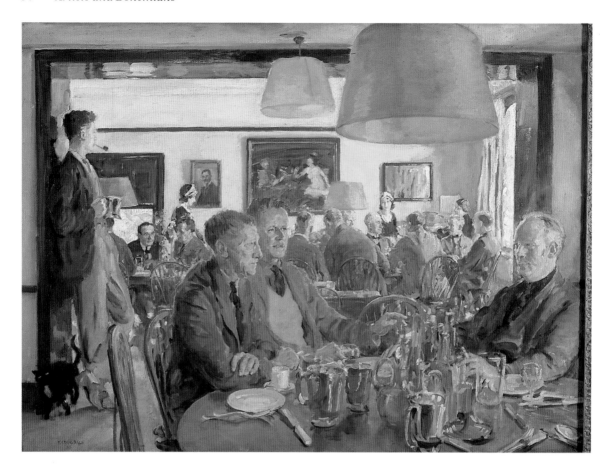

'Lunch at The Chelsea Arts
Club', 1933, by Thomas
Dugdale RA. 1. A.R. Thomson
2. John Ireland 3. Percy
Bentham 4. Leonard Jennings
5. Dyson-Smith 6. Henry
Bishop 7. Alexander Jamieson
8. John Cameron 9. George
Henry 10. Leonard Merrifield
11. William Stott, 12. Roland
Bevan 13. Henry Rushbury
14. Mrs Dunning.

7 A Confident Club

The decade of the 1930s saw the Club at its most self-possessed, a firmly established male enclave of tweeds, pipes and sketching tours. At a time when other London clubs were threatened, it had survived well, and had considerable resources. The various administrative shake-ups and the increase in members' subscriptions had improved its finances and the Arts Ball continued to pay substantial dividends, £2000 in 1930, £1500 in 1931. If membership was small, about 300 on average, this was from choice. Prices in the dining-room and the bar were low and the food, if plain, was plentiful. The Club's somewhat old-fashioned appearance was much enjoyed, as was the enclosed garden.

In 1931 Thomas Cantrell Dugdale took over the Chairmanship of the Club from the now-failing Sir William Orpen. Dugdale was a Lancashire man from Blackburn, who trained at the Manchester School of Art and in London and Paris. By 1903 he had moved to Chelsea and became a member of the Club. His portraits and figure paintings were widely seen at the Royal Academy and the Royal Society of Portrait Painters. He became ARA in 1936 and a Royal Academician in 1943.

In his painting *Lunch at the Chelsea Arts Club* (1933), exhibited at the Royal Academy in 1934, Thomas Dugdale gives an intimate record of the leading personalities of the Club in their own informal meeting-place. The scale is domestic and the dress is casual. Each member enjoys a standing in the world of art and displays an air of settled contentment. It is, in the words of Graham Petrie, a founder-member, 'A real Club, an artists' club, a unique club, such a club as will put to shame dull conventional clubs, organized by Philistines.'[1]

In Dugdale's painting the tall figure that stands in the opening between the two rooms is Alfred Reginald Thomson, already making a reputation as a portrait and figure painter and also a fine mural painter and caricaturist. He would soon become an ARA. He stands somewhat apart from the others, perhaps reflecting his separation from his friends, for Thomson could neither speak nor hear, and his principal means of communication in the Club was through his drawings and caricatures of fellow members.

Another member, the greatly gifted stage-painter Alexander Bilibin was also deaf and dumb; nevertheless, being born in Russia, Bilibin was fluent in five European languages and their equivalents in sign language. For many years Bilibin and his team of assistants painted the great backcloth which formed the centrepiece of the Chelsea Arts Balls. In one bizarre episode in the Club these two members came to a violent disagreement, conducted in agitated sign language and swiftly executed drawings. Matters ended violently, with the normally placid Thomson pursuing

Bilibin around the billiard table flourishing a knife. The protests of members, trying to stop the argument, were unheeded because they were unheard, but the dispute was eventually concluded without injury to either.

In spite of his handicap, Thomson was employed as a war artist during the Second World War, working in factories and hospitals. He painted the civilian heroes, firemen, ambulance drivers, wardens and nurses. One of these became particularly famous, his portrait of sixteen-year-old Charity Bick, the youngest woman Civil Defence worker to be decorated with the George Medal, pictured on her bicycle as a despatch rider. He also followed the example of Henry Tonks and made a gruesome but valuable record of facial injuries at RAF hospitals which helped with the treatment of burns. He contributed more than any other member to the number of drawings for Arts Balls, dinner menus and other decorations for the Club and remained an extremely popular member of the Club until his death at the age of ninety in 1988.

The composer John Ireland, who was an honorary member, and Percy Bentham, the sculptor, can be seen at the long table, and at the small table in the foreground are Leonard Jennings and Charles Dyson-Smith. Leonard Jennings was a Londoner from Lambeth, who joined the Club in 1906 and in the following year was appointed sculptor to the Government of India. In the years before the First World War he executed a number of important ceremonial statues, including that of King Edward VII at Bangaladore and the Prince of Wales at Bombay. Jennings had a distinguished war career: he went to France in December 1916 where he was appointed to the General Staff and was twice mentioned in despatches and awarded the OBE. He also had the pleasure of having a suit of clothes stolen from the Club by a waiter. Charles Dyson-Smith was also a sculptor; he had trained in London at the Royal Academy Schools and at the Royal College of Art and in Munich before the First World War. He became a frequent exhibitor at the Royal Academy and a member of the Club in 1923.

Mrs Dunning, the respected dining-room manager, guards the cash desk at the back of the room and the 'tweenies', the much-admired waitresses, dart between the diners. The figure that sits in the foreground on the right is Henry Rushbury (later Sir Henry Rushbury, RA), who was to have a considerable influence upon the Club, particularly during his Chairmanship in 1937–8.

This is now a Club in its maturity, and the group of seven members who sit around the head of the large table are mostly older members whose services to the Club have already been mentioned. We see the back view of Henry Bishop in deep conversation with Alexander 'Sandy' Jamieson, previous Chairman of the Club. Henry Bishop had trained at the Slade School and in France in the 1880s and had been a member of that idyllic artists' community of Gréz-sur-Loing. For a time he joined the painting community in St Ives, Cornwall, and also worked for several years in Morocco. He exhibited at both the New English Art Club and the Royal Academy and was elected to both. Facing them, but partly hidden, is John Cameron – Lieutenant Colonel J.J. Cameron, DSO, MC – the most decorated Club member and a strong force for order. The Glasgow-born George Henry sits opposite, one of the early Chairmen and now a much-respected Royal Academician. Opposite him is the sculptor Leonard Merrifield. The last two at the long table are William Stott and

'Thomas Dugdale, Full RA'.
A celebratory drawing by
A.R. Thomson RA.

Roland Bevan. William Stott was one of those members who had joined
the RAMC and one of the last to be demobbed. He was remembered in the
Club because of a beautiful pair of seal-skin boots that he had acquired in
the war, and also for his prowess at billiards. He later became a
hard-working Committee member and Trustee of the Club. Roland Bevan
became Chairman of the Club in 1940. It was these, and others like them,
who set the tone of the Club during the 1930s, hard-working and
well-established artists allied to the Royal Academy and the other exhibit-
ing societies in London.

As ever the Club continued to honour its past members. Francis
Derwent Wood, an important early member and a great supporter of the
Club, died in February 1926. After lengthy negotiations with the London
County Council, it was agreed that the Club be allowed to erect a
sculpture to his memory, which was set up in 1929 on the Chelsea
Embankment, opposite Oakley Street. It is a life-size nude 'Atalanta', a
bronze version of a Royal Academy exhibit of twenty years before, a work
which marks the end of a classical tradition in English sculpture.

*'Atalanta', 1923, by Francis
Derwent Wood RA. Placed on
Chelsea Embankment in 1929
in memory of the sculptor, by
members of the Chelsea Arts
Club.*

In August 1928 the sculptor Henry Poole RA died. He was a Londoner
from Westminster who had trained at the Royal Academy under G.F.
Watts. He joined the Club in 1904 and as a Council member he was one of
the enthusiasts who set up the first Ball in the Albert Hall; when the Ball
Company was formed he became a Director. As Chairman of the Club he
struggled to keep it going during the difficult days of the war.

Poole played a major part in the revival of the Arts Balls after the First
World War, designing and supervising the sculptured centrepieces and
decorations. In spite of the considerable profits that the Balls had made he
never took any payment. At his death, as a mark of appreciation, the Club
sent a sum of £50 to his widow and a Fund was set up for a permanent
memorial in the Club. This took the form of a decorative fountain in the
garden, in which the figure of Cupid, executed by Henry Poole and cast in
lead, rides on a scallop shell. The setting, of a circular pool lined with
mosaic and surrounded by stonework seating, was designed by an
architect member Leonard Holcombe Bucknell, and it was placed on a
new terrace of York paving opposite the bay window of the billiard room.
It was unveiled at a garden party on 25 March 1930.

The Club was now internationally known, it had world-wide contacts
and was regularly used by artists from overseas, particularly Australians
and Canadians. Many of these had come to Europe to complete their
training, some became residents of Chelsea and exhibited their work with
the Academy and the Societies and many became prominent as war
artists. The departure of many distinguished Australian artists from their
homeland was a source of regret to their fellow countrymen. Bernard
Smith, the Australian art historian, wrote:

They all seem to be here: Mackennal, Longstaff, Mahony, Fullwood, Spencer,
Norman, Minns, Fox, Tudor St George Tucker, Quinn, Coates, Bunny, Alston, Kay,
Sonny Powel, indeed by 1902, the exodus to Europe was at full flood. It was in the
Chelsea Arts Club that the Heidelberg School established its last and least
distinguished camp.[2]

The outgoing Australian artist George Washington Lambert joined the
Club in 1905. He was a portrait painter and mural decorator. He had been
born in St Petersburg of an American father and an English mother, but as
a child he was taken to Sydney. After two years in Paris he came to

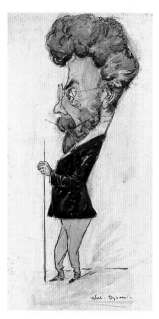

'A.H. Fullwood' by Will Dyson. Fullwood was a companion of Dyson and also divided his time between England and Australia.

London and played an important part in the foundation of the Modern Society of Portrait Painters. During the Great War he served in Egypt and Palestine as an official war artist, painting the battlegrounds from the Suez Canal to Damascus. In a hazardous dash he was the first of a group of artists and correspondents to reach the top at Gallipoli and his records of this engagement received a lot of attention in London. He returned to Chelsea after the war and was elected to the Royal Academy in 1922.

James Quinn had also been an official artist to the Australian Military Forces. In 1917 he was in Flanders and in the following year he followed the front line troops during the advances in France. Like Lambert, Quinn was a considerable drinker in the Club and whisky often made him aggressive. One evening George Lambert arrived, having just recovered from a bad attack of flu. As the evening progressed, Quinn, thinking his work was criticized, wanted to fight him on the lawn. The incident passed off and they left the Club together, but they had not gone more than twenty yards when Quinn again took off his coat and hat and challenged Lambert, who told him not to be a fool – they went away together.

Will Ashton (later Sir John William Ashton) became a member of the Club in 1931. He was the son of a drawing master at the York School of Art and had been taken to Adelaide at an early age. His father taught drawing at the Prince Alfred College where Will was educated, and after college he entered his father's studio for four years. Will was then sent to study at St Ives in Cornwall under Julius Olsson and Algernon Talmage (both respected members of the Chelsea Arts Club) and he was much influenced by Olsson's free rendering of marine subjects. Ashton became well known for his impressionist sea-scapes and landscapes and had a distinguished career in Sydney and Adelaide, with frequent visits to

Memorial to Henry Poole.

London and Paris. He later became a Director of the Art Gallery of New South Wales. In 1960 he received a knighthood.

One of the most powerful personalities was the Australian Will Dyson who became Chairman of the Club in 1933. He was a man of considerable physical presence and also very politically involved – it was he who brought in Aneurin Bevan as a visitor and later as an honorary member. His political views had been affected by his experiences as a war artist with the Australian forces. In a series of penetrating studies made during the winter campaigns of 1916 and 1917 in the Somme and Ypres, Dyson recorded some of the most terrible moments of the war. He drew the men in the front lines as they tramped through the mud, searching for their lost battalions, digging ditches, clearing trenches, shoring up the cracking walls, or as they tunnelled deep under enemy lines to lay mines. He followed the stretcher bearers moving slowly through the shell-riven contours of no man's land and drew the long lines of ghostly figures, moving like chain gangs as they returned from the battlefield. A selection of these drawings was published in 1918 under the title *Australia at War.* G.K. Chesterton, who wrote the introduction, spoke of the barbarism that Dyson had seen: 'Against such elemental emptiness of bare lands and bleak waters Dyson has moved and showed us his comrades moving; and his stroke is here none the less militant because he is now using only the artillery of art, which fights not with fire but with light.'[3]

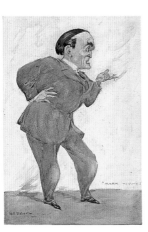

'Derwent Wood' by Will Dyson.

It was during the Chairmanship of Will Dyson that the Club entered upon its most ambitious scheme of rebuilding. At the Annual General Meeting in 1933, Dyson described the disgraceful way in which the staff was housed. 'Three maids sleep in one room; two in another; the steward and stewardess have only one room; the maids have no dining-room and no sitting-room and only one bathroom. The lavatory accommodation is inadequate.' One member had heard it said that the Club was a glorified cabman's shelter and lacked the amenities enjoyed by other Clubs. He believed they should have a lounge where they could receive their friends; there was also a serious lack of bedroom accommodation for members. Dyson suggested that this matter, which had been shelved for a number of years, should receive immediate action: a Building Sub-committee was formed and they were instructed to get busy at once.

This was a major reconstruction of the Club. An additional floor was built over the billiard room which provided a suite of five additional members' bedrooms with bathroom and WC. On the ground floor a new room, decorated 'in the modern style' took the place of the old Loggia. A new bar was created and a staff dining-room, plus additional lavatory accommodation. A steward's bedroom and sitting-room and a servants' sitting-room and bathroom were created by building over the western portion of the dining-room. It was also found that the electrical wiring of the Club was in a very bad state and required complete renewal. The Club was told that there was a grave danger from fire and that it was dangerous to allow people to sleep on the premises. Finally new parquet floors were laid and fitted bedroom furniture was made to the architect's design. The whole club was redecorated and new furniture was purchased. The total cost of £2835 exceeded the original estimates, but as this included rewiring and refurnishing it was thought to be reasonable. The work was completed in August 1933 and the Club gave a dinner for the workmen who had achieved a major remodelling of the Club during the summer months.

After the reconstruction in 1933. The Garden Room.

A handsome booklet produced shortly after the rebuilding of the Club described the new amenities:

Today the Club House more than meets the needs of its members. It was once two eighteenth-century cottages with a spacious garden. Through the modifications of over a century the original character is still apparent, and has not been disturbed by the complete re-modelling of the premises in 1933 . . . Since its foundation, Artists, who best understand the needs of Artists, have controlled the Club. It has been their aim to solve as far as possible the domestic problems of the Artist. The most urgent of these has always been economic and consequently all charges are fixed with this in view.

The booklet announced triumphantly 'The Club is now in a stable position.'

Although this last statement was correct the Club was by no means out of the financial wood. The accountant Leslie Paviere sounded a note of warning: 'The total expenditures in 1933 and 1934 in connection with the additions, alterations and furnishings were over £3000. This was met by the mortgaging of the club premises, sale of investments and a temporary overdraft from the bank . . . The dividend from the Ball company is being used at this time to meet the current expenses of the club.'[4] Fortunately the Arts Ball continued to be a staunch standby. Each year, between 1929 and 1935, profits of between £1000 and £2000 were paid to the Club.

The Club now had a settled and orderly appearance. Through the low door from the street, one entered the Entrance Hall with its large umbrella stand and brass gong. This gave on to the Writing Room with oak writing tables and several armchairs on a blue Persian rug by the fire. Beyond this room was the Library, the quietest room, where one could write or read, fitted with Georgian mahogany bookcases and books on art, architecture and travel.

The Billiard Room was the social centre of the Club with its two tables, each surrounded by Turkey-patterned Axminster runners. Here was held the Annual Dinner, which took place on Royal Academy Varnishing Day. The room was heated by a tall and highly decorated anthracite stove and a Bechstein cottage piano stood opposite the grandfather clock. Overlook-

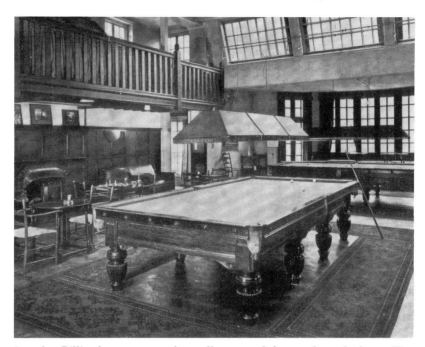

After the reconstruction in 1933. The Billiard Room.

ing the Billiard room was the gallery, used for cards and chess. The dining-room took sixty diners, most members sat around the old scrubbed dining table. There were also several circular tables and four large armchairs drawn up to the fire. The new garden room or loggia was a general meeting room and bar and breakfasts were served here in the summer.

The upper floors had seven members' bedrooms, all with their iron bedsteads and painted fitments and basins with brown linen curtains below. The staff bedrooms were along the front of the house and over the dining-room the steward had his sitting-room, bedroom and office.

The Club had a further opportunity to enlarge its premises in 1938 when Captain Adrian Jones, who lived next door to the Club, died. Again the Club was offered the lease of the house with its large studio in the garden. Various schemes were discussed by the Council; one of these would provide extra clubrooms and bedrooms, with the studio as a games room, connected by a covered way from the Billiard Room. It was estimated that this would give the Club five additional bedrooms for a capital expenditure of £6600. However it was calculated that this would mean an additional subscription of £2 per year and would be 'hanging a millstone around the neck of each member' and lead to a large number of resignations. In a second, and less ambitious, scheme the Club would use the Studio as a games room, and the house would be let. However there would still be a large annual loss. After much discussion it was agreed that neither scheme was practicable, and the offer was refused.

In the 1930s, a political decade, the older members of the Club mostly stood back from those events that affected the more politically aware, the Depression followed by the collapse of the Labour Party, the rise of Communism and Fascism and the clash of those ideologies at the time of the Spanish Civil War. They also averted their eyes from the antics of the avant-garde in art. The excesses of modernism, the cold doctrines of abstraction and the posturing of the surrealists were amusing topics for discussion in the bar. They found more congenial company in the home-grown domesticity of the Royal Academy and the more responsible of the London exhibiting societies.

'Ladies' Dance Under Control'. A protest made to the Committee by A.R. Thomson RA in 1933. Thomson believed that the Council were too restrictive over the admission of women to the Club.

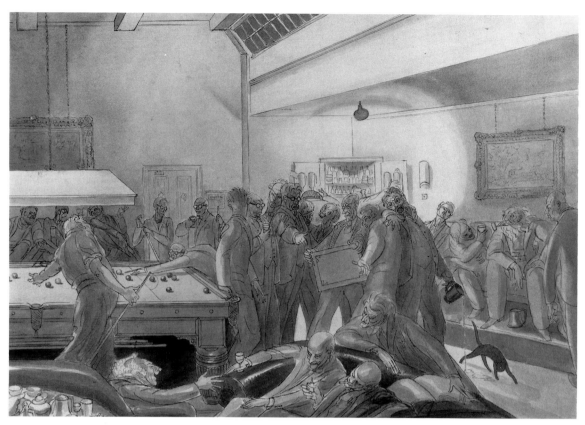

*'A Quiet Evening in the Club'
by William McMillan RA.
McMillan was a sculptor and
a member of the Club from
1921, and a friend of Charles
Wheeler and Frank Dobson.*

To the younger generation, the Club now represented a bastion of conservatism. Sir George Clausen ARA gave a criticism to the students of the Slade School in October 1931, in which he commented upon the pernicious influence of such modern artists as Cézanne, Nash and Gertler, and compared them to the immortals, Rembrandt, Velasquez, Watteau, and Claude. This resulted in an impressive rebuttal of Clausen's opinions by the Slade students in the form of an open letter which was presented to the Club. The students saw Clausen's remarks as worse than useless, a return to the blinkered past. 'Why should you and others of the same kidney as yourself,' the letter stated, 'accuse the present of being an art of rapacity, unprincipled, without healthy traditions etc., and then proceed to give yet one more unwholesome whack to the dead rump of an old stalwart such as Cézanne?'[5]

Nevertheless the membership, with the times, was changing. Modernism was uncomfortably close at hand and seclusion was not possible. During the 1930s older members were handing over to younger artists who were beginning to make their reputations in London and a number joined who represented more extreme points of view. One of the most important was Graham Sutherland, soon to be a leader of the avant-garde. Graham Sutherland described himself as an etcher when he joined the Club in 1931. He was then teaching two days a week at the Chelsea School of Art and had painted little up to this time, although he had built up a reputation as an illustrator and print-maker and for some years had exhibited his etchings at the Royal Academy. His work was at a point of change, moving into a form of uncompromising modernism. On holiday visits to Wales, Sutherland had discovered a special quality in the landscape of Pembrokeshire. In free and exploratory drawings he responded to this scoured coast and linked it with the jagged silhouette of predatory nature. Quiet and dedicated, working mostly in his studio in

Kent, Sutherland was not frequently in the Club and played no recorded part in its activities. He was sociable but naturally reserved, and he would have preferred the quieter pleasures of the library and dining-room to the rumbustious life of the bar.

When C.R. Nevinson was proposed by Dugdale in 1934, he was no longer seen as a threat to the established order in art. As a student at the Slade School, before the Great War, he was one of that disturbing generation, which included Mark Gertler and Stanley Spencer, who looked forward to a revolution in art. With Wadsworth, Allison, Lightfoot, and others they were known as 'the Slade Coster Gang'; they wore black jerseys, scarlet mufflers and black hats. His paintings, much influenced by cubism, were shown at the Friday club and, because of their extreme modernism, he had been advised to give up painting by Tonks. In Paris he had attended the Académie Julian and Matisse's school where he painted in a harsh cubist style. He became a friend of Modigliani, Wyndham Lewis, and, for a time during the Futurist demonstrations in London, of Marionetti. In London the Chenil Gallery, advised by Augustus John, took any picture that he sent there: his war paintings of the bleak battlefields were some of the most disturbing documents of trench warfare. However the raw emotion of his early painting did not survive into the post-war years. His work became acceptable to the Royal Academy and the now sober New English Art Club and he became a member of the New English in 1929 and was elected ARA in 1939.

The painter of animals and landscapes, Edward Seago, was – like Munnings, who proposed him for membership in 1934 – a countryman from East Anglia. From an early age Seago was fascinated by circuses and had travelled with circus people in Britain and Europe. His first London exhibition at the Sporting Gallery in 1933 coincided with the publication of his book *Circus Company*, which recorded these experiences. He later served as a war artist with the Royal Engineers and, during his time in Italy, often painted alongside Field Marshal Lord Alexander, also a keen landscape artist. In 1946 Seago's war pictures were exhibited in Norwich, his birthplace; he also published a number of illustrated books of his war experiences.

Sculpture at this time was generally at a low ebb. As *The Times* critic said: 'So long as the Academy does not use what power it has for the encouragement of the best sculpture in the country, it cannot plead even that it has done its best. Meanwhile the art of sculpture seems to be dying for lack of public interest.'[6] The fact that sculpture continued to be a public art at all in the immediate post-war period was because of the need for war memorials and the use of architectural decorations in building. But as the modern movement began to form, it encouraged young sculptors with more modern ideas, working in more experimental ways and determined to break the mould of the past. The Chelsea Arts Club was an important meeting place for both groups of sculptors, 'modern' and 'traditional'. It was also, perhaps uniquely, a place for regular social mixing of architects with artists – and a number of creative opportunities came from this and many commissions. Additionally Chelsea still had a considerable number of working sculptors' studios, plus the proximity of two great art schools – Chelsea School of Art and the Royal College of Art.

Frank Dobson had earlier made the acquaintance of Augustus John in Cornwall, who introduced him to art circles in London and to the Club. In 1920 Frank Dobson was the only sculptor member of 'Group X', an

'Dobbie'. Portrait of Frank Dobson RA by his fellow sculptor William McMillan RA.

avant-garde exhibiting society formed by Wyndham Lewis to recover the ground that had been lost by the pre-war movement of Vorticism. However the group produced only one exhibition and its lack of success showed how such revolutionary movements now appeared to be no longer relevant. In the early 1920s, Frank Dobson's reputation began to climb and he and his Cornish-born wife Cordelia spent increasing time in London. Their studio in Manresa Road, Chelsea, became a meeting place for distinguished figures from the art world and from London society. Dobson's work was greatly admired and he was feted for his design of the curtain for *Facade*, a piece for theatre with music by William Walton, with a commentary spoken by Dame Edith Sitwell through a megaphone. His bust of Osbert Sitwell (now in the Tate Gallery), was described by T.E. Lawrence as 'his finest piece of portraiture, and in addition it's as loud as the massed bands of the Guards.'[7]

Frank Dobson was by no means an easy member of the Club and he was in constant dispute with the Council. He had joined in 1914, but resigned and was re-elected in 1926. After a further period of absence he rejoined in 1935 with six years' subscription outstanding. He was reprimanded for his behaviour at the June dance in 1937 and an apology was required, but Dobson felt he had been unjustly treated and resigned yet again; however in January 1938 he apologized by letter and was reinstated.

By the mid-1930s, Dobson was seen as one of the most forward-looking sculptors working in Britain, a position soon to be overtaken by the more radical talent of Henry Moore. Much of his portrait work was exhibited at the Royal Academy and he also worked on a number of architectural subjects. He became an ARA in 1942 and RA in 1953 and for seven years, from 1946, he was Professor of Sculpture at the Royal College of Art.

As a student at the Royal College of Art, Henry Moore had been taught by Derwent Wood, one of the early pillars of the Club, who was Professor of Sculpture. Wood's report, dated July 1922, at the end of Moore's first year, read: 'His life work shows improvement. Design not to my liking. Is much interested in carvings.'[8] Henry Moore was soon to be the acknowledged leader of a school of contemporary sculptors. He was in no sense an architectural sculptor, preferring to create work on a relatively small scale, with a strongly experimental point of view and beautifully crafted. Henry Moore was briefly a member of the Club in 1939. At this time he was teaching for two days a week at Chelsea School of Art, but he left when the School was evacuated from London and Moore moved back to his country home near Canterbury. He rejoined the Club in the post-war period.

Charles Wheeler was also seen as one of the 'moderns', although his work was more decorative, as evidenced by the monumental sculptures that he had produced for the new façade of the Bank of England. At the time of his election to the Royal Academy in 1934, it was reported that 'the election of Mr Charles Wheeler is a tribute to the advanced school.' He continued to play a major part in the Club's activities, particularly during his Chairmanship from 1950 to 1952. Another sculptor member and a friend of Wheeler was Maurice Lambert, described as 'one of the younger men and one of the most promising'. His work combined abstraction with a more representational description of birds and animals, 'all experiments in movement, a sort of three-dimensional futurism'.[9]

Soon after completing its own reconstruction the Club was faced with

Proposed Alterations to the Rules 1933. With decorations by a member.

the most uncompromising modernism on its own doorstep. Immediately opposite to the Club in Old Church Street, two houses were built on the purist contemporary lines by the most avant-garde architects. No. 64, by Mendelssohn and Chermayeff, has a long straight front along the street. The adjacent house, No. 66, by Walter Gropius and Maxwell Fry, shows its back to Church Street and its main frontage looks towards its gardens. These two remarkable houses, described as 'a new design for living' had a style that was totally foreign to their neighbours. All was light, air and space. The staircase hung unsupported in the polished, roomy hall, rooms were heated from the ceiling and whole walls were of sheet glass. One was built for the playwright Ben Levy and his wife Constance Cummings, the other for friends. Ben Levy said 'I paid for it from the profits of a film script that I didn't want to write in 1936. The architect, Gropius, was a refugee who wanted a job, builders were idle and the plot of land was for sale. I didn't want to build an old house – so I built a new one.'[10]

That other apostle of modernity, the architect, Christopher Nicholson, brother of Ben, was proposed for membership by Augustus John in 1934. He had recently built a new studio for John at his home in Fryern Court, Hampshire. Nicholson then had his architectural practice at 12 Old Church Street, a one-roomed office over a chemist's shop, shared with his partner, Hugh Casson. 'How pleased we were,' said Casson, 'when Gropius and Mendelssohn, with their English partners, built here, opposite the dolls-house-size Chelsea Arts Club, and before our very eyes, two white flat-roofed houses that became ikons of the modern movement.'[11]

The most advanced artist, and perhaps the least likely member of the Chelsea Arts Club, was Naum Gabo-Pevsner, proposed by Bernard Adams the landscape painter in 1935. Naum Gabo was born in Briansk, Russia, of a family named Pevsner that included four brothers and one sister. He had been a witness to many of the turbulent social and political events in Europe which resulted in the First World War; he had lived through the period of revolution in Russia and shared the exalted hopes and aspirations of those artists who supported massive social change, and the inevitable frustrations that followed. In 1920 the limited sympathy shown to modern artists by the Russian State was withdrawn and official policy changed to support academic and naturalistic art. After a period of uncertainty Gabo was allowed to leave Russia in 1922 and he spent some years in Germany and France. Attracted by the interest in abstraction that had begun to develop in England, Naum Gabo came to London. 'It was such a contrast with Paris which was violent, gossipy and full of intrigue and jealousies which I hated, and London to me was like coming to a place of peace from a place of war, although I knew afterwards it was not so peaceful!'[12] In London, Gabo found sympathy for his position as an abstract artist in the group that came together in Hampstead with Ben Nicholson and Henry Moore as leaders; he formed a close friendship with Nicholson and in 1939 followed him to Cornwall.

When Henry Rushbury (later Sir Henry Rushbury) became Chairman in 1936 he had already been a member for ten years. He was a Birmingham man, brought up in the country. From the village school he won a scholarship to Birmingham School of Art, where he trained as a goldsmith and stained glass artist. He came to Chelsea in 1912 as an etcher and engraver. In the First World War he served with the infantry on the east coast and as a sergeant in the newly created Royal Air Force. In the last years of the war he worked as a 'general ability artist' for the Ministry of

'Sir Henry Rushbury' by J.K. Kirby NEAC. Rushbury was Chairman of the Club from 1936 to 1938.

Information, drawing London under the zeppelin raids and illustrating whatever subject was required – preparations against air-attack, the night watchers in the dome of St Paul's, sandbags around the Egyptian treasures in the British Museum and the tomb of Edward the Confessor in Westminster Abbey – all recorded in the direct manner of a magazine illustrator. At the end of the war, although he was by now exhibiting widely, he returned to the Slade School as a student for the winter of 1919.

Rushbury was fascinated by the architectural detail of fine buildings and the old towns busy with people. In London he drew the life of the Thames in a manner that was in tune with his teachers, Muirhead Bone and Frank Brangwyn. He also found many of his subjects abroad, in southern France, Spain and Italy. He was a master-printer, no theoretician. His views were practical and he took simple pleasure in the work. 'It's all such fun working under the sun, drawing a scene which delights your eye and stimulates your mind, seeing the world go by in some foreign city,' he wrote, 'and trying to capture some of the amusement you feel, some of the love you have for what you are experiencing.' He was, however, conscious of the deep divisions between the 'abstractionists' and those with more traditional views. He was by no means unsympathetic to the contemporary view and in his own work attempted to achieve a balance between these. Short and red-faced, rosy-cheeked with sideburns, Rushbury was known as 'the Coachman' in the Club because of his rubicund appearance. He combined the Bohemian with the businessman – he was one of the first in London to wear coloured shirts in the continental style, but his were made up in Jermyn Street. He had an acute political sense, veering very much to the left, and a wide circle of friends of all political persuasions. He was a friend of Churchill and Macmillan and also of Aneurin Bevan, a Chelsea resident.

Rushbury had a clear idea of the right and proper way for a club to run. He was a friend and verbal opponent of Munnings and he could be equally outspoken and argumentative. He was a strong man on committees and in the Royal Academy, but was by no means a stuffed-shirt. However there were times when his loyalties were divided between the Club and the Academy. He described the selection for the 1937 Academy exhibition as 'the bloodiest in living memory' and 'a holocaust as far as the Chelsea Arts Club was concerned', though he maintained that he had done his best. He remained firmly committed to the Royal Academy and became an Associate member in 1927 and a Royal Academician in 1936. He was a great friend of Charles Wheeler, later President of the Academy, and of the painter David Jagger: they frequently dined together in the Club. In 1949 Henry Rushbury became Keeper of the Royal Academy Schools and later received a knighthood for his services to art.

Henry Rushbury brought great personal authority to the Club. During his term of office, which lasted almost until the outbreak of the Second World War, the Club achieved an air of permanence that appeared to be unshakeable, but this was the turning-point for the shared catastrophe that was to come.

8 War and Post-War

In September 1939 the country entered the Second World War in a less jingoistic mood than before. There was no rush to join up, for conscription swept through the ranks of artists as of others, and patriotic pride was tempered by memories of the previous catastrophe.

For artists dependent upon the sale of their work, the war brought great difficulties. The art schools were closed or evacuated and, apart from those with special skills in map-making or camouflage, teaching opportunities mostly ceased. Portraiture, always to be relied on for a steady income, almost dried up. In any case (to quote Barbara Hepworth) a glass-roofed studio in London was not the safest place to be during a bombing. The Royal Academy extended its facilities in a democratic manner. In December 1939 it held a large and indiscriminate show of contemporary art, with 2219 exhibits ranging from a Barbara Hepworth sculpture to a portrait in feathers of Princess Elizabeth. John Piper suggested in the *Spectator* that perhaps the Academy wished to kill contemporary art with kindness.

The Club quickly took on a wartime aspect. Windows were fitted with blackout and crossed with tape in case of blast. Lighting was greatly reduced and blue bulbs were used for the staircases and corridors. Gas masks in their cardboard boxes hung on the coat rack in the lobby, soon to be joined by army greatcoats. But in spite of the difficulties the Club did its best to keep up appearances. In December 1940 a postcard was sent to all members reminding them that, in spite of the emergency, the Club was carrying on. Breakfasts, luncheons and teas were served each day and bedrooms were available. Members could only invite guests who were from the fighting services and then for only one meal per week.

It was sometimes difficult to exert discipline during these first months of 'Phoney War': there was an air of excitement, even frivolity in the Club.

NOTICE.

In order to help in the increasingly difficult task of supplying meals, it has become necessary to insist that Members residing in the Club for more than five days shall give their Ration Books to the Steward on arrival.

This applies also to Members taking ~~~~~~ meals on five days per week.

Members dining regularly would help greatly by giving the Steward a few Points each month.

- - - - - - - - -

War-time notice.

'Dunkirk Beaches' by Richard Eurich RA, NEAC.

In an air raid on 25 June 1940, several members broke into the bar and were later found in a high state of intoxication. The Council severely reprimanded Barney Seale, Robert Myerscough Walker and James Grant. Myerscough Walker, the distinguished architectural draftsman, was in further trouble for bringing a lady into the Club and buying her a drink, and he had not paid for dance tickets from a year earlier. As a result he was suspended from membership for three months.

Soon enough the war became a reality. In the last part of May and early June 1940, the frayed remnants of the British Expeditionary Force struggled from Dunkirk. By September the Blitz had begun in earnest on London. The artistic life of London went underground. The lunch-time concerts given by Myra Hess in the National Gallery were now performed in the basement shelter and its collection of pictures was safely stored in caves in North Wales. The Tate Gallery, also cleared of pictures, was hit by bombs on average once a month between September 1940 and May 1941. Some of London's art dealers managed to keep going, but as Eric Newton, art critic for the *Sunday Times*, said, 'the West End – let's face it – is no longer a fit place for the accumulation of valuables.'

As the younger members were called into the forces, the Club was run by a group of older members. Sidney Causer, a painter of landscape and town scenes, had become Chairman in 1938. He had painted in Spain immediately before the Spanish Civil War and was forced to leave that country in some haste. He lived in Chelsea and had joined the Club in 1926, but for some part of the Second World War he took a house on the cliff tops at Fairleigh, near his friend Charles Wheeler, whose London home had been bombed. Causer was succeeded by the architect E.R. Bevan who had become a member in 1920. He was elected Chairman in 1940, and continued throughout the war years until 1946. He was helped in his work for the Club by his fellow architect Graham Tubbs, and by R.T. Mumford as Chairman of the House Committee.

Alternative suggestions had been made for an air raid shelter for the Club, either for a large shelter to be built under the terrace or for the staff room to be used as a shelter. Barney Searle, who lived next door, offered the cellar of his house as a shelter for staff. Eventually a large dug-out shelter was made in the left-hand corner of the garden, with sandbags in the doorway and a stirrup pump and shovel to deal with incendiary bombs. The Steward, Mr Banks, who had attended classes in ARP, was in charge of the Club during air raids. There was a charge of 2/6d. per night, including dinner, for sleeping in the shelter (later reduced to 6d. with all food and drink at the normal prices).

For part of September 1940 a shelter log was kept by J.L. Pemberton, recording the dreadful uncertainty of bombardment. A small group of members, with Mr and Mrs Banks and their daughter Edna, shared an underground existence, their bad jokes interspersed with tea and sandwiches and occasionally whisky. When the raids were heavy all thoughts of sleep were abandoned, but it was sometimes possible to escape to the Clubhouse by about 2 a.m. to finish the night in bed.[1] There were times when the bombs fell disconcertingly near, but still the conversation continued. On one occasion the Yorkshire painter Joseph McCulloch disregarded German bombs dropping all round and refused to stop talking about Renoir's art. As each bomb fell nearer and he was interrupted, he said 'That don't signify' and resumed his discourse until the next fell. 'That don't signify,' he repeated.

The Club lived a day-to-day existence. Fire-watching became compulsory in January 1941 and a few weeks later London had its worst air raids. The East End, with its factories and warehouses, was a prime target, but Chelsea suffered as much as Whitechapel, close to Westminster and between the two power stations of Lots Road and Battersea, which supplied electricity for the London Underground. It was one of the most heavily bombed of the London boroughs and in the period of 1940–1 was often subject to nightly raids.

One of the most frightful nights of the war was the night raid of 16 April 1941 when 450 German bombers attacked south and central London for nearly eight hours. Thousands of incendiary bombs fell on Chelsea, and a number of high explosive bombs, including five parachute mines. One fell in Chelsea Square, another in Cranmere Court. At about one o'clock in the morning, two enormous explosions were heard at the end of Old Church Street, near to the river. The old Church of All Saints had gone, hit by a landmine. In place of the massive square tower was a jagged stump of brickwork and projecting timbers. Beyond the church in Cheyne Walk several houses were totally demolished; Petyt House had dissolved into a pile of rubble. As the wardens began searching for people sheltering in the damaged houses nearby, and as bodies were being brought from Petyt Place, an elderly artist ran by, clutching the fragments of a half-finished portrait, crying distractedly 'She's in ribbons! She's in ribbons!' In spite of the devastation, which almost totally destroyed the building and removed the roof, many of the early monuments and tablets were miraculously saved and within weeks the church was in regular use with a temporary roof and blacked-out windows.[2]

On that same night the Club was damaged, though this was mercifully light by comparison with all around it. The windows of the staff bedrooms on Old Church Street were blown in and the rooms were damaged. It was also feared that the front wall had become unsafe. Temporary repairs to the roof were quickly carried out and it was later found that the front wall was repairable. The row of old cottages that stood opposite to the Club, originally called Salamanca Row (now 80–92 Old Church Street) were also destroyed.

The Club was now approaching its fiftieth anniversary, and it had been planned to have great Jubilee celebrations.[3] But the nightly bombardment was at its heaviest and the last fragile links with the earliest part of the Club's history were breaking. On 3 February 1941 the deaths of Sir John Lavery and Professor Fred Brown were recorded at the Council meeting. Yet in spite of the emergency of war the Club celebrated its Jubilee on Tuesday 18 March 1941 with a luncheon to which the few remaining original members were invited. Five were present, including P.W. Steer, Ronald Gray and A.J. Hartrick, plus 61 members and guests. Ronald Gray recorded that Steer enjoyed himself hugely, but it was the last time he went to the Club. There was a bad air raid that night; surrounding properties to Steer's house in Cheyne Walk were severely damaged, all Steer's back windows were blown in, and the roof was damaged. A year later, on 21 March 1942, Steer died at the age of eighty-two. Henry Rushbury was staying in the Club at that time, working on a war artist's commission. He wrote to his daughter Julia:

Here I am staying at the Club. Breakfast is just over – during which Alfonso Toft boiled over in anger and wanted all the 'black market' shot in hundreds. Then he got a fish bone in his throat which put an end to his wholesale executions. Leigh

'HEIL'
THE NEW 'HITLER BLADE'

*'The New Hitler Blade' by
Edmund Blampied RBA.*

Pemberton was at breakfast too in his pilot's uniform, he is teaching young airmen to fly, an exciting job, because they often forget what to do just at the dangerous moments. Ronnie Gray is up in London to bury our old friend Wilson Steer OM who died yesterday – but he loves a funeral so he's really happy.[4]

The Club had become a melancholy place, little-used except for a few elderly members living nearby or those in the forces spending a few days of hard-earned leave. The war had cut deeply into the lives of members: by December 1941 food was in short supply and the Club's small stock of tinned food, for use only in emergency, was being drawn upon. The House Committee warned members that they would find that the small portions would cause disappointment. Members staying in the Club had to hand in their ration books and the cook prepared vegetable dishes with dried egg powder. Members who grew their own vegetables or fruit were asked if they would supply the Club. Cheerfully the bar prices remained low: whisky and gin at 1/2d. per glass, beer at 6½d. per pint, but supplies soon ran out. As the Club's quota of sherry was only 18 bottles a month, each member was limited to four singles a day. Wine was rough and red, mostly from Algeria, and it was found to be best when warmed with sugar and allowed to cool. This reduced the acidity but not the alcoholic effect.

After the Blitz came austerity, the bitterly cold winter of 1942, blackout, queues, propaganda and restrictions. Food was now strictly rationed and there were shortages of almost every commodity. There was still the threat of air raids and the shelters in the parks and gardens, the crowded basements and the tube stations, were in nightly use. Nevertheless confidence began to grow as victories were reported from distant lands, at El Alamein and Stalingrad. Talk was of a second front, an invasion of Europe and the future 'after the war'.

As war artists many members were again dispatched to far corners of the world. In November 1939 the 'War Artists Advisory Committee', under the Chairmanship of Sir Kenneth Clark, then Director of the National Gallery, was set up to select artists to work with the Services. The emphasis was on the need to produce a pictorial record; this discouraged those artists whose work was largely non-representational, abstract or based largely on the imagination. However it was a formula that fitted many of the members of the Chelsea Arts Club and the most successful of the war artists were those who were regularly showing at the Royal Academy and with the exhibiting societies. Some were employed on a salary, usually from two to six months and frequently renewed; others were commissioned to paint specific works.

The most popular subjects for a wartime audience were reconstructions of the great battles on land, sea or in the air, and portraits of military heroes. Even some of the earliest members did their bit. Sir Bernard Partridge, already in his eighties, was able to joke about the tragic absurdity of war and the pompous posturing of the war leaders, and reached an appreciative public through his regular contributions to *Punch*. Henry Rushbury, now a prominent RA, was asked by the War Artists Committee to depict the weapons factories in the north of England. In a series of large water-colours, he followed the building of a naval gun, from the pouring of the first ingot to its mounting in the turret of a battleship. In 1944 he was commissioned to paint the Glasgow Boatyards, where Stanley Spencer had spent two years painting a series of large-scale paintings. The Director of Merchant Shipping found Rushbury's work more acceptable than the visionary experiences of Spencer.

Few sculptors were employed as war artists: it was thought that their work lacked the atmospheric qualities needed to represent war and their figure groups tended to look like toy soldiers. Those that were used were mainly commissioned by the Admiralty. Frank Dobson produced a number of water-colours of destroyers and barrage balloons. He also made a portrait bust of the C.-in-C., Portsmouth. He worked on a clay model in the old Admiralty building in the docks, but when the building was bombed his portrait was reduced to the appearance of a deflated football.

Charles Cundall had been a member of the Club since 1925. He retained close contact during the war and joined the Council in 1944. He had been born in Manchester and worked with Pilkington's Pottery Company designing pottery and stained glass for a number of years. His training at Manchester School of Art was interrupted by the First World War, when he served in France and was severely wounded. He later resumed his studies in London and in Paris. In the 1930s he began to build a reputation at the Royal Academy with paintings of London – the Boat Race at Putney, Piccadilly Circus, the demolition of Waterloo Bridge – and with landscapes of the English and Irish countryside, interspersed with more exotic subjects in Spain and Italy. He was elected ARA in 1937 and RA in 1944.

Cundall's work was disciplined, accurate and conscientious, and he painted men at war in moments of crisis and triumph, working first for the Admiralty and the Merchant Navy. He then replaced Paul Nash as the RAF's choice to record the re-arming of Bomber Command: he painted the old Hampdens and Whitleys, and the Short Stirlings and Lancasters which replaced them. He produced large-scale paintings of the withdrawal from Dunkirk, depicted HMS *Exeter* as it arrived back in Plymouth after its heroic action with the *Graf Spee*, and portrayed the RAF celebrating the Battle of Britain. On a number of occasions he made complex reconstructions of famous military events, such as *The Assault on Normandy 1944*, as the tanks were launched in their hundreds from tank landing craft in the early morning of D-Day. In realistic detail he depicted them as they were slowly floated across the last mile of sea, protected by the fire-power of destroyers off shore.

During the First World War Vivien Pitchforth had been called from his art training in Leeds to join the Royal Artillery. After some months in the proximity of the guns he became stone-deaf. When the war was over, he returned to Leeds College of Art and then went on to the Royal College of Art in London; his extended art training lasted until 1925. In spite of his disability he became one of the most prolific of the artists of the Second World War, although the army had to provide him with assistance in the war-zones, so that he did not fall into trouble. In a series of large watercolours he followed the progress of the war at home. He depicted the training of ARP wardens and anti-aircraft gunners, the havoc caused by bombs on the telephone exchanges and Post Office buildings, the broken lift-shafts emerging like great animals from jagged walls. In October 1943 he became an Admiralty artist; he painted motor torpedo boats in action and travelled on convoys to the Azores and to Gibraltar. With a commission as Temporary Captain RN, he joined the combined amphibious and airborne assault on Rangoon and reached that city in advance of the first troops and in time to paint their arrival.

Richard Eurich, like Cundall, also created powerful reconstructions of scenes of battle, a necessary expedient as artists were rarely allowed to

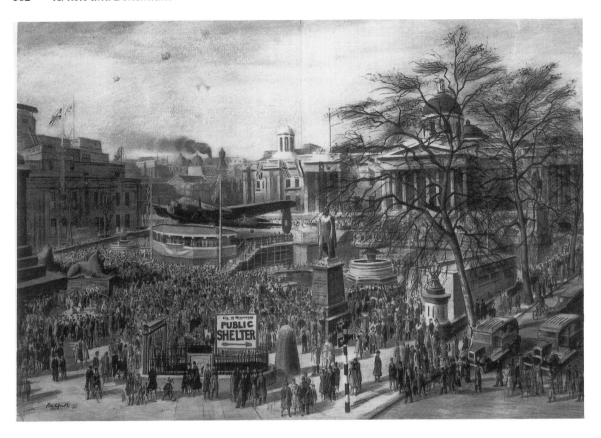

'Wings for Victory Weeks,
Trafalgar Square 1943' by
R.V. Pitchforth RA.

witness military action. His interpretation of the rescue from the Dunkirk beaches brought him overnight fame and election to the Royal Academy. Born in Bradford, Eurich had trained at the Slade. In the 1930s he spent much time by the sea near his home in Southampton. It was the coast and the changing light and shadow that fascinated him, and in his war paintings he set his scenes of heroism in known locations. His painting *Survivors from a Torpedoed Ship*, which Churchill considered one of the best paintings to come out of the war, was freely adapted from a newspaper photograph of three sailors on an upturned boat, two of whom are unconscious and are supported by a Jamaican shipmate, as they wait through the long hours of night for assistance to arrive. Occasionally he used elaborate models, such as one of Dieppe prepared from RAF reconnaissance photographs used for briefing airmen.

Anthony Devas, who joined the Club in 1944, was of that same generation of Slade students at the end of the 1920s that included William Coldstream and Rodrigo Moynihan, and he was associated with them at the Euston Road School at the outbreak of war. Anthony Devas had begun to exhibit his portraits at the Royal Academy in 1940. He had worked in Civil Defence during the war, but he also received a number of independent war artist's commissions. His portraits capture a sympathetic likeness, even when presented with such a formidable subject as the Matron of Charing Cross Hospital, *Miss M.S. Cochrane, RRC, SRN*, whom he described as 'the sort of woman who goes on down the ages – one can imagine her painted by Rembrandt, Hals or Goya.' Bernard Hailstone, who had earlier studied at Goldsmiths' College and the Royal Academy Schools, was a fireman in the early years of the war and his first war scenes were of the bombing of Portsmouth. In 1941 he became a salaried war artist and travelled to the Mediterranean and North Africa, painting

the preparations for the invasion of Italy. In the last year of the war he painted portraits of the Supreme Allied Commander in South-East Asia, Lord Louis Mountbatten, and the generals of his staff. He became a member of the Chelsea Arts Club in 1949 and a regular exhibitor at the Royal Academy until his early death in 1958.

Many of the war artists were among those invited to a special dinner in the Club in December 1946, arranged by Cosmo Clark for those members who had become Royal Academicians or Associates since the outbreak of war. They included Thomas Dugdale, James Bateman, Bernard Fleetwood-Walker, William Dring, Richard Eurich, Arnold Henry Mason, John Wheatley, Reginald Brundrit, Stanley Anderson, the architects Charles Holloway James and Edward Brantwood Maufe (later Sir Edward Maufe) and the sculptors Charles Wheeler and Frank Dobson.

Sigfried Charoux RA (left), 'Pop' Banks, the Club Steward, Stanley Grimm RP, Joe McCulloch ARWS (seated), photographed in the Club garden, 1949.

Throughout the war the Club's Steward, 'Pop' Banks, was a pillar of strength. He was a retired sergeant-major and ran the Club with enough discipline to keep order in these difficult times. With his wife as stewardess they managed the Club's economy and gave excellent service to the members. There was always a hot meal on hand, even if it had to be cooked over a tiny gas flame after bombs had cut the electric power, and members' ailments and minor financial difficulties were treated with the same kindness. Throughout the bombing, they spent their nights in the Club's air raid shelter, disturbed by the sirens and bombs and the gossip of members. The strain began to tell, however. By the summer of 1941, the language used by Mrs Banks was found to be too robust even for Club members and she was reprimanded by the House Committee. It was also clear that 'Pop' Banks was under strain and it was arranged for him to be seen by a doctor. The House Committee offered to send him on a holiday to the Artists' Rest Home in Rickmansworth, but he declined 'for personal reasons'. 'Pop' could display considerable tact when required. On one occasion a member's wife persistently telephoned, asking if her husband was in the Club. To every enquiry Pop replied 'No, Madam, your husband is not here.' At last, at the ninth call, 'Pop', in an angry voice, barked 'No, Madam, there are no husbands in this Club.'

With the conclusion of hostilities across the world the memory of war began to fade, but the austerities continued. It was a time of terrible winters, the continuation of food rationing and utility furniture. The blackout had gone, but London was still dark and dirty; owners who had left their houses empty returned to find them bombed and boarded up. In Chelsea the scars of bombing were everywhere: decayed and battered buildings, gaps in the streets, bomb sites, shops whose windows had long gone but were open for 'business as usual'. Flats and houses requisitioned by the Borough for the use of bombed-out families were slowly returned to their owners, and artists returned in search of studios. The Chelsea Arts Club was an oasis of companionship, more like the officers' mess that many had known.

The Club was making every effort to get back to normal as quickly as possible. Supplies were easing, the Food Controller allowed a small increase in rations to the Club and more fuel was available for the main rooms. The hatch through which 'Pop' Banks had served members in the hallway was closed and a new bar was installed in the billiard room, with a full-time barman. Dinner, which had been suspended, was resumed on two nights a week and new staff were taken on, bringing the total to ten. Again the Club remembered the names of those who had died in action.

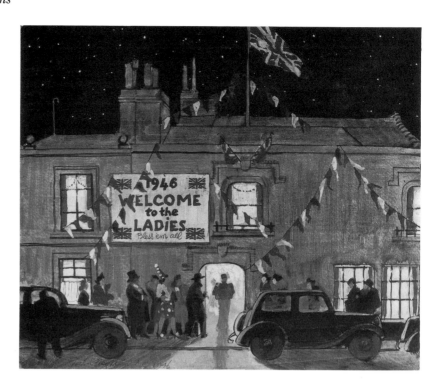

'Welcome to the Ladies. 1946'.
Artist unknown.

'Sir Charles Wheeler' PRA,
c.1950. Charles Wheeler was
Chairman of the Club from
1950 to 1952.

They were Gordon Demter, Leonard Finn, William Haines, Tom van Oss.

Charles Wheeler became Chairman of the Chelsea Arts Club in 1950. Modest, good-mannered and thoughtful, he was a man of precise and regular habits. Each day at ten minutes to one, he would leave his large studio, cross the Fulham Road and walk to the Club. There he would sit at his usual place at the head of the scrubbed table with his regular coterie of friends. These included William McMillan, who had worked closely with him on the fountains in Trafalgar Square; the tall and elegant Sir Edward Maufe, architect of Guildford Cathedral, with whom Wheeler and McMillan had both worked on a number of War Graves Commission memorials; Vincent Harris, also an architect, whose many fine municipal buildings included the circular library at Manchester, built on the plan of the Pantheon. Charles Wheeler's tastes were as simple as his habits. His favourite and unvarying lunch was one poached egg on mashed potato, followed by one tinned peach on rice pudding. These two courses of identical appearance were washed down with a glass of tonic water to which was added a slice of lemon 'Not to look prudish'. After lunch he was back to the studio and in the evening home by train to Mayfield in Sussex.

Wheeler had been born at Codsall in Staffordshire and brought up in the country. From the Wolverhampton Art School he gained an exhibition scholarship to the Royal College of Art, where he met others who would remain friends for life: Charles Sargent Jagger, who made the Artillery memorial at Hyde Park Corner; Gilbert Ledward who sculpted the Guards Memorial on Horse Guards Parade; Alfred Hardiman, whose equestrian statue of Haig in Whitehall caused controversy; and James Woodford who sculpted the Queen's Beasts at Windsor.

It was this group of sculptors who changed the face of London in the inter-war years with their statues and decorative architectural carvings. Many of them were encouraged to produce their finest work by the architect Sir Herbert Baker, also a member of the Club. Before coming to

England, Baker had built extensively in South Africa, including the Cathedrals of Cape Town and Pretoria. In England his work included many magnificient public buildings, including Rhodes House in Oxford and the Bank of England. For this he commissioned Charles Wheeler to make sculptured decorations, which included fourteen giant statues to grace the façade and which were carved on site. He also designed five bronze doors, twenty feet high, plus a large number of decorative works.

In the 1920s Wheeler was engaged with so many sculptural projects for the Bank of England, India House, bronzes for South Africa House and sculptures in Threadneedle Street, that his two studios, one in Chelsea and one in Kensington, were insufficient for his needs. He built a third studio in the garden of his house in Tregunter Road to accommodate the large-scale work. During this period of intense activity, Wheeler and William McMillan worked on sculpture for Trafalgar Square. With Edwin Lutyens as architect, Charles Wheeler did the Jellicoe Memorial Fountain and William McMillan did the Beattie Fountain. It was planned to unveil the sculptures in 1939, but with the outbreak of war the bronze groups were buried in the vaults of the British Museum; it was not until after the war that they were placed in their completed basins.

By the time of his Chairmanship of the Club Wheeler, once considered a young leader of the avant-garde, had become a pillar of the establishment. He had already begun to receive the honours that his talent and industry had earned. He had been created Commander of the British Empire in 1948. He was elected President of the Royal Academy in 1956, a position he retained for ten years, and he was awarded a knighthood in 1958.

Wheeler was the undisputed leader of a Club whose members, wedded to the Royal Academy, were now well-established and drew their strength from the regulated attitudes of the 1930s. Many of the RA's were portrait painters and it was noticeable that they came into lunch a little later than the others, having finished the morning's work and enjoyed a farewell drink with their sitters. Their studios were also more impressive and better furnished than their lesser neighbours. The sculptors, with their friends the architects, sat with Wheeler in his place at the head of the long table and it was only by invitation that other members joined them.

The Club was again to resume that central position in the art world that it had held in pre-war days. Adrian Bury described the Club as it might appear to a new member:

On his first visit he will rub shoulders at the bar with sculptors and painters who are the talk of the day and may well be the admiration of posterity. But they will not embarrass him, for the better the artist the less conceited he is about his achievements. Having broken the ice, the new member will dine at the whitest of tables, scrubbed for nearly a hundred years by the energetic hands of countless maids . . . Since it is an irrefutable rule that good and reasonably priced food must be served, even if we make a loss on this side of the business, the newcomer will realise how far about three shillings and sixpence will go in our altruistic assembly.[5]

Adrian Bury was a poet, painter and journalist, who had known the Chelsea Arts Club since the 1920s. He was born in Chelsea, the son of the sculptor and the nephew of Sir Alfred Gilbert, creator of Eros in Piccadilly. In the early part of his life Adrian Bury existed in the two worlds of art and journalism; he began by writing for the *Bystander*, for which he also provided illustrations and which took him to Paris where he trained at

Julian's Académie. Between the wars he worked mostly as a freelance journalist for the *Daily Mirror*, the *Sunday Review* and several art magazines. He also made illustrations for the Press and exhibited landscape and portraits. He wrote a number of books on art, particularly water-colour painting, on which he became a considerable authority. In his autobiography *Just A Moment, Time*, Adrian Bury described in affectionate detail some of the leading personalities of the Club.[6]

The portrait painter David Jagger gave the appearance of never really working at all. He was an incorrigible gambler and part of a group who regularly took breakfast in the Club. After reading the sporting paper, he would retire to the telephone box to ring up his bookie. He was happier to win £20 on a horse than to paint a portrait for £1000. Although his reputation was high in the Academy, he could always find time for a day at the races – and if he had been successful there would be drinks all round in the Club. His fastidious portraits were painted in his studio by night. He worked from photographs interpreted with superb draughtsmanship and he had evolved a technique so highly finished that he could paint a herring-bone suit with accuracy; striped trousers could also be done at a price.

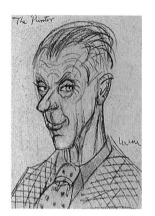

'David Jagger, The Punter' by William McMillan RA. Jagger was a successful portrait painter and an inveterate gambler.

Jagger believed that money was important to him in order to survive the discipline of catering to wealthy clients. Yet money was seldom a subject for conversation in the Club. On one occasion a gifted member had the bad taste to confess that he was hard-up and could not pay his rent; there was talk of helping him with a grant from one of the artists' charities. Graham Petrie, a founder-member and a well-to-do water-colour painter, could not understand that anybody could be in such a position. 'Hasn't he got any debentures?' he enquired, as if these were issued at birth.

Leonard Bowden, also a portrait painter, believed that the best way to please one's clients was to flatter them. He was quite prepared to take ten years off the age of a woman whose looks were beginning to fade. However, on the occasion that he was engaged on a portrait of the Queen he was quite defeated. He found the sitting trying and, in order to achieve a more relaxed pose, he suggested 'Ma'am, perhaps we can forget who we are.' This did not have the desired effect: the Queen's reply was 'You may do exactly as you please.'

The sculptor Barney Seale had the house and studio next door to the Club, previously occupied by Adrian Jones. Seale was a great character in the Club, his portrait busts of Nevinson, Joe Simpson and Augustus John done between the wars were strongly characterized and broadly modelled, but he also had strong commercial instincts and pleased his wealthy clients. He was a big man, weighing nearly twenty stone, and a bottle of whisky a day was not unusual. Adrian Bury tells of a celebration that started in Seale's studio one morning. He and Loris Rey were invited, to find a long row of champagne bottles on the mantelpiece. Barney opened one, filled three enormous glasses and said 'My Birthday'; they drank his health and the glasses were refilled. After an hour or so, other friends arrived and joined the party and at about 12 o'clock all returned to the Club to find the Steward opening the bar. As members came into lunch, all, including the staff, were drinking as much champagne as they wanted. Their money had long run out and Seale, Rey and Bury were signing chits. Their friends were of the opinion that one of them had come into a fortune, as champagne had never flowed more freely in the

'Barney Seale' by Bert Thomas PS. The sculptor Barney Seale lived next door to the Club in the house and studio previously occupied by Captain Adrian Jones.

Club's history. When they entered the dining-room that evening, they looked solemnly at each other and said simultaneously 'Barney's birthday'. The Steward quietly asked if they would like to see their chits. 'No hurry to pay, of course.'

One of the more colourful members was Joe McCulloch, a talented water-colourist and etcher from Leeds. He was a Bohemian extremist living in Manresa Road, often seen in a ragged dinner jacket and check trousers. He was continually in trouble with the House Committee, but his problems usually had a touch of originality, as for instance when he was reprimanded for taking a group of ladies into the Club for a game of snooker at 2 a.m. one winter morning. He also built up a large number of unpaid chits and it became clear that he was about to be suspended from the Club, so Adrian Bury and George Leech, Art Editor of the *Strand* magazine, combined to pay Joe's debts. To be sure that the money actually got to the Secretary, they stood over him while Joe wrote a letter of apology, then handed him the notes to put into the envelope, sealed it up and dropped it into the mail box. 'Let us hope this will be the end of the matter,' said Adrian Bury. 'Thank you, Laad,' McCulloch said in his Yorkshire accent, 'very good of you and George.' That evening, Joe McCulloch was in the bar, standing drinks all round. Adrian Bury was a little anxious – had that money gone into the envelope or not? 'It's all right, Laad,' Joe said, 'I know what you are thinking. I had to keep a couple for myself just to celebrate like.' He had managed to slip a couple of pound notes up his sleeve.[7]

In the late 1940s and 1950s some of the most senior figures were still seen in the Club. Alfred Munnings would often drop in at breakfast-time, when he came from his nearby studio, in his mackintosh, collar turned up, a weatherbeaten hat on the back of his head, and survey the few members busy with their eggs and bacon. He was always free with his opinions. Some comment from the newspaper would lead him into a diatribe about Picasso and he would make a comparison with Thomas Lawrence:

Ah, there's an artist for you. Who is there today who could paint his best portraits? Nobody. Ask the critics! No comments. Don't ask! They'd rather have any piece of modern rubbish from Paris than Lawrence's finest work. But Lawrence was English, that's the handicap. What about Reynolds, Gainsborough and Turner? Ain't they no good? Not judging by writers who praise Matisse, Braque, and all those foreign humbugs. . . . When are you chaps going to start work? It's nine o'clock. No good sitting there reading the sporting papers. I've been on the job since seven and must get back to it.[8]

And he would stalk out of the dining-room waving his arms.

Munnings's influence at the Royal Academy had grown during wartime and his name was put forward for the Presidency. At an election on New Year's Day 1944, Munnings beat Augustus John into second place by twenty-four votes to seventeen. Munnings's Presidency in the first years of peace coincided with a tremendous expansion of popular interest in the arts, but Munnings's intemperate utterances were damaging to the Academy and to the course of art in Britain. His most prominent attack was on the occasion of the Royal Academy banquet of 1948, the first that had taken place for ten years. Winston Churchill, Academician extraordinary, had agreed to speak, the event was to be broadcast live on BBC radio and the press were in full attendance. With earthy rhetoric, Munnings castigated leading European artists, Cézanne, Matisse and Picasso, and

included for good measure Henry Moore. He said he was President of a body of men who were shilly-shallying, feeling there was something in 'this so-called modern art'.

I myself would rather have – excuse me, my Lord Archbishop – a damned bad failure, a bad dusty old picture where someone had tried to do something, to set down what they have felt, than all this affected juggling, this following of what – shall we call it the School of Paris? (I trust the French Ambassador is not here tonight).[9]

By this outburst he finally broke the fragile links that existed between the Royal Academy and many of the younger artists in Britain, and set a standard of rigid iconoclasm that was to last for a considerable time. At the end of the year he resigned, and the Presidency passed to Charles Wheeler.

A few month later, Munnings opened an exhibition by Chelsea artists at the Chenil Galleries in the King's Road. In his usual forthright way he lambasted any of the paintings that betrayed modern tendencies and told the crowded room the story of a donkey that had painted a picture with a brush tied to its tail, which was praised at the Paris Salon. For this he was barracked by a crowd of more than a hundred students, carrying banners inscribed 'Down With Alfie'. At one point several invaded the platform and Sir Alfred gave one a swig from his hip-flask. Cheers and hoots interrupted his remarks, while demonstrators banged on the outer doors and imitated a donkey's braying.

Munnings died on 17 July 1959. A memorial service was later held at St James's, Piccadilly, and a conspicuous mourner was Augustus John, wearing a wide-brimmed straw hat, daubed with black paint for the occasion. After the service, he said 'I think Munnings was greater than Stubbs. He made it move, had greater narrative quality and his groupings are better.'

In spite of Augustus John's extraordinary and at times irrational behaviour, the legend of his supremacy persisted through the war. He remained a fabled figure in Chelsea. 'I can see him now walking beneath the plane trees,' said Charles Wheeler.

He is tall, erect and broad-shouldered, wearing a loose tweed suit with a brightly coloured bandana round a neck which holds erect, compelling features. . . . He is red-bearded and has eyes like those of a bull, doubtless is conscious of being the cynosure of the gaze of all Chelsea and, looking neither to the left nor the right, strides on with big steps and at a great pace towards Sloane Square, focussing on the distance and following, one imagines, some beautiful creature he is intent on catching. . . .[10]

For many years John had been a regular exhibitor at the Royal Academy, mostly of portraits of the rich and famous. However heavy drinking had aged him greatly. In the Club drink changed him into a different person. At first it released his energies, his conversation becoming for a time sparkling and warm, with an intoxicating turn of phrase. But he soon became confused, and then he could be insulting or physically aggressive. In January 1929 the Club gave a dinner to celebrate his election to the Academy. John, who had already had a great deal to drink, was morose and silent; a number of his old friends tried to get him to speak but John refused. At one point he appeared to pass out and fall, but immediately jumped up and started to talk and was articulate and amusing. 'John is in ruins,' T.E. Lawrence had noted in 1932, 'but a giant of a man, honest, uncanny.' He did not admit to being an alcoholic, but

invented a variety of ailments, from lumbago to sinusitis, whose treatment relieved him temporarily of dependence on alcohol. One of the bathrooms in the Club had an inscription 'Augustus John slept here.'

In spite of the restrictions, it was a time of heavy drinking, and the Club survived as a social meeting place, part of a new Bohemia in post-war London. A mobile transient group linked the Club to a network of pubs and clubs in Chelsea and Soho. The Queen's Elm, nearest to the Club, the Pier Hotel, the Anglesea, the King's Head, the Australian, the Crossed Keys, the Eight Bells and the Pheasantry, all were crowded with the same group night after night. More distant relations were maintained with the Soho bars and clubs used by artists and writers, such as the Fitzroy Tavern and the Wheatsheaf to the north of Oxford Street, and the 'French' pub (the York Minster) in Dean Street. For an afternoon's drinking the Gargoyle Club in Meard Street had its own artistic integrity. The most reassuring sight on this circuit was the still energetic figure of Augustus John, 'like a great tree, swaying from one pub to the next.'[11]

On the last occasion that the Club gave a dinner for Augustus John, there was great uncertainty. Various dates were proposed but the great man could not be persuaded to agree to any of these. Eventually a date was selected and Arthur Upton drove down to Fryern Court to collect him. At the end of the dinner John was asked to speak. With great dignity he rose from his seat in the smoke-filled room and waited for silence. 'Beware . . . ' he said and sat down. After a long pause he rose again and continued ' . . . Abstraction.'

John's last years were mostly spent painting at Fryern Court, in the company of his wife Dorelia. He died there quietly in the autumn of 1961. His death was treated as a landmark. 'In a very real sense, it marked the close of an era,' recorded the leader-writer of the *Daily Telegraph*.[11]

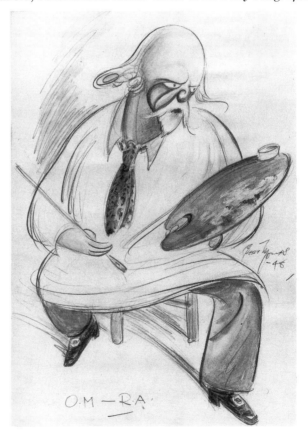

'Augustus John OM, RA', 1948, by Bert Thomas PS.

9 The Last of the Balls

The first Arts Ball after the war was held on New Year's Eve 1946. The theme was 'Renaissance' and more than four thousand people danced round the great centrepiece of a Phoenix: at midnight he was reborn, his eyes lit up, his giant wings were ablaze, rockets (impelled on wires) shot up to the ceiling and the balloons floated down. The costumes were bizarre; some barely existed. The students wheeled out their tableaux; one, built in two tiers, representing Heaven and Hell. On the top deck were a group of rather shaky angels in rakish haloes, tormented by demons with spiky tails and savage horns, who shook their tridents viciously. The figure of Joan (not Jonah) appeared in the mouth of a plaster whale surrounded by scaly mermaids. A very large and very pink plaster Venus rose from the foam in a piece called 'Bottichelsea' and a

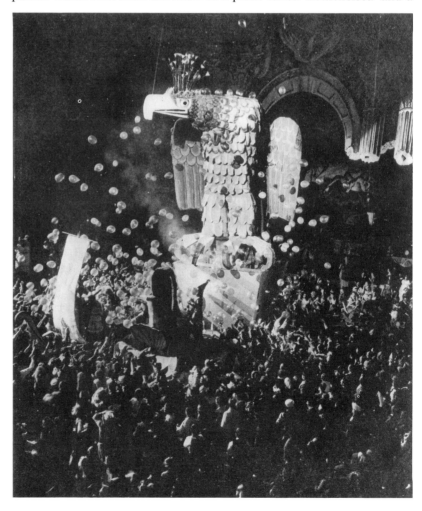

The balloons come down at midnight at the first Chelsea Arts Ball to be held at the Royal Albert Hall since the war. More than 4000 revellers danced around the giant 'Phoenix' designed by Frank Dobson RA.

110

group of nymphs on a Greek stage made another charming group. Following the established tradition, the tableaux were torn to pieces leaving a great deal of plaster and broken wood to be swept up by the stewards before the dancing could resume. As the new year was born, artists, models, art students, stars of stage and screen and an exuberant crowd rejoiced in one great glittering pageant; the first post-war Chelsea Arts Ball had captured its old carefree revelry. It was as if the war had never happened.

It was a post-war miracle that there was a ball at all, for the Albert Hall, which had been used for patriotic rallies during the war, had escaped major damage. The Club was anxious to restart the great occasion; discreet enquiries were made to find out if Sherwood Foster was again able to produce the Ball, for it was known that he was unwell. Sadly his wife reported that he was seriously ill and quite unable to take part. In fact he was past hope of recovery and died in October 1946. The extrovert sculptor Loris Rey, who was now extremely active in the Club, offered to take his place and became managing director of the Ball Company.

Loris Rey was a Scot from Kirkcudbright with a love of poetry and an extravagant attitude to life – his wit was as sharp as a needle. He had joined the Club at the outbreak of the war; within a year he was suspended for breaking the licensing laws by selling drinks at the bar door, but he soon became an indefatigable member, served on Council on a number of occasions and became Chairman in 1948. He was Librarian, Treasurer and for a time he was the turbulent Secretary of the Club; he even looked after the garden. Loris Rey was an ambitious drinker, as were many others as that time; he was also invariably rude to the younger members.

Frank Dobson RA with his model of the 'Phoenix' for the centrepiece of the Ball of 1946.

His first task, after taking over responsibility for the Arts Ball, was to assemble the team of artists and craftsmen, at a time of national shortages in post-war Britain. The Albert Hall was available but the rent had more than doubled. Delicate negotiations were required within the new licensing laws for a late extension: eventually one was granted until 5 a.m., never previously given at the Albert Hall. The great floor had been stored during the war and nobody knew what condition it was in, but it was tested and found to be in order. Forty men were required to erect it on its steel supports and the floor was then laid on a framework of springs for dancing. A.R. Thomson designed the huge backcloth for the first Ball, which was painted by A. Bilibin; the cost of his services, including five buckets of colour, tips and bribes, was £34.15s.9d. The centrepiece, 'the Phoenix', was designed by Frank Dobson and made at the Royal College of Art where he was Professor of Sculpture; it was built of timber, cloth and laths, with flapping wings and flames provided by ingenious lighting. The bands were engaged, the famous 'Blue Rockets' Dance orchestra directed by Eric Robinson, 'Felix Mendelssohn and his Hawaiian Serenaders' (with dancing girls) and 'Leslie Douglas and his ex-Royal Air Force Bomber Command Dance Orchestra'.

Balloons were a problem. Weeks beforehand exhaustive enquiries had been made, but because of wartime controls the production of balloons had been prohibited and none had been manufactured for some years. The Club was offered carnival novelties, but this would not do. After a great deal of trouble an emergency supply was rushed through by one of the manufacturers and the balloons, as ever, fell at midnight. The stunts were on a somewhat reduced scale, improvised by the Art Schools; the

Alexander Bilibin paints the backcloth for 'The Crystal Festival', designed by A.R. Thomson RA.

Royal College of Art produced a 'Dante's Inferno' and Hammersmith School of Art contributed 'Export Only'. Artists' models who took part in the stunts were expected to provide their own costumes.

The BBC again broadcast from the Albert Hall on New Year's Eve. As an experiment it was hoped to have a television broadcast from the Hall, but the less-than-sensitive cameras required extra lighting which would have spoilt the atmosphere of the Ball, so this request was refused; instead an interview at Alexandra Palace was presented for 'Picture Page'. Food was not up to the pre-war standard and the cost of drink had increased considerably. Vintage Champagne was in short supply and when available was now 59/- per bottle; the price of whisky and gin had been raised to £4.10/- per bottle.

After such a long absence the Press were uncertain as how to present the Ball to their readers. The costumes were discussed by the fashion writers. In the *Daily Express*, Patricia Lennard wrote; 'The most striking gown at last night's Chelsea Arts Ball was the one that was *not* worn by a nymph on one of the floats. Many of the evening gowns, in fact were barely there. Cleavage reached new depths, back and front. The strapless evening gown won by a neck and shoulders.'

Inevitably there were problems. A pipe band had been provided by the Irish Guards Battalion from Chelsea Barracks. Later, Loris Rey had to write a stiff letter of complaint to the Commanding Officer, saying that the band 'failed to carry out my instructions absolutely.' It appeared that the corporal in charge had reported to Rey in plenty of time and was instructed that on the stroke of midnight he was to play 'Auld Lang Syne' as the band marched through the Hall. At the appointed time, and to everyone's astonishment, he played some unknown air and marched his men out of the Hall and into the street. Rey suspected that this irresponsible action might have had something to do with the amount of refreshment the men had taken beforehand and it produced chaos at a critical moment in the evening.

Whatever may have taken place in the deeper recesses of the Hall, public displays of nudity were not permitted, though one incident at this Ball was a portent of things to come. A letter was received by London County Council addressed to 'The Department of Public Morals'. A lady wrote: 'at a recent gala New Year's Eve night at the Chelsea Arts Ball women were openly mixing with the throngs *quite naked*. I have always understood this sort of thing was an offence against the Law. Will you please communicate with me on this point, and if I have not written to the right department, will you kindly forward my letter to the right quarter?'[1] The outraged lady was complaining about a stunt that had been produced by the students of Goldsmiths' College which included two nude models and which had been arranged by Joseph McCulloch, who taught there and who was one of the less respectable members of the Chelsea Arts Club. The stunt was 'Burning Heretics' in which two women, the heretics, were to be surrounded by students in costumes representing flames. McCulloch had insisted that he intended to employ a model called 'Bing', and that she would be nude, but Loris Rey said quite categorically that she must not be. On the night of the ball two nudes appeared on the stunt, which toured around the hall. The police took the names and addresses of the women and informed the Directors of the Ball Company that this was against the law. The Club was forced to take this matter seriously for they feared that a prosecution might endanger the future of the Ball. It

The stunt 'Burning Heretics' by students from Goldsmiths' College of Art with two nude models. Publication of this photograph was suppressed.

appeared that McCulloch had instructed the girls to appear nude and that he had boasted beforehand that he had 'squared the police'. For this McCulloch was suspended from the Club for three months, but there was no prosecution.[2]

And so the Chelsea Arts Ball settled into its role as the greatest party of the year. In 1947, Picasso had been invited to design the backcloth for the theme 'Baroque', but he refused and the decoration was put in the hands of Edward Ardizzone who designed the 120ft. cloth to hang in front of the organ. The centrepiece was a towering figure of the great god 'Pan' designed by William McMillan RA, who was very much in the news as he had recently designed the Victory Medal and his memorial to Admiral Beattie was about to be placed in Trafalgar Square.

Organizing the huge affair that the Ball had become occupied about six months; towards September there was a steady intensification of effort, involving hundreds of operatives, conferences on music, lighting, sound and (very vital) catering. Offices and staff were organized in readiness to deal with the applications for tickets from people all over the country and from many parts of the world. In their studios and schools, the artists and art students of London were busy making their costumes, constructing fearsome creatures in cardboard, and designing the elaborate movable tableaux on which the students of the different art schools, each seeking to outdo their rivals in imaginative and fantastic effect, rode in triumph into the arena. Everything connected with the Ball was on the same outsize scale. There were five bands, with more than 100 musicians, and nearly 400 performers who took part in the entertainment. Finally a small army of men was employed to lay the 16,000 square feet of dance floor which covered the vast arena.[3]

Stephen Spurrier ARA designed the backcloth for the 1948 Ball, a huge figure of Henry VIII overshadowing the pageantry and pleasures of the Thames. The theme was 'London River' and the centrepiece was an illusionist sculpture of Father Thames, surrounded by fishes and mermaids, which revolved and was illuminated to look like water. Among the dancers, mermaids were also much in evidence, for the film 'Miranda' had recently been shown.

The Ball, like all the others, was planned with military precision. The evening started at 10 p.m. with dancing to the massed bands, reinforced

The theme for the Ball of 1947 was 'Baroque'. The centrepiece of 'The Great God Pan' was designed by William McMillan RA.

by the great organ. Then the big bands of Oscar Rabin and Ted Heath took over. As midnight approached the lights slowly dimmed, leaving the arena lit by a deep green ripple of light and at two minutes to midnight 60 stewards from the Old Blues Rugby Club cleared the dancers from the floor, to allow the Pipers to march in playing a skirl. They waited in silence for the first strokes of midnight from Big Ben and with each stroke extra arc lights played on the floor, the backcloth and the centrepiece. At the final stroke the Pipers, the massed bands on the stage and the great organ struck up together with 'Auld Lang Syne'. They played it again at double tempo and at full pitch; the auditorium erupted with applause and the balloons descended from the dome of the Hall. Within minutes it was time for the stunts to come on. The first was Hammersmith School of Art with 'the Fiddling Ferry', while the band played 'the Ferryboat Serenade' and coloured spots picked out the decorated float and its costumed attendants. To another fanfare Bartlett School of Architecture brought in 'London Pool' and the orchestra played 'What Do You Do With A Drunken Sailor?', and again all the crowd joined in. Then it was the turn of the Croydon students with 'Greenwich Observatory', followed by the Harrow students with 'Medieval River' to the tune of 'I am Henry the Eighth I am'. At half past midnight, the Pearly Kings and Queens arrived in their decorated costumes, a tradition from before the war. They made a circuit of the hall to the tune of 'Lambeth Walk' and 'Knock 'em in the Old Kent Road'. Then the students, the musicians and the revellers all joined in the dancing. At 5 a.m. the massed bands, conducted by Ted Heath, played the theme of the evening 'Old Father Thames' and the colour of the stage gradually changed from amber to red and finished on a deep warm pink.

It was a joyous and happy time but there was an undercurrent of violence not previously noticeable. Social pleasures were taken greedily

amid the continuing rationing of the post-war slump. The art students were men who had served in Normandy and in the desert and their girlfriends had driven ambulances in the London blitz. Boisterousness more quickly led to aggressive behaviour. John Moynihan, the son of the painter Rodrigo, went to the Ball of 1948. He was then a schoolboy and he came as a spectator with his friend Keith Critchlow. From their high viewpoint in the gallery, the two young men watched the swirling floor, and the devastating effect of drink on the dancers. With a more cynical eye, John Moynihan wrote his own account.

And then it was the midnight hour and the crowd swept back by the stewards awaited a new year with a ravenous, knock-kneed lust for destruction, the stewards throwing a rope across the bellies of the front ranks and holding them back with linked arms.

Everything seemed to happen at once, the bells of Big Ben chiming midnight, the cheers of the mob, the skirl of pipes, 'Auld Lang Syne', the crowd merging, locking together, lips pressed on lips, the arrival of the absurd floats rolling awkwardly into the hall, the crowds breaking the barriers, fists exploding against jaws and stewards rugby-tackling giggling drunks, squalls of anger, women screaming, the floats being smashed, a nude art student held aloft suddenly falling into a twisted mass of fighting bodies, screaming, her breasts losing their protective covering of twinkling beads, rolling as she fell awkwardly into the mass, screams and shouts, the crowd coming on towards Father Neptune. A steward raced after a youth, caught him by the trousers, tearing them almost off, lay on top of him bashing him. The noise was hellish, the hall almost torn apart; people surged into people, wood splintered, floats were ripped up and the wreckage dragged across the floor, destruction took top priority. Skulls smashed against skulls. . . . 'Happy New Year,' I said to Keith. We shook hands.[4]

These displays of aggression had not occurred in the pre-war days and stewards were instructed to be 'vigilant for any unseemliness or ruffianism or serious disorder. Tact and persuasion must be exercised to control the offending parties.' They had to work hard to prevent anyone from climbing onto the centrepiece or the band platform, or interfering

The pipers lead in the procession of stunts at the Ball of 1948.

*The Ball of 1950. A.R.
Thomson RA (seated), with his
design for the Ball 'The Crystal
Festival'. This was to be
painted as a backcloth 144ft
long and 65ft deep by
Alexander Bilibin (standing).*

with the decorations. To clear a space for the stunts the stewards circled the area with a sturdy white rope, and they were advised 'in gaining this space good humour with firmness is of the greatest value.' However in the euphoria of the midnight celebrations there was always a rush to dismember the floats and this was when problems occurred.

The Press seized on any incidents of rowdiness and the opinion soon formed that the Ball was no longer respectable. In order to promote the Ball and to remedy this impression, Loris Rey brought in a public relations adviser, E. Lindsay Shankland, who tried to build up general interest by an intelligent plugging of stories and pictures to the London and Home Counties Newspapers and the picture magazines. Although space was still limited in the national dailies, the Ball was always a good pictorial subject and for days the national press carried photographs of girls in costumes, students preparing the floats, artists working on drawings for the Ball and so forth.

In 1949 the theme was 'Weather Cock'. The stewards were prepared for a repetition of the hooliganism of the previous year and no chances were taken, but it was not such a rowdy party. Robert Newton was there in grey flannels and a blue shirt topped by a tea-caddy; Ann Todd in a Spanish costume with her husband, the film director David Lean; Frances Day, Peggy Ashcroft and 'Two Ton Tessy O'Shea' as Bo-Peep. The floats were hauled rapidly round the hall in the midnight procession, closely guarded by rugby players from the 'Old Blues', wearing pirates' garb, and eighteen Beefeaters from the Corps of Commissionaires. The exuberant audience could only take vengeance on the balloons. At 1.45 a.m. the last float from Croydon Art School appeared, a fifteen-foot-high Chinese pagoda carried by eight lusty lads with a scantily clothed girl student as a Sun Goddess. She held grimly on to her headress and they were allowed to make a double circuit of the floor without incident, but as soon as she dismounted her pagoda was wrecked by the crowd. As the Ball ended William Lake,

the Ball secretary, who had attended 23 previous Arts Balls, said 'this is the best-behaved crowd we have ever had. Everything went off like clockwork.'

By 1950 all London was talking of the forthcoming 'Festival of Britain' and with the theme 'The Crystal Festival' the Ball re-created the 1851 exhibition. A sumptuous backcloth of the Crystal Palace by A.R. Thomson dominated an entire side of the Hall, and the costumes and the tableaux were free adaptations of Victoriana. Girls dressed in wide-hooped skirts and bodices, except that the skirts were transparent and the bodices minimal. Hammersmith School of Art constructed an 'Emmett Railway' train carrying a bevy of young Victorians and current interest in flying saucers was shown by the St Martin's float 'Global Visitors', with horned devils of both sexes.

For the first time since the war, New Year's Eve fell on a Sunday, so the Ball was held on Friday 29 December. As in pre-war years there was strong opposition to holding the Chelsea Arts Balls on a Sunday and so it was customary to avoid Saturday or Sunday nights. By comparison to the success of the previous Balls, this was a very subdued affair. The Superintendent of the St John Ambulance Brigade, John Ownes, who had attended every Chelsea Arts Ball since 1912, said it was the quietest and most orderly he had seen. 'We have had only twelve people needing attention, in previous years our first aid room has been packed with an overflow in the corridor.' As this was no longer a New Year's celebration, only half the tickets were sold; as a consequence, for the first time in its history, the Ball made a catastrophic loss.

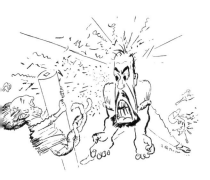

'Loris Rey with Alexander Bilibin' by A.R. Thomson RA.

However by the following year all appearance of austerity had gone. The theme of the Ball was 'Huntin', Shootin' and Fishin'' and the backcloth was more splendid than ever, designed by John Minton and painted by Alexander Bilibin in a church hall in Chelsea, armed with 36 brushes and six hundredweight of paint. Hounds and huntsmen, dinosaurs and fishes, a plenitude of mermaids and sea anemones paraded around the floodlit dance floor. John Minton invited a group of his friends and fellow teachers from the Royal College of Art, including Rodrigo Moynihan who danced in a white linen suit, red and white spotted handkerchief and a bandolier. Two tons of chicken, 50 York hams, half a ton of sirloin of beef and several hundred pounds of fresh salmon went to prepare the suppers served by 200 waitresses in the boxes and gallery. At midnight a huge figure of 'Diana the Huntress', made by Colin Corfield, descended from the roof and the balloons came down. A thirty-foot-high canvas and plaster elephant, with an exuberant party of students on its back, would not leave the dance floor. Time and again Hammersmith School of Art students tried to push it through the exit door, but a tussle started which ended with the destruction of the great beast. The Ball was one of the most genuinely enjoyable of all and was almost incident-free.

By the mid 1950s the Chelsea Arts Ball was the most scandalous social event in the calendar, known for its colour, imagination, gaiety and sexual license. The press loved it, they photographed the preparations and the scantily clad girls and they exaggerated its excesses to brighten the otherwise dull period of the holiday season. Everyone who attended it retained his own memories. Laurie Lee, a long-time member of the Club, had his own romantic view of the Ball:

It slipped in just before the so-called permissive age began, spoke too soon and was slapped down by the authorities. Orgiastic floats used to come sailing round the

*The Ball of 1951. 'Huntin',
Shootin', Fishin'', designed by
John Minton RBA.*

ballroom covered in girls from banks in cheap tulle from the Co-op, pretending to be slave girls, the floats pushed by fine-looking muscled men. And at midnight a shower of balloons came down from the dome which was a signal to rip the netting off the girls and carry them kicking and screaming to lay them in the loggias. . . . Perhaps our memories are wish-fulfilling but I seem to remember everyone as half-naked.[5]

*The Ball of 1951. Students
from St Martin's School of Art
with their stunt 'Deep Fish'.*

The Ball of 1953. The theme was 'Fun' and the decorations were designed by John Minton RBA and James Fitton RA.

For the year of the Coronation the theme was 'Happy and Glorious'. In spite of the unruly audience it was one of the most colourful balls. The huge backcloth, the work of A.R. Thomson, depicted in brilliant colours the lion and the unicorn 'Fighting for the Crown'; high above the crowd, draped in crimson, were four golden crowns. The fanciful medieval archway which occupied the centre of the dance floor came to life at midnight. The centre pinnacle, 45 feet above the crowd, rose upward to reveal a gilt and tinselled sculpture of a woman dressed as a queen. 400 performers took part in an entertainment produced by Loris Rey.

With more materials now available, the Art Schools' tableaux were more splendid than any seen before. Leading the parade was a jaunty galleon with Nelson on the bridge accompanied by American seamen and Spanish contessas, made by students of the Bartlett School of Architecture. The craft was boarded by raiders as it passed from the arena and largely demolished by the time it reached the exit. The Architectural

Association students arrived to the accompaniment of post-horns, in an Edwardian motor-car with a sportsman at its wheel and a suffragette by his side. The Chelsea students, wearing outsize heads, represented the characters from *Alice in Wonderland* and a decorative tram-car was filled by the Hammersmith students. The press described it as the rowdiest Arts Ball for years. Despite a ring of white-jerseyed stewards, none of the tableaux was allowed to circuit the floor before being smashed and what the *Daily Mirror* described as 'hand to dress fighting' broke out all over. 'One girl who had been wearing a strapless evening gown was soon wearing a gownless evening strap.' Stretcher-bearers had to take away the casualties.

The theme for the Arts Ball of 1953 was 'Fun'. Adrian Bury contributed a piece of poetry for the programme, as he did every year:

> Old Time is on the Wing Away,
> The year is nearly done,
> So Let Us Dance and Sing and Play,
> The last hours fill with FUN!

The decor was by John Minton and James Fitton and depicted a Venetian Carnival in which a multitude of renaissance figures enjoy a great parade. It was set on a stage, the curtains supported by caryatid figures. A stork in flight carried the newly born year (but this time a painted baby, not a real one). In the hall, revellers danced beneath clown-like faces and other mobiles suspended from a great carousel. This Ball was successfully filmed for television and for British Movietone News. The TV cameramen, who were broadcasting live, found that they had to be very selective in their choice of subjects, as the appearance of some of the revellers was by no means suitable for family viewing. But the Ball had entered national life. All of the newspapers and press agencies sent reporters and photographers and even 'Mrs Dale' went to the Ball in a script devised by Jonquil Anthony for 'Mrs Dale's Diary'.

There were still those outbreaks that had marred other Balls. From the box that Minton was sharing with the Moynihans and others, they saw a steward begin to beat up a reveller. One of Minton's friends, Richard Chopping, went down to protest and was beaten in his turn; another friend, Norman Bowler went to help and received a kick in the face which broke his jaw. He was taken to hospital by ambulance but was able to return to the Ball.[6]

For the following year Ronald Searle called upon all of his powers of invention. The décor was even more sumptuous, on the theme 'The Seven Seas'. In a ghostly dance, weird sea monsters, giant spider crabs, mermaids and octopuses swung slowly above the heads of the dancers, illuminated by multi-coloured lights, whilst a giant King Neptune held court with his mermaids in the centre of the sea-bed. At midnight the First Battalion of the King's Own Scottish Borderers marched in with drums and pipes playing and were given their usual great welcome. Because of the violence of previous years, no decorated floats were wheeled around the ballroom, but students paraded in strange and varied costumes.

At a time of reconstruction, in 1955, the theme 'Bow Bells' had a topical significance. Bow Bells had not rung since 1941, when they were destroyed by enemy action. The Lord Mayor of London was invited to the Ball as part of a fund-raising effort to replace the bells. In the centre of the

Costumes at the Ball of 1956. The theme was 'Primavera'.

floor was a thirty-foot model designed by A.R. Thomson in which four spirits, symbolizing London's re-emergence from war-time destruction, rang the bells at his arrival. Again this was a noticeably quieter affair because the Ball took place on 30 December, not on New Year's Eve, and there was no midnight climax. Nor were floats used because of the problems in previous years. However the Art Schools staged tableaux on London themes, 'Oranges and Lemons', 'Trafalgar Square's Lions', 'Dolphins and Pigeons' and 'Goon Fish Porters'. The grim theme 'The Plague' was chosen by Hammersmith School of Art. Every effort was now being made to quell the riotous behaviour of the crowd. The theme of the Ball for 1956 was 'Primavera', based on Botticelli's painting of Spring, but the newspapers called it 'the Rock and Roll Ball' because to foil the drunken attempts to wreck the tableaux, the orchestra immediately went into a Rock and Roll number. By now there was a distinct feeling that the Ball was running out of steam.

The theme for 1957, 'Forty-Nine Candles', was intended to celebrate the anniversary of the first large-scale Ball held at Covent Garden, 49 years before. The surrealist imagination of Gerard Hoffnung conjured up a menagerie of grotesque musical animals, hanging from the roof of the hall above the dancers: a twisted centaur, an elephant ecstatically blowing through its trombone trunk, lions beating their tummies as drums and a Sputnik tuber, all part of an outrageous orchestra conducted by a grotesque figure of Sir Malcolm Sargent.

The last of the great New Year's Eve Balls to be held in the Albert Hall was in 1958. This was still the period of the London 'pea-soupers' and on the night of the Ball, England was enveloped in a terrible fog. Public transport was brought almost to a standstill, flights were cancelled from abroad and those coming by road from any distance were considerably delayed. The hall appeared to be very empty. The theme was 'Golden Jubilation' and Felix Topolski decorated the hall with charming and irreverent representations of well-known personalities. Every attempt had been made to quieten the crowd, but it hardly seemed necessary. There were no floats; instead students from the Art Schools wore bizarre costumes which were paraded on a stage ten feet high, out of reach of the dancers and greased to prevent students from climbing up on it. But in spite of these precautions there were some fights, and at 3.45 a.m. someone let off an RAF smoke canister and the Albert Hall was filled with sulphurous smoke.

However it was neither nudity nor violence that felled the Balls, it was finance. Immediately after the war the Balls had been financially successful. In 1946 it was found that all the expenses had increased; for example, payments to the Hall were about £9000, just about double what they had been before the war. But with tickets in great demand the income had also doubled, the Ball made a healthy profit and it was possible to hand over £1500 to the Club. The next two years were similarly profitable and each year £1250 was given to the Club. But in 1949 the profits dropped to just over £1000 and only £250 could be paid as a dividend.

When the Ball was held on 29 December, in 1950, it was a financial disaster with a loss of £4464. In the years that followed it was a battle to keep the Balls going. In some years there was a small profit, in others a loss, but on only two occasions were dividends paid to the Club. All efforts

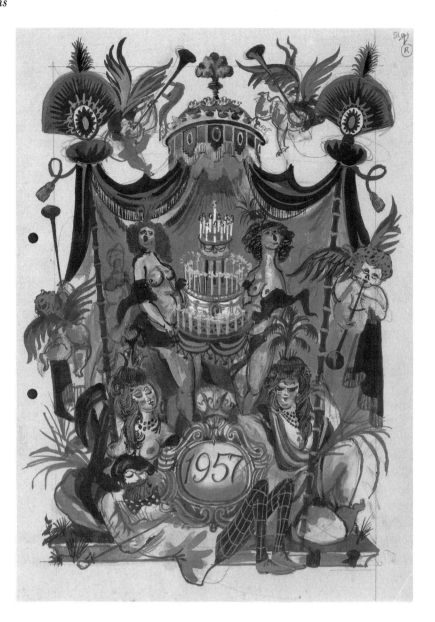

*Programme design for the Ball
of 1957 by Anthony Helliwell.*

to economize or to increase the price of tickets were made, but this
resulted in smaller attendances and the losses continued. For the last four
years, from 1954 to 1958, the Ball lost between £1000 and £2000 each year.
Finally, with great reluctance, the decision was taken to suspend the
Balls.

Loris Rey gave a troubled interview in the Club in September 1958,
after the decision had been taken not to continue with the Chelsea Arts
Balls at the Albert Hall. He was described by the interviewer as 'a
stubble-chinned, Roman-nosed sculptor and conversationalist, like
"Gulley Jimson" in *The Horse's Mouth* whom he strikingly resembles.'

'We're doomed,' Rey said. 'The notice to quit is nailed on our doors. We can't afford
Chelsea any more. The studios are coming down to make lodgings for technical
students. Civilisation is moving west as it always does. . . . We meet here of course.
And sometimes in pubs. But we don't stay in one pub long. Otherwise the queer
men and queer women start following us. Then we go out like a snuffed candle.
Artists are essentially male. We have to be with real people.'[7]

Over the years the organization of the Balls had been in the hands of a
small group of senior members of the Club, including at various times

The Chelsea Arts Ball 1958. The theme was 'Golden Jubilation' with decorations by Felix Topolski. View of the dance floor after an RAF smoke cannister had exploded.

W.S. Causer, E.R. Bevan, Henry Rushbury and others. The only salaried member of the Company was the Managing Director, Loris Rey, and it was his death in 1963 that finally removed any likelihood of the Balls being continued in the near future. However, the Company, Chelsea Arts Ball Ltd. continued to be in existence and each year the directors discussed ways in which the Ball could again be promoted.

10 Changes in Chelsea

Chelsea was a village in retreat, washed by the strong currents of change and powered by money. A wave of upper-class prosperity was moving westwards, pushing through the quieter squares and working-class terraces in search of attractive flats and dinky little houses. These were immediately refurbished with bright paint, swinging flower baskets and white-washed walls. The King's Road became a stalking-ground for the rich young marrieds. A new type of Chelsea resident appeared, dressed in a mixture of the City and country casual, who spent the weekends drinking on the pavement outside the King's Head and the Eight Bells, noisy and undisciplined. They worked in the media, advertising, or in public relations. In their skirmish with commercial forces the artists had lost their studios, which were turned into six-storey blocks of flats. They moved out to Fulham or Hammersmith, no longer walking distance from the Club. When legislation against drinking and driving was introduced, car use became more awkward and the cost of a taxi was an added expense to a night's drinking. Chelsea Council did its best to help artists by putting new studios on the roofs of the working-class flats, but this was a token gesture only, and soon the phrase 'studio flat' became a trade term for a cramped single-room apartment. The flood continued past the Club and on to World's End, where rubber plants and Chianti bottles sprouted from every basement and fishermen's sweaters and peasant skirts shared the laundrette with teddy-boys.

In a piece of destructive humour, Bevis Hillier in the *Sunday Telegraph* magazine examined 'the chic studio life'. He found that the studio built by Augustus John in 1913 as 'a cure for restlessness' was now a backcloth for the active social life of its owner, Mrs Hamush Bowler, an Iranian, who had turned one end of the studio into a copy of her family's hunting lodge in Persia, hung with Islamic art. 'It is more poetic to live in a studio and I love to give parties. I like to think he would enjoy coming here now,' she said. Another of the great Chelsea studios at 44 Tite Street had been designed in 1878 for Frank Miles, a friend of Oscar Wilde. It was later owned by G.P. Jacomb-Hood, who fixed heavy hooks and pulleys to the beams to hang large canvases that were too big to be put on easels. With its Japanese-style staircase and vast inglenook fireplace, it converted beautifully into a large family house.

In spite of the changes around it, the Club retained its prestige and in the immediate post-war years it was deluged with applications for membership. A selected list of those applying in 1949 included the following. (The comments are from their supporters in the members' book.)

Edward Ardizzone – 'most social and entertaining painter' said Anthony Gross.

Frederick Brill (later Principal of Chelsea School of Art) – 'excellent painter'.

Sigfried Charoux, supported by Henry Rushbury.

Colin Hayes, then teaching at the Royal College of Art.

Bernard Hailstone.

Morris Kestelman, painter, lithographer and stage-designer.

Laurie Lee – supported by Robert Buhler.

Rodrigo Moynihan.

Edwin la Dell.

Edward le Bas – 'well known to most members of the club'.

Henry Lamb.

John Minton, described by Ruskin Spear as a 'really good chap'.

Henry Moore (a re-application) – Charles Wheeler said that as a social mixer he had found him easy and affable. 'He had exhibited almost everywhere except at the RA,' said Frank Dobson.

John Nash – 'a clubbable friend'.

Adrian Ryan, 'a charming personality and, according to Robert Buhler, 'a very good painter'.

Lawrence Scarfe – 'fine chap'.

Ronald Searle.

Ruskin Spear.

John Skeaping – Loris Rey had known him for twenty years, first as a Rome Scholar where he married Barbara Hepworth.

John Ward.

Carel Weight.

F.R.S. Yorke the architect – 'a splendid addition to the Club'.

These artists represented a new element in the Club in contrast to the older academicians. They were part of a generation who were young and enthusiastic, yet tempered by the experience of war and impatient to make up for the time lost. Some of these became long-time supporters of the Club and were the nucleus around which its post-war character was formed. Among the most prominent were those who were associated with the Royal College of Art.

When the Royal College of Art returned from its wartime retreat in Ambleside, only the most basic repairs had been made to buildings that had been severely damaged during the war. The Exhibition Road premises had been hit by a flying bomb in 1944 and the Queen's Gate sheds were turned into builders' huts for the duration. There was talk of a fine new building to be built alongside the Royal Albert Hall, but this was many years away. The conditions in these improvised buildings were anything but comfortable and the staff would meet in one of the local pubs or preferably the Chelsea Arts Club.

The appointment of Robin Darwin as Principal in 1948 gave impetus and direction to the College. He was a descendant Charles Darwin and Josiah Wedgwood and already a member of the Chelsea Arts Club. He had earned a reputation as an innovative educator at Eton College, where he had been educated and where he later taught art, and as Professor of Fine Art at Durham University. He was a born clubman, a gourmet who took regular gastronomic trips to France and knew a great deal about wine. His first years at the Royal College were spent in a major restructuring; Carel Weight described him as a 'dynamo'. He started by sacking the whole staff and selectively reappointing some, ruthless but successful surgery which brought the School again into a central position in art and design training.

Rodrigo Moynihan became a member of the Chelsea Arts Club in 1949. He was then living close by at 155 Old Church Street with his wife, the

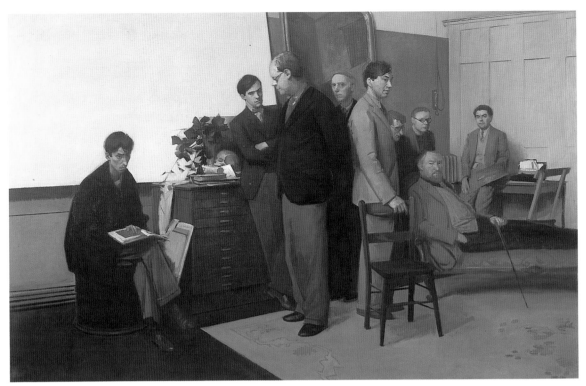

In his group portrait of 1951, Rodrigo Moynihan portrays the teaching staff of the Painting School of the Royal College: (from left to right) John Minton, Colin Hayes, Carel Weight, Rodney Burn, Robert Buhler, Charles Mahoney, Kenneth Rowntree, Ruskin Spear and (on the far right) Rodrigo Moynihan himself. Almost all of these were members of the Chelsea Arts Club and some were to remain among the most prominent.

distinguished artist Elinor Bellingham Smith. He had moved to Old Church Street at the conclusion of the war, when it still bore the evidence of recent bombing. In 1948, then thirty-eight years old, he became Professor of Painting at the Royal College of Art.[1]

Moynihan was from a cosmopolitan background, his father was Irish and his mother's family was Castilian. His early years were spent in Tenerife where his father was a fruit-broker. He trained at the Slade School and was a contemporary and friend of William Coldstream, Victor Pasmore and Claude Rogers, and with Pasmore and others produced some of the most uncompromising non-figurative paintings made in England in the early 1930s. He was also involved with them in the Euston Road School, where he taught in the evenings. In October 1939, he was called up and became a gunner in a signal training regiment. He wrote 'I have misgivings in my ability to cope with the morse code and the insides of motor cycles . . . it is all supposed to do me an immense amount of good, only really I prefer to be bad.' After two years' service he was invalided out and commissioned as an official war artist, producing a number of portraits of high-ranking army officers, as well as one of the best-known portraits of an unsung war-hero, *Private Clarke ATS*, now in the Tate Gallery. He also painted a wry comment on the indignities of army life in *Medical Inspection*.[2]

His portraits exhibited at the Academy had attracted attention and in 1944 he was elected ARA. In 1953 he was awarded the CBE and became a Royal Academician in 1954. He was widely travelled, a great reader, with a visual appetite second to none. In his teaching and in his appearances at the Club he was talkative, friendly, argumentative and at times hilarious.

For almost ten years he was a central figure at the Royal College, a pivot about which others turned. The circumstances of his life changed abruptly when in 1957 his marriage was dissolved. At the same time he left the Royal College and resigned from the Royal Academy (however he was re-elected in the following year). To complete this circuit of change

he left London for France, where for a time he lived on the Côte d'Azure and later in Paris. For many years portrait painting was abandoned and his work became increasingly abstract.

John Minton had gone to the Royal College to teach in the same summer of 1948 as Moynihan. They had known each other as teachers at the Central School of Art. John Minton has become, in retrospect, an archetypal figure of the war-torn generation. He was extreme in all that he did and was a prominent member of the Chelsea Arts Club, up to the time of his tragically early death. He said little about his childhood, although it is known he had two brothers, one of whom was mentally handicapped and the other killed during the D-Day landings. He had trained in art at St John's Wood School where he met Michael Ayrton who became a close friend. Together they spent a year in Paris where they became fascinated with the late flowering of the Surrealist movement that was affecting painting and the decorative arts at that time. At the outbreak of war Minton registered as a conscientious objector, but then suffered a change of conscience and served in the Pioneer Corps until he was discharged for homosexuality. During these war years Minton's extraordinary power as a draughtsman began to flower in the form of densely worked drawings which owe a great deal to Samuel Palmer. Minton created a personal vision of an idyllic and luscious rural England, which he contrasted with the ruins of bombed London; both dream landscapes are peopled by the same somnolent, emaciated figures.[3]

The Chelsea Arts Club was for John Minton part of that frantic circuit of activity that included the Gargoyle Club in Soho, the Colony Rooms, and the pubs of Fitzrovia and Chelsea. As his friend Keith Vaughan recorded:

> Johnny's use of life might be compared to a Tibetan's use of a prayer wheel. A circuit of activity is revolved with monotonous persistence in the simple belief that disaster can thereby be avoided and some lasting gain can be tasted. But the revolutions are so quick that nothing can be grasped or savoured.[4]

Minton was never short of money, for a generous allowance from his grandmother was supplemented by his teaching and by a continuous flow of commercial work. He had great magnetism, he could be astonishingly captivating, perceptive and witty, and his outgoing personality put him at the centre of a pleasure-seeking crowd. His taste for high life and night life was much reported in the Press although at this time his homosexuality could only be inferred.

Minton was not the first homosexual to be a member of the Chelsea Arts Club, but he was probably the first to make this blatantly apparent. Because of this he was not liked by many of the older members who refused to talk to him and on occasions were directly insulting. One senior member entered the bar when Minton was present and said in a loud voice, 'I smell buggery here', turned and left. On another occasion Minton was criticized for bringing 'one of his sailors' into the Club. Minton wryly commented that had the sailor been wearing an Admiral's uniform instead of a rating's, his friendship would have been a matter for congratulation. The extent of the personal prejudice shown to him was most marked in relation to the Royal Academy. He was a prodigious worker and exhibited regularly at the Royal Academy from 1949, but his work was badly hung and much criticized. He had shown a large painting called *The Harbour* which Sir Alfred Munnings, then President, singled out for attack in his Banquet Speech, the first to be broadcast by the BBC. Munnings described it as 'an awful thing, just juggling about copying

'Self-Portrait with Gun and Bottle' by John Minton. A sketch from one of the Arts Balls designs.

others, it wouldn't even make a good poster.' Nevertheless Minton dearly wished to become a member of this exclusive club and continued to exhibit. On more than one occasion he knew that his name had been put up for membership; he waited anxiously for news of the elections and was each year disappointed.

The best examples of his work are decorative drawings closely associated with their purpose, such as his excellent illustrations to Elizabeth David's *A Book of Mediterranean Food* or for *Coral Island*. To these must also be added the decorations for several Chelsea Arts Balls, including the wonderfully light-hearted drawings for 'Huntin', Shootin', Fishin'' of 1951 and 'Fun' of 1953. Then there were the parties at the Club. The fifties jazz band 'the Temperance Seven' had some of its first engagements here. The billiard tables were taken down and members decorated the room in an impromptu manner. John Minton painted a huge frieze which was hung from the balcony and a fight broke out afterwards when members disputed as to who should take it away with them. To quote Keith Vaughan again:

He was profligate with everything – with his affections, his money, his talents – and with all his warmth and charm essentially destructive. He turned everything into a joke and a subject for laughter. People never stopped laughing in his presence. 'What does it all mean?' he would repeat year after year, without really wanting to know the answer.

The end came for Minton with astonishing suddenness. He was a highly complex emotional character; his hilarity could be quickly replaced by black despair, rejection and isolation. He had become increasingly dissatisfied with his reputation as an illustrator and wished to be taken seriously as a painter. At the same time major changes were happening in the world of art around him, which he felt distanced him from the most progressive movements. The attention of the world had focussed on the new American painting, shown comprehensively in London in the summer of 1956 at the Tate Gallery in the exhibition 'Modern Art from the United States'. In that year Minton gave up his teaching at the Royal College of Art; he was openly despairing of his kind of art and confessed that he was giving up painting. To those who saw him during the last days of his life he offered gifts of paintings and drawings with embarrassing persistence. It is said that he had also suffered from the loss of his current lover to the barmaid of one of the Soho clubs. He drank heavily for several days and the last evening of his life was spent in a corner of the bar at the Chelsea Arts Club, his head in his hands. On 22 January 1957 he was found dead in his home in Apollo Place, Chelsea. The Coroner's verdict was suicide from an overdose of barbiturates.

Carel Weight was born in Paddington, London, and educated at a Board School for very poor children and then at the Sloane Secondary School, Chelsea. His mother was partly German, his father an unhappy man who felt trapped by his job as cashier in a bank. For much of his young life Carel Weight was brought up by foster-parents who lived in the most derelict areas of Chelsea and Fulham. It was these images of the menacing city landscape, endless streets and cold pavements, the child's memory of decaying gardens and struggling vegetation, that he drew upon as the background for the figures of his imagination, who appear to be involved in some violent activity, full of partly explained horror.

He trained at Hammersmith and Goldsmiths' Colleges of Art. His first exhibited picture, at the Royal Academy Summer Exhibition in 1933, was

'Self-portrait'
by Carel Weight RA.

prophetically called *An Episode in the Childhood of a Genius* and described the perilous ascent of a small boy to the top of a pub sign, watched by an anxious crowd below. On the basis of this Henry Carr, then Head of the Beckenham School of Art, offered him two days' teaching a week, a post which Weight continued until 1942. He soon established a modest reputation, although he suffered one staggering reversal when, in the blitz of 1941, his studio in Shepherd's Bush was totally destroyed and all of his paintings, with the exception of a few works out on exhibition, were destroyed. His early wartime career in the Royal Armoured Corps was not distinguished. He described himself as 'probably the worst conscript in the history of the British Army'. In the post-war period, still in the army, he became an official war artist with the rank of captain and for a year drew and painted in Italy, Austria and Greece, recording the ruins and devastation of war.

He joined the Chelsea Arts Club in 1949, supported by Harold Workman who described him as 'a quiet reserved type of person and a successful artist'. In the Club Carel Weight was an observer, quiet, composed and sometimes quizzical. He served for a time on the Council and was frequently in the Club, but he did not identify with the ruling clique and did not become involved in committee work.

In 1957 he became Professor of Painting at the Royal College of Art, in succession to Rodrigo Moynihan. He was a popular teacher, strongly of the opinion that each student possessed an individual vision which could develop without prescribed rules, a view strongly supported by his first group of students which included Peter Blake, David Hockney, Ron Kitaj and Alan Jones. In 1955 he was elected ARA and ten years later Royal Academician; since that time he has played an important part in the affairs of the Royal Academy. He has also received many honours, most notably the CBE in 1962.

As Chelsea identified with the 'swinging sixties', so the Club appeared to be out of fashion, a remote island distant from the artistic changes that flowed around it. Many of the better-known artists who had joined in the post-war years were no longer members and there was a distinct absence of those younger artists who were now achieving prominence in London's art world.

Nevertheless, for those who used it, the Club remained a homely and friendly place. The successful portrait painter Henry Carr became Chairman in 1964; he always sat in the same place, tapping his pipe; to some he appeared rather pompous. His friend Henry Holt would try to take him down a peg. On one occasion Carr was talking about a holiday in Scarborough in his younger days when he 'had his bumps felt' by a phrenologist, who told him that he would be a good greengrocer. 'Not so far wrong' said Henry Holt. Such criticisms were easily ignored by Carr, who had a high opinion of himself. When complimented on a recent portrait that he had exhibited at the Royal Academy he said loftily 'it slid off my brush.' On another occasion, when he was asked how he would paint an unattractive sitter, his reply was 'if they have an awful head, I will give them a good head. I look on it as an opportunity to paint another Carr.'

Claude Muncaster, President of the Society of Marine Artists, recalls a visit to the Club for lunch. 'What do you think of the food here nowadays?' he asked the man on his right. No reply. He then put the same question to the man on his left, with the same result. It did not dawn on him until

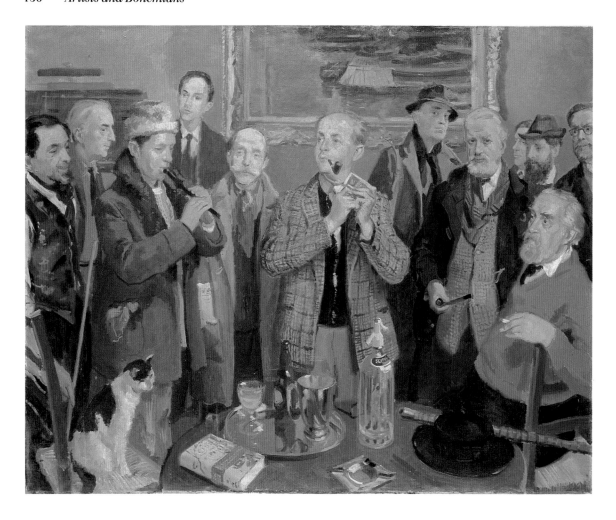

'Concert at the Chelsea Arts Club 1960' by Paul Wyeth ARCA. (From left to right) James Proudfoot, Loris Rey, Laurie Lee, Norman Hepple, John Macadam, Henry Carr, Vladimir Sozonov, Bilibin, John Ware, Henry Wilkinson, Patrick Larkin, Stanley Grimm (seated).

afterwards that both his neighbours were deaf. The cooking was plain; 'nursery meals' were popular with the members. A set lunch, price three shillings, was served each day and dinner was available twice a week.

The group portrait by Paul Wyeth called *Concert at the Chelsea Arts Club* depicts the members who formed the backbone of the Club in the 1950s and 1960s. Paul Wyeth was a Londoner who had trained at Hammersmith School of Art and at the Royal College of Art and who later taught at Hammersmith. He was a well-known character in the Club, once suspended for entertaining a lady in the ladies' room after closing time. On another occasion he decided to roast a whole sheep on a spit on the patio for a party. The fire got completely out of control, with the fat spitting madly and paving stones cracking, and Wyeth burnt himself quite badly; even after a day's cooking the meat still tasted raw. The 'concert' that he pictured was being given by Laurie Lee, the poet and writer who had recently published his best-selling autobiography *Cider with Rosie*. Wyeth shows a copy of the book on the table in front of Lee, who is playing the recorder.[5]

Laurie Lee was born in Stroud, Gloucestershire, and educated at the village school in Slad. His writing celebrates in richly evocative language the slow-moving life of his village community and his early travels in Spain at the outbreak of the Civil War. He had been brought into the Club by his friendship with the portrait painter Anthony Devas, with whom he lodged during the war in Markham Square. At that time Lee was working for the Ministry of Information, but he was also writing his best poetry

'Laurie Lee' by Anthony Devas ARA, c.1939.

and he became a friend of many of the Chelsea artists. He was described by Nicolette Devas, the wife of Anthony, as having two different characters. 'During the winter he appeared poetically haggard, with bags under his eyes. At the first ray of spring sunshine, he relaxed like a lizard and with closed eyes turned his face up to the sun and baked his skin brown with deceptive health.'[6] As Laurie was not a practising fine artist, he was made an honorary member of the Club.

To the right of the group in a red pullover is Stanley Grimm. He was a giant of a man, of splendid aristocratic appearance, which contrasted with his rather ribald conversation. Stanley Grimm was descended from the brothers Grimm, of fairy-tale fame. He was born in London, but following the death of both parents he was brought up by his father's family in Riga. He studied in Munich and Berlin and was in Russia for a time during the first revolutionary period – he had to escape to England in a smuggler's fishing-boat. When Henry Matisse saw his work in 1919 he called him 'a very gifted painter with a fine sense of colour'. In the 1920s he became a fashionable portrait painter and exhibited in a number of galleries in Bond Street and with the Royal Institute of Oil Painters and the Royal Society of Portrait Painters, both of which elected him to membership. He was an instinctive painter and his work was vigorous and direct. As the *Times* critic said, 'ploughing his way to composition through painting would not be a bad description of his way of making a picture.'[7] During the General Strike and during the early part of the war he served as a Special Constable, and his bearded and uniformed figure added distinction to the Chelsea streets. He then became a liaison officer with the Royal Navy where his expert knowledge of Russian stood him in good stead in northern waters and he spent eighteen months in Iceland, mostly painting landscapes.

Stanley Grimm had joined the Club in the early 1930s; he was elected to the Council in 1961 and he remained a member until his death in 1966. He was a regular lunchtime visitor to the Club. His booming greeting to anyone drinking alone at the bar, friend or stranger, was 'Steward, give him a drink.'

'Stanley Grimm' by Alan Stern.

In spite of reduced membership the programme of formal annual events continued. The Annual Dinner, the Varnishing Day Dinner, garden parties in the summer and the ladies' evenings in the winter were well attended and gave great delight. The dinners were treasured occasions for the Club to reach back into its folk history. Speaker after speaker remembered the great personalities and rejoiced in their eccentric or bizarre behaviour. They recalled the feeble utterances of John Singer Sargent as he scratched the table with his fork, unable to find a word. They retold the 'spoof' Post-Impressionist exhibition created by Shannon and the invasion of Chelsea by members of the Dover Street Art Club during George Henry's time. They remembered Robert Hayward's announcement 'Ten minutes left, gents, to wreck the Club' and John Cameron's reply 'Be careful Bobby or I'll have to hurt you.' These and many other incidents like them, some of which are repeated in these pages, formed the background to these convivial occasions.

The dinners had long been part of London life and invitations were accepted by leaders of the nation. In 1947 the guests included major figures from the military, politics and law. General Sir William Slim sat down with the Rt. Hon. Aneurin Bevan, Sir Norman Birkett and others. At a time of food scarcities, the simple meal of clear soup, roast chicken and

Annual Dinner invitation for 1947. The guests included General Sir William J. Slim GBE, KCB, CB, DSO, MC, Sir Norman Birkett KC, JP, and the Rt Hon Aneurin Bevan PC, MP.

ice cream was emphasized by the sinister menu card, which portrayed a vulture presiding over an empty table. In 1948 Sir John Cunningham, Admiral of the Fleet, and Marshal of the Air Force Lord Tedder, sat alongside Professor Thomas Bodkin and Joyce Carey; the menu in French added to the occasion. By 1949 the arts were dominant with Julian Huxley and Sir Malcolm Sargent as the chief guests. In 1951 the Guest of Honour was the Rt. Hon. Anthony Eden and in 1953 H.R.H. the Duke of Edinburgh.

At a time when membership of the Club was strictly limited to those working in the visual arts the Club had benefited by the judicious use of honorary membership. In the early years this was offered to those who gave professional advice to the Club, the solicitor and the accountant, but later extended to distinguished founder-members and leaders in other professions. In May 1920 honorary membership was offered to John Sargent, although it was understood that he was then mostly in America and came to the Club very seldom. Another who was so honoured was the famous inventor of penicillin, Sir Alexander Fleming. Fleming became a well-known figure in the Club, he would come each evening on his way home from St Mary's Hospital and play snooker with silent precision. He was a good friend to many members, advising them on their ailments; he was also a man of wide contacts and very kind in giving letters of introduction to members who were travelling abroad.

By the 1940s the list had grown to some fifty honorary members drawn from the visual and performing arts, the sciences and the professions. Many were annually re-elected, for example the world-famous oboist Leon Goossens, who gave concerts to members and guests during the darkest days of the war. Other notable personalities in music were Sir Thomas Beecham and John Ireland, and in the theatre Sir Lawrence Olivier, Sir Ralph Richardson and Hugh Burden. Those from literature included James Laver, A.P. Herbert, Vyvyan Holland and Laurie Lee, and for many years the sporting representative was Joe Davis. There were always invitations to the President and Keeper of the Royal Academy and the Royal Scottish and Royal Hibernian Academies, although frequently

Cover of Menu for the Annual Dinner of 1962 by A.R. Thomson RA. The past members shown in the drawing are (from right to left) James McNeill Whistler, Augustus John, John Singer Sargent, P. Wilson Steer, Sir Alfred Munnings, Sir William Orpen, Ambrose McEvoy, Charles Cundall, Leonard Jennings, Sir John Lavery, Henry Tonks, Francis Derwent Wood, Loris Rey, John Minton, T.C. Dugdale, Stanley Grimm, Leslie Cole.

The guests at the dinner included Sir Charles Wheeler PRA, Sir Donald Wolfit, Sir Basil Spence, Sir David Webster, Group Captain Douglas Bader CBE and Dennis Compton CBE.

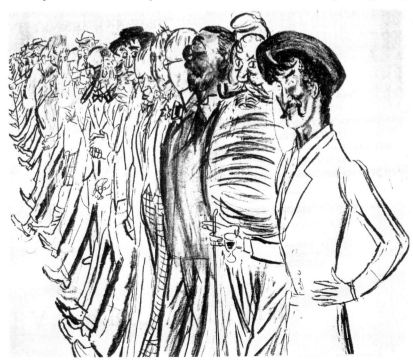

these were members in their own right, and to the civic leaders such as the Mayor and Town Clerk of Chelsea and the Borough Surveyor, the Member of Parliament and the Chairman of the Chelsea Society. Because of Sir Alexander Fleming's close involvement with the club a large group of doctors and surgeons became honorary members.

The Club's picture collection and library were valuable resources of the Club, both mainly acquired by gift from members. Paintings, drawings and prints had been given to the Club from its earliest days. By the time of the First World War, all of the public rooms were hung with a collection which included portraits by Wilson Steer, John Sargent, drawings by Rowlandson, etchings by Turner, Hogarth, Holbein and others. Year by year the collection changed, new work was added, and work on loan was removed, sometimes without authority. In 1928 the Hon. Librarian complained of 'certain egoists who imagine that they can dictate and even go so far as to remove pictures from the walls and replace them with products of their own choice.' In spite of such depreciations the collection has grown into an intimate record of the membership, particularly by drawings and caricatures made in the Club for the amusement of members. Two of the most prized gifts are Whistler's *Butterfly* and the painting after Gerrit van Honthorst *Lais and Xenocrates*, always a feature of the dining-room. This celebrates the attempted seduction of the philosopher Xenocrates by the courtesan Lais. She had been paid by an enemy to shame the philosopher, but when she was rejected she declared that she had not lost her money as she 'had pledged to conquer a human being, not a stone.' This version of the picture, a copy of the original of 1623 now in The Hague, was given to the Club by John St Helier Lander, who had bought it at auction, but whose wife refused to have it hang in the house.[8]

The Club library was always a contentious matter. For many years it was well housed in glass-fronted bookcases in a small room at the front of the building (now a bar store). In its early years it had been a valuable resource, with up-to-date magazines, guide books, maps and books on art. Members donated examples from their own library or their own published works. But there was always a lack of supervision and even in the early years there were times when a general air of neglect and dilapidation reigned. In a lengthy report on the library in the 1920s it was reported 'it is seldom to see a library with so little rubbish, but the books are huddled together in a dark corner of an uncomfortable room, very badly lit and very cold.'

In the early 1950s the library was at the centre of an extensive outbreak of dry rot. Four leading architects and Sir Charles Wheeler, then Chairman, came to look at it. Clifford Roberts, Club Treasurer, was startled by Wheeler's remark after the inspection: 'Gentlemen, you realise you're taking dry rot home with you. . . .' It was decided that the only thing to do would be to strip the plaster off and stick wine bottles into holes in the walls, neck first, with treatment fluid in them. This went on for two weeks and everyone thought that the problem was solved. But within six months the dry rot had spread all over the floor. The library was moved to different parts of the clubhouse and from this time it ceased to have a real existence.

Sporting activities were an essential part of the Club. In the summer, bowls in the garden; in the winter, darts and always snooker and billiards. From its earliest days the Club had a billiard table and as soon as money

allowed, improvements were made to accommodate a second table. As early as 1901, the takings from billiard tables had amounted to abut £50 a year. Nevertheless the billiard tables remained a source of contention. At the AGM in 1920 there were complaints that there was nowhere for the non-billiard players to go, except for the stuffy annexe. One member said that the Club should be called the 'Chelsea Billiard Saloon' rather than Arts Club and that the billiard players should pay rent to the Club. Those who supported billiards complained that the tables were in poor condition and that a Marine Store dealer would not give more than four pounds for each of them. Ronald Gray, then Honorary Secretary, argued that billiards were a tremendous asset because they brought money to other parts of the Club: 'If you shut up the billiard tables you shut up the Club.' From some there were even proposals to acquire a third billiard table. A battle took place between the House Committee and the Entertainments Committee over taking down the billiard tables for a children's party on Twelfth Night 1921. The House Committee suggested that the party be held in Crosby Hall, but it was pointed out that this possessed neither lavatories nor heating, so the children triumphed and the tables were, temporarily, removed.

Some members were remembered as much for their prowess at billiards as for their painting. James Proudfoot was a distinguished portrait painter, but he was better-known as Chairman of the Billiards Committee. He was also notable for the old yellow Rolls-Royce that he drove. Another well-known billiard player was the illustrator Harold Earnshaw. In the First World War he had lost his right arm, but with cheerful determination he learnt to draw with his left and became a well-known illustrator and cartoonist for *Punch*. He was frequently seen on the billiard table, playing with a hook screwed into his false right hand. Alexander Fleming was a familiar figure at the billiard table and frequently played the landscape painter Vivian Pitchforth. One of Pitchforth's comments about Fleming's play was 'Lucky shot! Just like Fleming, he always played the outside chance. No wonder he discovered that bit of mould.'

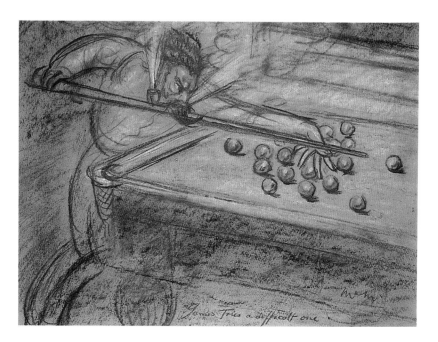

'James Tries a Difficult One' by William McMillan RA. James Proudfoot at the Billiard Table.

'The Billiards Mafia': Harry Spires (left), Ronan O'Rahilly (seated) and Billy Murphy.

In spite of the various efforts to remove at least one of the two tables, to allow more drinking room, billiards and snooker remained persistently popular. The billiard tables were carefully maintained by 'Lofty', the billiard marker, who sat upon a high chair overlooking the main table. The snooker score book, in which breaks of 30 or more were recorded, had few entries. In the 1950s Ley Kenyon and Henry Carr gave way to Paul Wyeth, Harry Spires and Brian Young. One match was particularly remembered, when Ken Pottle played against a visitor to the Club that he did not know. Ken Pottle broke and scored with a red. All of the other balls, red and coloured, were taken by his opponent. At the end of the match Pottle said with astonishment, 'You must be the best player in the world.' 'I am,' answered Hurricane Higgins, who was then the World Champion.

Reginald Bosanquet, nationally known as a television news reader, had his own fond recollection: 'six crotchety old members formed themselves into a billiards committee, and passed a rule that billiards could not be played on the main billiards table! The reason being that my friends and I took too long to reach 101!' He said this was proof of the eccentricity of one of London's most delightful institutions.

Bowls and croquet were equal sources of displeasure to the neighbours. A beleagued neighbour wrote to the Club, asking plaintively: 'I wonder if your members would answer my plea? During the warm summer evenings I am often kept awake till midnight by the noise of those playing croquet, accompanied by shrieks of dismay and cries of delight. I can even hear what the players are saying. Would the Club be prepared to stop playing by, say, 11.15 each evening?'

In the 1920s and 1930s boxing became a popular diversion. As 'John' the Steward recalled:

The next big event was a boxing and wrestling display. Several well-known boxers participated, such as Bombardier Wells, Sgt. Voyles, the middle-weight of the Western Command and the middle-weight of Ireland. They gave a good display, but they missed the last train to Aldershot and had to sleep in the billiard room all night on mattresses. I got up and gave them breakfast next morning at about 5.30 a.m. It consisted of kippers, bacon, eggs, tomatoes, etc. and they departed at about 6 a.m. On the previous evening they were 'stood' beer by the members and I have never seen such quantities of beer drunk before: buckets and buckets of it.

'Reggie Bosanquet' by John Warner.

On a later occasion there was a demonstration boxing bout from Len Harvey, one-time world light-weight champion. Stanley Grimm had the courage to oppose him in the ring but the bout did not last long.

In the mid 1950s the Club began to face hard times. Membership had dropped away; the maximum full membership was 500 but there were 90 vacancies, and many members were not able to pay their subscriptions. Year by year the Club was losing money on its own operations. Fortunately it still had income from the Arts Balls, but this was erratic. In 1950 the Club received £1250, in 1951 only £250, and in 1952 nothing. Many of its investments had been sold and increasingly the Club was living on money borrowed from the bank. The alternatives were either a reduction in expenditure or an increase in subscriptions, but neither was palatable to members. At the Annual General Meeting of April 1953, the Hon. Treasurer, Graham Tubbs, said that the Club was balanced on a razor-edge and a small push might put us 'back in the red'. By 1954 the bank overdraft stood at £1149 and the matter was becoming increasingly serious.

A special sub-committee of ex-Chairmen, including Roland Bevan, Charles Wheeler, Edward Halliday and Loris Rey, was set up in 1955 under Harry Riley, who was Chairman at the time, to look at the falling membership. They came up with a proposal for a new category of 'Associate Members' of those working in the fields of literature, drama and music. They were aware that this might alter the character of the Club and that such a radical change be adopted only *in extremis*. They therefore suggested that before this was adopted, to preserve the unique character of the Club, every opportunity, such as House dinners, parties and circular notices, should be taken to draw attention to the urgent need for new membership. By 1957 there was talk of cancelling evening meals and there were suggestions that the Club garden be opened to lady visitors on Saturdays and Sundays. The decision to admit associate members was finally taken in 1958, but numbers continued to fall and by 1960 there were 152 vacancies. In the following decade the drive to increase associate membership was interpreted liberally and this category grew to include company directors, bank managers, students of law and medicine, engineers, interior decorators and film and stage actors.

During the 1960s the Club had a succession of hard-working and effective Chairmen including John Ware, Leonard Bowden, Tom Hancock, Henry Carr (who had to retire through illness), Edward Bishop and Ley Kenyon. However much they battled, the financial difficulties seemed insuperable. In 1961 the Club received a final capital sum of £1824 from Chelsea Arts Ball Ltd, signalling the end of the long years of subsidy. The earlier dependence upon the Arts Balls was now a chain around the neck of successive Chairmen and Treasurers, who tried to coax and cajole members into paying for the services of the Club, and even into paying their debts. After much disagreement, subscriptions were increased to ten guineas for town members (from eight). In 1962 the Club received a notable windfall when an anonymous donor gave £2000 to form a permanent memorial to the founder-member Ronald Gray, to be known and referred to in the Club's records as the Ronald Gray Memorial Fund. A portrait of Ronald Gray by Alfred Hayward was also given to the Club by the artist. In 1964, to prevent continuing losses in the bar, it was decided to introduce a fruit machine, referred to by Henry Carr, the Chairman, as 'the mechanical member at the end of the room' – which, according to estimates, would produce a profit of £800 p.a. Over the next few years it produced barely half of this and was discontinued.

Tom Hancock, Chairman of the Club in 1962.

A member who played an important role in the Club during these difficult times was the architect Tom Hancock. He had worked in government service in the Far East and was responsible for the parliamentary buildings in Malaysia. On returning to London he became an architect for the London County Council. In 1961 the Club celebrated his marriage to Mary Vicary with a wedding reception. After a number of years on the Council he became Chairman in 1962 and later, as Hon. Secretary, he continued to give valuable assistance to Henry Carr, who was ill for much of his Chairmanship. Tom Hancock was also the Club historian: he wrote a number of articles on the earlier phases of the Club's history and collected a great deal of valuable information, some of which has been drawn upon for this study. In the 1970s he continued to serve on the Council as Hon. Treasurer and later, during the most far-reaching changes that the Club was to experience, he made a major contribution as a Trustee.

11 From Crisis to Catastrophe

> Here's luck to the Chelsea Arts Club
> It's cheery when everything palls
> It's nought but a crazy old pub
> That lives out its life on its Balls.

That old rhyme, originally coined by the early member John da Costa, characterized the Club as it entered its most rackety period from the mid 1960s. The lack of foresight that had been shown over financial affairs and its earlier dependence upon the Arts Balls were to bring the Club to its knees within a few short years. It had become essentially a drinking club; its life revolved around the bar. Many of its members were part-time teachers in the London art schools – as Henry Rushbury said 'never throw a bottle, you might hit a teacher.' There was a great deal of noisy conversation and a few knock-down fights; the wounded were treated at St Thomas's Hospital.

The bottom of the barrel was now near. The serious financial position of the Club was reflected in its chaotic management. The situation was well understood by the senior members. Tom Hancock's financial analysis of the period contains in the margin such comments as 'inefficiency in staffing, management and book keeping', 'unrealistic forecasting', 'pilfering' and 'fiddling in the bar'. Members had more amusing memories, such as the part-time barman who claimed to have been a parachutist in the army. After some weeks he disappeared, taking with him not only the contents of the till but the heavy brass till itself, the scratches of which could be seen across the bar and hatch. A little while later he reappeared in the Club looking very sunburnt. When asked by the steward where he had been and what he had been doing, he replied 'Folkestone' and offered no other explanation. Matters were put into the hands of the authorities, but no prosecution was made.[1]

The main problem was under-use of the Club. From the early 1960s ladies had been admitted as guests for dinner on Wednesday evenings, and on other evenings they could be entertained for drinks in the ladies' bar, which became known as 'the ice box'. However there was still strong feeling that the main rooms, and particularly the billiard room, should be reserved exclusively for men.

In 1966, in order to widen the membership, it was proposed to admit practising women artists. It was acknowledged that this would change the character of the Club, but it was seen as necessary to bring the Club into the second half of the twentieth century. For this important matter a referendum of all of the members was taken. In a deluge of correspondence, they were invited to agree to either: (a) Full membership for

women – this would increase subscriptions, but might cause problems over bedrooms. (It was also thought that it would probably lead to heart failures if accepted.) Or: (b) A form of associate membership, with limited facilities, at a reduced subscription. Or: (c) Women to be admitted as guests, as at present.

The arguments in favour of the admission of women were put forcibly in a letter to members.

Why should we regard the female sex as though it were some sort of potato blight? If we agree that their presence is a fate slightly better than the death of the Club, then what on earth is it about them that we want to be protected from? They are usually just as amusing, witty, well-informed, intelligent and broad-minded as we are and any member's chance of being raped by a lady whilst in the Club is extremely remote. . . . Isn't it about time we abandoned our pre-suffragette attitude and accepted what the House of Lords accepted long ago. Or do we feel that we are more exclusive than even they are. If we agree to allow in any women at all, then surely we want the lively, intelligent ones and they will not tolerate being treated as second-class humans and why the hell should they, this is 1966 not 1866. . . .[2]

Of the 104 replies to the referendum, 46 were in favour of category (a), 31 for (b), 27 for (c). The results were discussed at a special general meeting on 24 October 1966. There was clearly support for the admission of ladies, but as (b) and (c) were together greater than (a), the meeting agreed that 'Social Membership' be offered to women. This meant that they would have full use of the Club with the exception of the billiard room and 'such functions as the Council may determine'; this was meant to include the Annual Dinner, a notoriously all-male affair, and dinner on Monday nights. This grudging acceptance did not produce a flood of new members; instead of the invasion of women that had been gloomily predicted, they were noticeably slow to join.

A few distinguished artists were, however, persuaded to join, mostly because they already had connections with the Club. The first of these was 'Anton', the name adopted by Antonia Underwood Thompson. She had used it first when she was in partnership with her brother Harold, already an established cartoonist, illustrator and poster artist. Antonia had trained at the Royal Academy Schools, but for many years she had been a semi-invalid and was then under-employed; at Harold's suggestion a partnership was formed in 1937. They worked closely together, sometimes on the same drawing, changing places at the drawing table; Harold was responsible for the furniture and backgrounds and filling in, whilst Antonia did the figures. One of their first cartoons was sold to *Night and Day*, a magazine started by Chatto and Windus in an effort to establish an English *New Yorker*. However this well-intentioned project foundered because of a failed libel action – the Graham Greene–Shirley Temple dispute which was much discussed at the time. From that time *Punch* became the main outlet for their work and the 'Anton' technique became easily recognized and created a clear identity for their work.[3]

When the war came Harold was called into the Navy. After the war the partnership was reformed for a while, but soon Harold withdrew and Antonia carried on alone, although they maintained close contact and exchanged ideas whenever possible. At the time of her admission to the Club, Antonia was living in Cheyne Place with her husband John Yeoman, secretary for the Council for the Preservation of Rural England, Mayor of Chelsea and a member of the Chelsea Arts Club. Antonia became a popular member: small and delicate, she was always friendly and charm-

Menu cover for the Ladies' Dinner, October 1968, by 'Anton'. The principal guest was Miss Peggy Ashcroft.

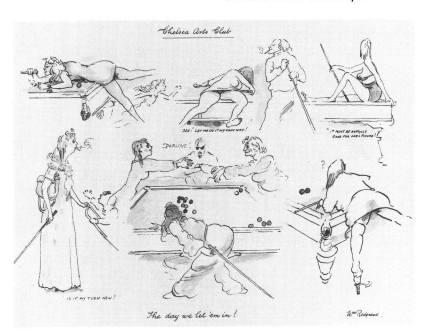

'The Day We Let 'Em In' by
William Redgrave.

ing. Her drawings of London types, elegant men about town, superior spivs and 'modern' women, set in Chelsea flats, Arabian harems or desert islands, poked gentle fun at bourgeois life.

The first honorary membership for a lady was offered to Dame Laura Knight. In her letter of acceptance she wrote, 'I am absolutely thrilled, and very, very proud that the Chairman and Council of the Chelsea Arts Club have invited me to become the first Honorary Lady Member of the Club.'[4] She was then a leading member of the Royal Academy, the most discussed woman painter in England and well known to a number of the senior members. Others who joined in the early days were Elizabeth Trehane (later Lady Trehane, and a Trustee of the Club) who gave her profession as 'patron', the actress Dame Peggy Ashcroft, Mary Glasgow, the well-known Secretary to the Arts Council, and the sculptor Elizabeth Frink.

The Club was not always to everybody's taste. In her letter of resignation one lady said that she found that the focus was on the bar and on snooker and that the groups were so closed that there was no room for conversation. In the first months ladies did not have access to the whole Club; they were allowed to use only the small bar, which was redecorated and refurnished, and the dining-room. It was thought there would be little demand for the use of the snooker room by lady members. However Sandra Blow, painter and Royal Academician, who had joined as a social member in 1971, was of the opinion that women members should have the same rights as male members, a view that was widely held in the Club. The Chairman diplomatically suggested 'a dialogue'. In October 1976 it was agreed at a special general meeting that lady members would be admitted to all parts of the Club.

Ley Kenyon had been prominent in his support of women's membership of the Club. He became Chairman in 1967. He had joined the Club late in 1945, soon after returning to England from his prisoner-of-war camp, Stalag Luft 3, near the German-Polish border. As Flight Lieutenant Kenyon, DFC, he had taken a leading part in one of the great heroic events of the war, which became known as 'The Great Escape'. He helped to plan the longest escape tunnel ever dug, 320 ft. long and 30 ft. below

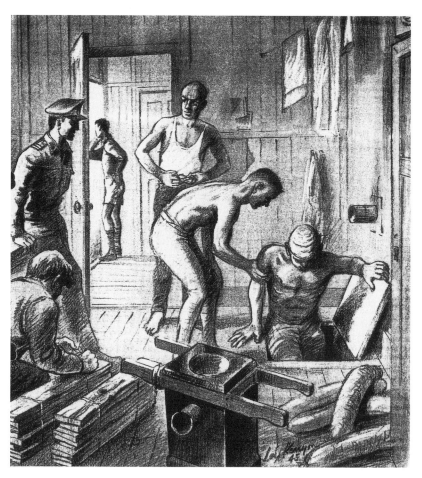

'Preparations for the Great Escape from Stalag Luft III 1945' by Ley Kenyon. Ley Kenyon was the Chairman with the longest continuous service, from 1967 to 1971.

ground, with several change-over stations, an improvised railway track, an air conditioning plant and a printing press to forge documents. He also recorded the ingenuity of the three hundred officers involved in this ill-fated enterprise. Tragically the escape was detected and fifty men were later executed on the direct orders of Hitler.

Ley Kenyon was born in London and studied art at the Central School of Art and Crafts. In 1940 he had joined the RAF as Bomber Air Crew and manned the rear gun-turret of Halifax bombers on 45 missions before his plane was shot down. He collected the Distinguished Flying Cross for 'courage and cool determination'. Whilst a prisoner of war, Ley Kenyon had started art classes and became the official artist to the camp. He was due to be escaper no. 120 and, in preparation for his departure, he buried a portfolio of drawings of life in the camp and details of the escape. He later managed to retrieve these after the Russians overran the area at the end of the war.[5]

With a studio off the Fulham Road, Ley Kenyon was soon drawn into the affairs of the Club, although from time to time he would be away from London for long periods, on expeditions to draw and film animal and marine life in exotic locations such as the Indian Ocean and the South China Seas. In 1953 he joined Commander Cousteau's organization as a lecturer and aqualung diver and shortly afterwards was called to Buckingham Palace to teach HRH Prince Philip to dive.

As Chairman Ley Kenyon had responsibility for membership applications, which came in usually at about the rate of ten or twelve each month. One he remembered particularly – a well-supported application from a certain 'Runcibal Foss'. As was customary he asked the Council,

'Who knows this candidate?' Two knew him well. Peter Goodall said that he knew the candidate personally and although he was unreliable on finance, it was otherwise a good application. Freddie Dean also agreed that this candidate should be admitted, but both seemed to be showing some signs of mirth. However Runcible Foss was duly elected and it was only after the application had been signed that Ley Kenyon discovered that the Club cat had been accepted as a member.

Throughout the 1960s the Club was losing money. It was a sad procession of incompetence. The chickens finally came home to roost in the ensuing decade but a goodly part of the blame must be apportioned to the decisions of earlier Councils, who had been bolstered by the activities of the Arts Balls.

After the usual period as Chairman of two years, Ley Kenyon was invited by the Council to continue for a further two years, the longest continuous Chairmanship in the Club's history. He was notably assisted by the Vice-Chairman Stanley Ayres; together they took upon their shoulders a great deal of the day-to-day running and organization. But financial matters were always pressing. During his period of office the annual accounts showed a deficit of approximately £2,000 needed to satisfy creditors. It was at Ley Kenyon's instigation that the Council agreed to offer life membership at £250 each, and the sale of seven or eight of these overcame the immediate financial problem.

As Vice-Chairman Stanley Ayres played a major part in the Club. He was born in Kingston-on-Thames and trained at Kingston College and at the Royal College of Art. When he joined the Club in 1944, most of the members were in uniform, the majority of them commissioned; Ayres was the exception. As a conscientious objector he had spent the war in the Civil Rescue Service, with two periods of imprisonment in Wormwood Scrubs because of his beliefs.[6] During this time he came often to the Club as a guest and although, as far as he was aware, there were no other conscientious objector members, he was well received. Towards the end of the war and now living in Chelsea, he was allowed to find employment and became Head of Painting (part-time) at Putney. He later taught part-time at a number of other London art schools.

Stanley Ayres, previous Vice-Chairman and currently the oldest member.

Denis Stevens became the next Chairman, in 1971. He was a painter, lithographer and industrial designer. He became art organizer for the Inner London Education Authority where he fostered the appreciation of art, the crafts and industrial design in London schools. The problem before his new committee was the renewal of the lease which was to expire in 1974. As a condition of the lease renewal, it was necessary to put the old Clubhouse into a good condition and urgent structural repairs were needed. There had been considerable damage from dry rot in the upper part of the house and in the dining-room; the kitchen was antiquated, windows were in need of replacement and the building needed rewiring. It was estimated that at least £10,000 was needed for the essential work. In addition the Club badly needed redecorating both inside and out. It was also hoped to improve lavatories and, if possible, to put in central heating.

Up to this time the Club had had its premises at a rent of only £30 per year, as set out in the lease of 1914. However a very considerable increase was anticipated. Various possibilities were examined, there was even talk of leaving Chelsea or of associating with another Club in the West End. Strenuous efforts were made to create a lease redemption fund and

Lady Elizabeth Trehane as 'Diamond Lil' with Paul Wyeth at the Midsummer Night's Ball, 'The Wild West', 1973.

happily, in 1972, Denis Stevens was able to tell members that the Club had agreed a new lease which would allow it to use its premises until at least 1994. As predicted the rent was greatly increased, from £30 a year to £50 a week and it would be reviewed again in 1980. He was also able to say that restructuring of the finances had enabled the Club to pay their first year's rent with no call upon capital.

Although the financial outlook remained bleak the Club was doing its best to battle back. The Council had been very lenient with its members: they were allowed to run up considerable bills through a chit system which was described as 'a fiddler's dream'. There were also a large number of members who had not paid subscriptions, sometimes for two years or more. With uncharacteristic severity the Council agreed to terminate their membership; back membership had to be paid before re-election. In order to establish tighter control of bar stocks, a professional gauger was employed on a monthly basis. Reductions in the number of staff had meant that the Steward was also expected to be cook and book-keeper, a near-impossible task. As a consequence dinner was only served on Wednesday evenings; the new lady members rallied round and produced pleasantly informal suppers on other evenings. In place of the somewhat stuffy functions of the past there was a move to include the other arts such as music and literature.

It would be wrong to give the impression that a permanent black cloud was hanging over the Club during the mid 1970s. On the contrary, the Club was being used more than ever for dinners, balls and other entertainments, and those members who were not engaged in crisis management – and some of those who were – continued to enjoy themselves as vocally and extrovertly as ever. At this time the Club events were advertised by specially produced posters placed in the entrance hall. Many of these were produced by Peter Sachs, a German who had arrived in England in 1939. At the suggestion of some friends he improved his command of the English language by studying and learning by heart passages from *Finnegans Wake* by James Joyce. This gave him an unusual vocabulary and a concern with the idiom which then led him to earlier classics. Eventually the sonnets of Shakespeare provided him with a source for a series of black and white illustrations. He gave the verse a contemporary visual translation and certainly did not include doublet and hose, for the garb was to be found in the bar at the Queen's Elm and the Chelsea Arts Club garden. Sachs's public reputation was made as an animator and industrial film-maker, but in the Club he was even more well known and applauded for his wickedly witty and beautifully drawn posters, his penetrating humour and his appreciation for Glenmorangie whisky and women.

Although the lease had been secured, the Club was still living a hand-to-mouth existence. As a Trustee John Frye Bourne was well acquainted with the precarious financial position. One evening he happened to be in the bar when Tom Hancock, then the Treasurer, emerged from a stormy meeting, much in need of sustenance. John Frye Bourne gently asked if he could help, and on the spot he agreed to lend the Club £4,000. His generous assistance averted yet another disaster for the Club.

John Frye Bourne's connections with the Chelsea Arts Club extended to its earliest days, for he was introduced by the founder-member and friend of Wilson Steer, Ronald Gray. The drawings of the young John Frye had been noticed by Gray when he was visiting Bishop's Stortford College,

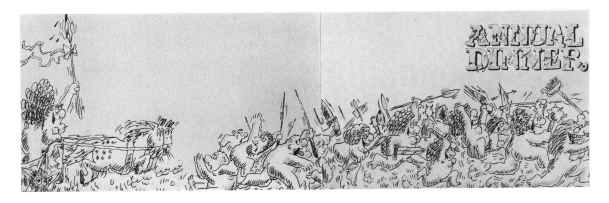

'Invasion of Women' by Peter Sachs. Menu cover for the Annual Dinner of 1976.

Freddie Deane, who became Chairman of the Club in 1973.

where John Frye was a boarder. Gray had suggested to the Master of the College that Frye be given as much freedom as possible to draw and paint. This led him to develop a talent which took him to the Royal Academy Schools at the age of sixteen, the youngest student there since Turner. John Frye Bourne had early success with his portraits, took a studio in St John's Wood and for a short time worked as studio assistant to Sir Gerald Kelly, later PRA. He then moved to Harpenden, Hertfordshire, where he married, but his professional career was interrupted by the war. In the post-war years Frye's portrait commissions continued, but these were now limited by the responsibility of a farm at Sidbury in Devon. His visits to the Club were usually marked by the presence of his silver Rolls-Royce, which then could be parked for a day or two directly outside the Club's doorway without any response from the police.[7]

In these years the Club struggled with disaster, but the real crisis came when Freddie Deane, the incoming Chairman, discovered that the Club's affairs were in a dreadful state. At a special general meeting, on 16 January 1975, he reported to the members some very disturbing facts concerning the control of stock and finance. The accounting system was totally chaotic; there was about £9000 of unpaid bills, many of them relating to the recent building work, and it was discovered that the only money in the bank was the loan made by John Frye Bourne which had been illegally transferred to the current account to make it look good.

The seriousness of this information could hardly be exaggerated; unless immediate action was taken the Club could not continue in existence. In forthright language the Chairman explained that if considerable funds were not found the creditors could obtain judgement against the Club and bailiffs could be sent in to seize the Club's property and premises.

As a result of these disclosures the meeting agreed to a series of emergency measures to save the Club, which included the discharge of most of the staff, the possible disposal of the Club's assets and investments, including its collection of paintings, and measures designed to increase membership. The Club was put on an emergency basis with Miss Py, the new managing secretary, in financial control. To meet the immediate need for cash Freddie Deane proposed a levy on members of £20 each. He emphasized that this support was needed immediately and asked each member to give a cheque that day so that the Club could remain in being. If the members did not respond at once the Club would certainly be closed as the sale of pictures could not be arranged in time to meet the outstanding debts.

The first weeks of Freddie Deane's Chairmanship were an ordeal by

fire, an unexpected situation for an artist and ex-soldier. Freddie Deane had had a hard war. He had fought in North Africa as one of the desert rats. He later parachuted into Holland with the 10th Battalion of the 1st Airborne Division as part of the ill-fated expedition at Arnhem. In this last bloody engagement he was shot in the head, the bullet hitting his left eye and passing through his right cheek. He expected to be shot on capture, but to his surprise he was treated with kindness by the Germans who treated his wounds. He still wears a piratical black patch that has become his trade-mark in the Club.

When Freddie Deane was released from the prisoner-of-war camp, he continued his interrupted art training in Manchester and then at the Royal Academy Schools under Philip Connard. It was soon after this that he joined the Chelsea Arts Club, at first as a country member, proposed by Harry Rutherford, a friend of Sickert. When Deane later came to live in Chelsea, he shared a studio with Ley Kenyon for about six years and taught part-time at the John Cass College. His childhood fascination with the circus continued to provide him with subjects for painting. He made portraits of the great ringmaster George Lockhart and many drawings and paintings at the ringside of the animals, acrobats, clowns and other performers. Other notable sitters included Lord Denning, Master of the Rolls. These formed the greater part of his work.[8]

During this period in which the Club was struggling for its very existence, two honorary members gave prominent help: Bill Michael, who had trained as an artist at the Slade School but who had spent most of his subsequent life in property and investment, and Gunther Heil who also had considerable financial expertise. With the Treasurer John Warner they prepared an elaborate paper to show how the Club could become profitable in the future. On the evidence of this, Barclay's Bank agreed to a further overdraft of £12,000 against the still-considerable assets of the Club in the form of pictures and stocks of wine. Members had also responded nobly to the call to assist the Club. The levy of £20 had produced an immediate response and in addition a number of members personally guaranteed the Trustees in the event of the Club failing to meet its debts. Some of the Club's paintings were sold at auction, including important works by Sargent and Steer, but the greater part of the collection was saved.

Bill Michael became the Club's hard-working Treasurer, and spared no efforts to alert the Council and membership to the continuing financial realities. He set out two principal reasons for the present difficulties: the programme of improvements required by the new lease and the lack of proper supervision of the staff. 'There is no doubt that this lack of control has permitted and even encouraged dishonesty on the part of employees, all of whom have been dismissed.'

For a club that was always under the public eye, it was hardly possible to keep these affairs out of the press. In an amusing and frank article in the *Sunday Times*, Jeffrey Bernard gave a detailed account of the present financial position and admitted that 'None of this seems to have come as the least bit of a surprise to the members of a slap-happy Club that has one foot in the 1920s, its head in the sands and both hands around a beer mug.' He continued:

The Club is an odd mixture of Bohemianism and old-world propriety. . . . It would be more of a surprise, perhaps, if a number of artists could be found anywhere who were capable of running a club for over eighty years without getting into some sort

There was a remarkable Person in Chelsea,
Who long Kept the books
looking healthy.
Some Members, they'd Blub:
But, he DID save the Club.
That amazing person after Selsey

'Bill Michael' by John Warner. William Michael OBE was for many years Treasurer to the Club and later Chairman of the Trustees.

of trouble. Individually canny with money in some ways, artists as a whole are manically prodigal and quite unable to organise beyond the present.... Even gentlemen painters, it seems, are at a loss to run a business with efficiency.[9]

Older members, who now used the Club little, were alarmed by the publicity. One who had been a member for 45 years wrote:

The Club has changed so much that I am sometimes asked if I am a member: this occurs at weekends – when class SW3 and 7 take over. The last time I brought my wife in we were regaled by a member in stable-boy kit, wearing a polo jersey. In view of all this laxity I cannot see the Club ever regaining its pre-war character. I often wonder what the ghosts of the lower table, Charles Wheeler and Henry Rushbury, would say if they could gaze from the elysian fields on such festivals.[10]

By May 1976 it appeared that disaster might be averted; the new Chairman, William Thompson, was leading the Club delicately along the path to recovery. The membership had rallied round and the sale of pictures arranged by Robert Buhler and Peter Goodall at Sotheby's raised £3140. Miss Py left the Club bowed down by the quantity of work.

When John Warner took on the Chairmanship of the Club, in June 1977, he was well aware of the difficulties he faced. 'It has become a tradition of the Club that Council be roundly criticised for the many problems members encounter as soon as they enter the front door – that is everything from beady-eye cockroaches in the ladies' loo to beady-eyed alcoholics in the billiard room bar.'

Although closure had been averted, the general opinion was that the problems could only be solved by appointing a professional management organization to run the bar, restaurant and other services on some form of profit-sharing basis. A proposal had been received by the Council from Oliver Stutchbury, a long-standing and respected member of the Club and a neighbour. He proposed to become the manager and proprietor of the Club and to make drastic changes in its operation. In the event, however, an agreement was entered into with another company, Duleek Catering Services Ltd, on a franchise basis, to run the bar and dining-room. Unfortunately this proved no more effective than any of the previous arrangements. Managers changed with bewildering frequency, as did the barmen, one of whom, to the great enjoyment of members, actually gave away the drinks free of charge.

The Club was very vulnerable at this time; the bar seemed to be commanded by a small clique of habitual drunks. The relaxed and easy-going atmosphere had made it an easy target for a number of local people, non-members, who used it as a drinking club when the pubs had closed. It was said that spare keys to the Club's front door would be passed around the Queen's Elm bar at the end of the evening, so that drinking could continue in the Club. In the past a certain boisterousness had been permitted among the members, but this intrusion into the Club by non-members was new. The Club was fast going downhill, as Bill Michael reminded the Committee: 'eccentric behaviour is one thing, boorish belligerence and destructiveness is quite another.'

In spite of the turbulent financial climate, the Club continued to provide a refuge for the artists who were wholly engaged with their work, and many remained loyal. One was Robert Buhler who would be seen most lunchtimes in the summer relaxing in the garden, after a long morning's work in his studio in the Fulham Road.

Buhler was a cultivated mixture of English, French and German. He

Robert Buhler by himself.

was born and brought up in London of Swiss parents, his father a mathematician from German Switzerland, his mother from the French-speaking canton of Valais. Encouraged by his father, he had some early training in Zurich and Basle and then in London at St Martin's School of Art and briefly at the Royal College of Art. With a gift for portraiture and a studio in Camden Town he soon gained commissions and he earned a little extra by producing illustrations for the press and posters for Shell.

After serving in the Fire Service in Hampshire, at the end of the war Buhler came to Carlyle Studios, Chelsea. He taught at the Chelsea School of Art and later at the Central School of Arts and Crafts, where he came to know Rodrigo Moynihan, Ruskin Spear and John Minton. When Darwin was appointed as the new head of the Royal College of Art, Buhler joined the Painting School and divided his time between Norfolk and London, working on landscapes, urban and rural, and portraiture. In his painting he renders what he sees in formal terms, with an accuracy based upon precise observation, transcribed by strongly patterned shapes and colours. 'Painting,' he wrote, 'should need neither explanation nor description – it should be self-evident through the language of paint.'[11]

In 1975 he resigned from the Royal College of Art and painted, mostly from landscape, in many European and Mediterranean countries and the United States. He exhibited regularly in London and most significantly at a retrospective exhibition at the Royal Academy of Arts in 1980. Over the years he gave great assistance to the Club. He was several times a member of Council and when Freddie Deane was Chairman, he became Vice-Chairman and was helpful in bringing artists back to membership.

The friendship between Ruskin Spear and Robert Buhler over most of their lifetimes can be attested by the lack of reverence each displayed for the other. To quote Ruskin Spear:

I thought I would ring my old pal Brother Buhler. Nothing of importance, just to say I would join him for lunch at the Club. 'May I speak to Robert?' A mellifluous voice replies: 'He's on his way to the studio.' I ring the studio. No answer. I ring, instinctively, the Queen's Elm. 'He's on his way' – this is a very Irish voice, totally convincing, if you know what I mean. On his way? Try studio again. Total void. Think maybe the idea of lunch not really important as it is now 1.45 p.m. Ring Club. 'Robert? Oh yes, he'll be in any time now.'

Decide to risk everything and chance our meeting. The SW7 air suits me anyway. Park outside Club. Ring bell (I've lost my key) and gain entrance. 'Robert Buhler, Sir? – bit early, Sir – usually later, Sir.' Order half-pint of bitter and stare with due respect at view of the Thames at Chelsea – hung between the Gents and the billiard table. After some twenty minutes a slight commotion at the front door, voices, shapes, footsteps, and, believe it or not, there is the one and only Robert Buhler. . . .

A last noggin before lunch (or is it tea?) And what a lunch. No wolfing into a cheese sandwich. Nothing but the best. I glance nervously at the Menu. But, taking a hint from R.B., order the most expensive dish. What about the wine? Nothing but the best. As Robert slowly expands his outworn theories about the political situation, the food begins to wilt on the plate. To get stuck into my grub would look revolutionary, an imitation of Kirk Douglas in *Lust for Life*. Another bottle. Another area of political misunderstanding. Occasionally God gets mixed up in it. Another bottle. What about the Meaning of Meaning? Let me fill your glass? We finish lunch by about 4.30 and then, what next but a spot of bother on the Snooker table?[12]

Ruskin Spear was greatly respected by members of the Club as an artist, although his sometimes rough tongue and earthy humour kept them at a distance. He did not involve himself in Club affairs or committees but used the place as he used the pubs in Fulham and Chelsea. He was a Londoner, trained at the Hammersmith School of Art and at the Royal

'*paint yr portrait – Sir?*'

'Ruskin Spear' by Robert Buhler RA, NEAC.

College of Art. He delighted in the familiar streets, the pubs, music halls and snooker palaces from Hammersmith to Putney, and painted them, as Sickert had, with wit and understanding. In his extraordinary portraits he captures the unguarded moments of some of the most notable figures of his time – Churchill in his last years, Harold Wilson, astute and devious, Sir Lawrence Olivier and Sir Ralph Richardson seen in stage costume, and many others. But he also portrays the ordinary people of London, known to him on first-name terms, relaxing in the pub or glimpsed in the street.

A childhood brush with poliomyelitis badly affected one leg; this exempted him from war service: 'During the war I sold *Peace News* around Hammersmith Broadway and persistently refused to see army doctors.' He was then also a jazz pianist with several small bands in bars, clubs and dance halls. In 1944, the year in which Sir Alfred Munnings became President of the Royal Academy, Ruskin Spear was elected as an Associate member, but he had little in common with Munnings: 'I think the idea of a working-class cockney joining the establishment was a bit much for him!' Spear and Carel Weight, who represented the more adventurous of the new membership of the Academy, remembered Munnings's cry, 'Why can't you get out of here? You're spoiling it all.'

In 1948 Ruskin Spear became a tutor at the Royal College of Art and in the following year, with many of his colleagues, he joined the Chelsea Arts Club. In his application, when he was asked to indicate where he had exhibited, he wrote 'universal'. In 1954 Ruskin Spear became a Royal Academician and in 1979 he was created CBE.[13] Robert Buhler writes of him:

He is very good company and likes his drink which, when boozy, makes him even meaner and more lecherous, but no less likeable. He loves music, knows a lot about it, and isn't half bad on the piano. All in all, you couldn't find a nicer chap – Florentine painter or pirate – take your choice. . . . [14]

12 Ingredients of Success

The cartoonist and illustrator Barry Fantoni remembered his first introduction to the Club:

One day I was walking along the road towards the Club when I saw a drunk being thrown out of The Queen's Elm, he was staggering about and being sick in a completely comic drunk way. When he got to the door of the Club an arm came out and dragged him in. I thought that anywhere that pulled drunks in rather than threw them out was a place I wanted to belong to. I went in. It was about 4 o'clock on a blazing June afternoon and the sun was pouring in through the windows. There were men lying comatose all over the floor. One man was asleep at the piano – he wasn't the pianist, he had just been sitting there – one was lying flat on his back on the floor with his legs over the bar stool. There were two legs sticking out from under the snooker table: they belonged to Reggie Bosanquet. There wasn't a sound, just gentle snoring. It was like a Paul Nash painting where the ugliness is diffused and you see these beautiful but tragic figures lying dead in a landscape. That's the Arts Club.[1]

'What I like about the CAC etc.'
by Barry Fantoni.

Fantoni was a critical observer of the years in which the Club had fallen to pieces: 'what the Club needed was a business mind at the top; what it got was a succession of chairmen who were a cross between Basil Fawlty and Groucho Marx in *Room Service*.' Fantoni took on the Chairmanship in 1978, with John Warner as his Vice-Chairman. In a series of meetings he steered the members through the most critical decisions in the Club's history.

In March 1978 Messrs Duleek, who had been running the bar, dining-room and bedrooms, withdrew and another management company, Bateman's, took over. However losses continued. The situation was no longer serious, it was desperate. The Club was now losing about £140 per week. Already dining-room staffing had been drastically reduced and more radical remedies were proposed, such as the closure of the dining-room in the evenings – sandwiches only. It was even suggested that the meals be abandoned altogether and the Club become a drinking and snooker club.

Clearly the Club was running out of control, but it was decided to make a final attempt to interest a responsible management organization to take control of the services of the Club, to be responsible for all expenditure and to receive the income from those activities. This would be on the understanding that the traditional activities of the Club would be maintained and the Council would have the right to decide on membership.

Dudley Winterbottom, who was at that time running a successful restaurant in Oxford (owned by Tony Verdin), was looking for a club in London. He had been introduced to the Chelsea Arts Club by Patrick Corbett, immediately fell in love with it and expressed an interest in the management possibilities. Oliver Stutchbury, a respected and long-

standing member, made an alternative proposal to take over the lease of the Club, its assets and liabilities and to be responsible for the management.

When these proposals were made public the Club divided into two camps, those favouring the Winterbottom proposal and those who preferred Stutchbury's. There were two special general meetings in 1979. The first of these won general approval for Dudley Winterbottom's approach. The second, chaired by Barry Fantoni and attended by 210 members, was a pro-Stutchbury counter-attack. It was a free and vigorous debate, at times acrimonious, entered into by many of the senior members of the Club, Trustees and past Chairmen.

The debate was wound up by Bill Michael who said it was a question of deciding what type of Club members wanted. Mr Stutchbury proposed to keep the Club as close as possible to what it had been in the past; Mr Winterbottom intended to run the Club in a more aggressive way. 'The controversial point is the degree of control that will remain with the Club. We would clearly be handing over the future of the Club to Mr Stutchbury, but in Mr Winterbottom's case, if he fails, the Club comes back to the Trustees.' The members then voted: 155 were in favour of Mr Winterbottom's proposals and 49 in favour of Mr Stutchbury.

This was a clear decision by the membership, but it was not the end of the affair. In 1981 the two Trustees who were also the signatories of the lease, which required them to maintain the building in good condition, grew increasingly concerned about their potential liability and announced their wish to transfer the lease to two other members. Two members could not be found to take their place, and Dudley Winterbottom and Tony Verdin were faced with the choice of either seeing the Club founder and all their efforts wasted or taking on the lease with the personal liability that entailed. They chose the latter.

Throughout these difficulties and negotiations Dudley Winterbottom and his Yugoslav-born wife Mirjana had been working in the Club, initially for a fee of 'five bottles of yellow wine' – the only stock in the Club when they took on its management – and later for 10% of turnover subject to profitability. The Club was in a considerable state of dilapidation, the kitchens were atrocious and the dining-room was only serving on Wednesday evenings. The quality and frequency of meals were soon improved with a single fixed-price menu, cooked and served by 'debbie' girls and later by a professional staff.

By the summer of 1978 Dudley Winterbottom and his partner Tony Verdin were running the Club's bar, restaurant and accommodation. Through the management company, Chelart, they were also responsible for the premises, repairs, redecoration and security of the Clubhouse. Within this new structure the Club became 'Chelsea Arts Club Ltd', a company limited by guarantee, and each member was asked to guarantee £15 in the event of the closure of the Club.

In 1979 Dudley and Mirjana sent their first letter to members signed 'As ever in haste'. They admitted that they were seen as representing the forces of change and undoubtedly this had alarmed some, but the only changes they wished to make were those designed to bring previous members back to the Club and to attract a suitably qualified new membership. In short, to make the Chelsea Arts Club once again the first meeting-place in London for artists, sculptors, designers, architects and their friends.

Dudley Winterbottom,
Secretary to the Chelsea Arts
Club and Managing Director
of Chelsea Arts Club Ltd.

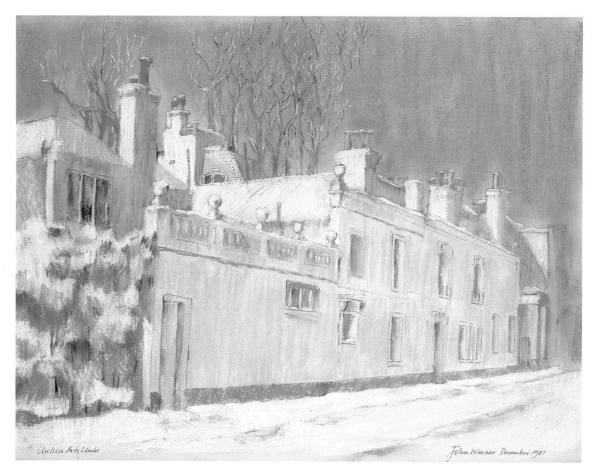

'Chelsea Arts Club, Winter 1981' by John Warner.

For the first two or three years after the changeover, almost anyone who was able to pay the subscription could join, but then membership became tighter with the emphasis upon practising artists. The new members did not come from Oxford, rather from the friends of existing members. Word went around the London art world, but there was no attempt to recruit celebrities. Membership grew from about 500 in 1988 to the present total of about 2000, which includes about 1600 paying members, plus many subscribing life members, retired members and honorary members.

The new membership included many who were in the public eye: men and women from the stage, television and the press, from advertising and public relations. Also many who were associated with the arts through dealing, writing and arts production in a number of forms. The Club began to attract attention and speculation from the press. Some of this was highly critical, in particular a series of attacks that appeared in the *Evening Standard* during 1985, prompted, it was thought, by a disgruntled member. Frequently it was the guests of members whose behaviour excited the headlines, as if the Club was a public arena in which uninhibited performances could take place.

The male chauvinist character of the Club was put firmly into the past when Jane Coyle became the first (and as yet the only) lady Chairman of the Club in 1980. She is a sculptor, trained at Reading University and at the Royal College of Art and was then teaching part-time in a number of art schools. She joined the Club in 1973 and was one of those who kept the dining-room open and the spirits of the members high by providing special suppers when all else failed.[2]

The Club was now enjoying an energetic social programme, jazz nights became a regular feature, poetry readings by Richard Ingrams, editor of *Private Eye*, and Christopher Logue were arranged, and an auction of artist members' work raised money for the Club.

There had been attempts to revive the Chelsea Arts Balls. In 1973 a Ball was held at the Royal Albert Hall under the title 'The Television Arts Ball', the idea of Richard Levin, former Director of Design at the BBC, intended to raise money for the muscular dystrophy group. However this Ball was not presented by the Chelsea Arts Club. Denis Stevens, who was then Chairman, wrote to *The Times* to disassociate the Club from the announcement. He took exception to the words 'nudity' and 'violence' which the Press and the public associated with the Chelsea Arts Balls and which, it was said, led to the Arts Balls being discontinued. He wrote:

For many years our New Year's Ball was a happy occasion, until literally broken into by gangs of hooligans who caused extensive discomfort and damage. To disassociate itself from such ruffianism and avoid financial loss, the Council of the Club decided to continue this event in a more private form and holds the New Year's Ball on its own premises, but as entrance is limited to members and their guests, attendance is now numbered in hundreds rather than thousands.

From that time, New Year parties had regularly been held in the Club. One of the most ambitious was produced by Tessa Fantoni in 1978 and the newspapers mentioned that Reggie Bosanquet, Francis Bacon, Gerald Scarfe and Richard Ingrams were among the guests. This was as grand an affair as the Club could manage, with five orchestras and three marquees in the Club's garden. Some £6000 was spent on the settings and special effects. Dudley Winterbottom said 'We are reviving it on as grand a scale as possible. If it's a success we hope to return to the Albert Hall if they'll let us.'

On the initiative of a Club member, Roy Ackerman, there were two

'Dear Members' by Don Grant.
1. Dilys Rosser 2. Jane Coyle
3. Dudley Winterbottom
4. John Whiting 5. Stanley
Ayres 6. Topsy Gordon 7. John
Walton 8. Dennis Gould
9. Patrick Corbett 10. Miriam
Young 11. Bill Michael
12. Richard Nowne
13. Clifford Rainey.

revivals of the Arts Balls at the Albert Hall in 1984 and 1985, but not on New Year's Eve. The first of these, in October 1984, had the theme 'La Belle Epoque' and was organized in conjunction with Maximes de Paris. As Adrian Forsyth explained, 'In this increasingly puritanical age it seemed that the time was ripe for a celebration like this. I think it is an indication of the increasing success of the Club in recent years as a focal point for the Bohemian life.' There were no floats and no excessive behaviour, no brawls and no obvious nudity. A second Ball on a Venetian theme took place in the following year.

For one memorable summer day, the Club was declared 'The People's Arts Club' when 'The Colonial Administration of Tom Hancockland' invited 'Members of the Brotherhood of United Mucharti Freedom Fighters to the Independence Day Celebrations of Mucharti' – a (semi) formal occasion for which the dress was a black tie, topi or loin-cloth. This was a further extravagant party for which the whole Club, including two marquees in the garden, was transformed by Annie La Paz into a tropical jungle (with assistance from Shepperton Film Studios). The music was African and the costumes, or lack of them, were as tropical as the music. The food was served from a native market, served by fifty topless maidens, who also provided the staff for the massage parlour and native brothel (both fictitious).

The new membership had changed the tone and the pace of the Club. There were many moments of magic and absurdity. Music played a much greater part in the programme as did the spoken word. Fiona Pitt-Kethley read her poetry. At dinner Alan Yentob sat alongside his 'Spitting Image' puppet and performed a dialogue with his 'alter-ego'. Spike Milligan, Avin Hewitt, Melvyn Bragg, Joan Bakewell, Stephen Fry and Tim Rice all raised laughter and provoked ideas.

George Melly, the jazz singer and writer on art, was one of those who joined at Dudley Winterbottom's invitation. He remembered that he received a letter suggesting he might like to join and this reminded him of Ronnie Scott's dictum. 'Last week the bouncers were throwing them in off the streets.' On the first letter he misread Dudley's christian name as 'Dorothy' and continued to address him as such throughout a long correspondence until he was elected. It was only when confirming this did Dudley Winterbottom add a postscript setting him right. 'But for me he will always be a Dorothy, an illusion his unique mix of fluster and charm does nothing to dispel.' Melly continued:

My membership coincided with the discovery of the Club by the young and trend-conscious. There were of course the regulars: grizzled, tweedy and jovially grumpy, but there were also these incredible, beautiful, terminally bored girls with torn fishnets and black lipstick and their Dracula look-alike boy friends. They didn't stay long but they had a salutary effect. They brought with them a new, less ephemeral generation who took root. Like policemen, the committee got younger and livelier. . . .[5]

At the Annual Dinner on 7 May 1982, Bill Michael the Honorary Treasurer spoke of the perils of the last few years and of the changes that had taken place. The Club had been transformed, he said, 'the dining-room is habitually full, the membership has increased substantially. Although most of the new members were born some time after 1891, their appearance compensates for their lack of experience.' He was pleased to see that the proportion of practising artists had greatly increased and for the first time in many years the income of the Club exceeded its

expenditure by a reasonable margin. He gave the credit for this to Dudley Winterbottom whom he described as 'an android designed by a sub-committee of the Council to combine the qualities of lunacy, perspicacity, sensitivity, enthusiasm, common sense, untidiness and money and equipped with a beautiful wife.'

Roger McGough joined the Club in 1974 as a country member; he was then in Liverpool as part of the musical group 'The Scaffold' for which he provided much of the wit and many of the words. When he moved to London, living in the Fulham Road, the Club became his local and he was brought on to the Council by Adrian Forsyth. As befits a poet, he celebrated his own Chairmanship in 1984 with a quatrain which begins:

> It was in the year of Her Majesty 1974
> That I was given the key to the Arts Club door
> And I watched the Club metamorphose
> As more than once it threatened to close.
>
> But now with heady optimism I note
> That not only is the Club afloat
> But flourishing. And we give thanks
> To Dudley (he of the windmill shanks)[4]

Roger McGough (right) with Brian Patten, 1987. Roger McGough was Chairman of the Club in 1984.

The painter, printmaker, writer and broadcaster Patrick Hughes, who became Chairman in 1986, had a preliminary skirmish with the Club when he became a member for a few months in 1970. He was then living in Old Church Street and at a particularly lively New Year's party he was thrown out of the Club for fighting. In retaliation he removed all of the coats of the party-goers, an action which resulted in his expulsion.

After some years living and working in St Ives, and now married to Molly Parkin, he rejoined the Club as a country member in 1977. He soon moved to the United States and from 1979 to 1982 he travelled between the Chelsea Arts Club and the Chelsea Hotel, New York. By the time of his return to London in 1982, the Club had totally changed in its management, its appearance and its membership. Patrick and Molly lived in the Club for several months and contributed considerably to this stimulating time.

Molly Parkin, the fashion writer, novelist and artist, then considered herself to be the Club mascot. She remembered that her bedroom had pink sequinned curtains, and she hung all her clothes in the window; from the garden it looked more like a Turkish brothel than the Chelsea Arts Club. 'I used to describe the Club as a bar with nine bedrooms,' she wrote. 'I thought of myself as a colourful flamboyant member but I got a letter from the Council saying I should amend my behaviour. . . . I took an American friend there, who was appalled by it. He described it as a hell-hole, full of the drunken dregs of English aristocratic eccentricity. He quite saw how I fitted in. . . .'[5]

'The Arrival of the Council, 1987' by Patrick Hughes. During Patrick Hughes' Chairmanship it was customary for meetings of the Council to wear red roses when they interviewed new candidates.

The recent history of the Club is one of highly complex legal and financial discussions interrupted with wild enjoyment. When the dust of each of these activities has settled, the Club is again revealed, standing a little firmer than before. Patrick Hughes served on the Council for four years, and for only one year as Chairman, but it was a critical year for the Club.

In 1986 the landlords asked for a rent increase to £36,000 a year. Tony

Verdin and Dudley Winterbottom countered with a suggestion to the landlords that they should sell them a new 99 year lease, at a price which was subsequently agreed, in 1987, at £720,000. Though the new lease was valued for mortgage purposes at £1.4.million, Tony Verdin and Dudley Winterbottom then offered the new lease to the Club on condition that the Club Members raised the bulk of the purchase price and agreed that their company, Chelart Ltd, should continue to manage the premises, service and amenities of the Club without interference for the next 25 years, subject to the authority of a supervisory board of Club, Chelart and independent directors.

Patrick Hughes and Bill Michael brought firmness and clarity to the discussions which followed in Council and at two packed special general meetings, which approved nearly unanimously the proposals for the restructuring of the Club. David Parker, a member who was appointed by the Club to represent its interests, supervised the drawing-up of the legal agreements needed to protect the interests of everyone involved. These sometimes delicate negotitations were satisfactorily concluded owing to generosity on all sides.

The principal officers of the Club held a meeting at which Dudley Winterbottom outlined his scheme for raising £300,000 from the members. His audience was sceptical but there were no other proposals and the plan was accepted. Patrick Hughes suggested that everyone put down on a bit of paper their guess as to how much could be raised and most put down figures in the low £10,000s. Patrick Hughes himself wrote down the telephone number of the Club £352,097.30p and he was astonishingly close. In fact £360,000 was collected in three months. The response was overwhelming: some cheques were so large that they had to be checked that people meant to give so much: others sent their bus fares. Members who were notorious for dud cheques or non-payment of subscriptions were among the most generous givers.

As part of these extraordinary efforts to raise funds for the Club, an auction of members' work took place at Sotheby's in October 1988, arranged by Mirjana Winterbottom. She threw herself into this with enormous enthusiasm and approached all of those members, ex-members, friends and supporters, whether artists or not, who could offer work for sale. The auctioneer was Lord Gowrie, the former Arts Minister, and 137 works were provided by 131 artists and other supporters. At the same time an exhibition of members' work was held in the Conduit Street Galleries and works by a further 124 artists were donated and offered for sale.

These events were spectacularly successful. The list of artists included almost all of the prominent members as well as many past members. The total raised, including an auction in the Club and contributions from individuals, was £145,506. This display of astonishing generosity was yet another milestone in the Club's revival. In addition to helping in a major way to pay off the loan, it was also possible to establish a Trust Fund 'to encourage and advance the cause of art' by scholarships and grants for artists of all ages and at all stages of their careers.

Further important changes were made to the organization of the Club. Business and day-to-day management, so long the burden of the House Committee, is now the responsibility of the management company, Chelart; the broad interests of the Club are under the supervision of Chelsea Arts Club Ltd., whose seven directors include a number of

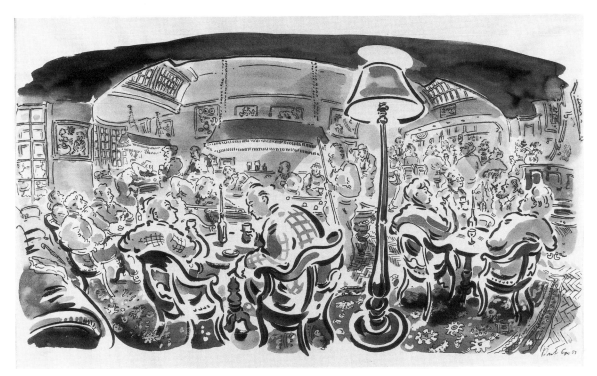

'Billiards and Conversation'
by Paul Cox.

'In Charge of the Office', Katy
Tatchell with Orlando.

individuals of independent judgement and experience. The Council, elected by the membership, retains responsibility for the election of new members and for all disciplinary matters affecting members.

In 1991 the old Club is again undergoing a major renovation, prompted by the need to bring it up to the strict fire regulations of the Royal Borough. There will be better accommodation on the ground floor for an office and a porter's lodge and new electrical systems and heat detection systems will be run throughout the building. Other refinements are being considered, including central heating, air conditioning and a modern telephone system. The club will be completely redecorated: considerable debate is taking place about the final colour scheme and decorations for the public rooms. In all of this it is hoped to retain the atmosphere of a Club that has survived a hundred years of hard wear by its members and to preserve those many features that have made it a remarkable institution.

The Club now has all the ingredients of success. It is in use from the early breakfast, cooked and served by the ever-patient Roger, who will deliver the most thorough-going meal in Christendom – 'Anything you like dearie, what about a lovely kipper?' – to an appreciative group of country members, foreign visitors, those who have strayed in from their studios or from an all-night party. During the quiet morning the sun reaches into the deeper recesses of the billiard room, tables sheeted and laid out with a crisp display of the morning papers. Katy Tatchell and her assistants – all called Emma – preside over the office, sorting through the confusion of accounts and members' complaints, administering unflappable assistance to the multitude of bizarre requests that come from all sides. As lunchtime approaches the bar is open. The bar staff, until recently governed by the redoubtable Brenda but now by the patient Max and the colleen Bridie, prepare for the first real onslaught of the day.

The dining-room has also made its preparations. This is under the capable hands of Tony Costello, from La Coruna in Spain, who came to the Club in 1980. He had worked as a cook in London and arrived at the

Recently departed and much missed, Slim Gaillard at the piano.

Hugh Gilbert, Chairman of the Club in the Centenary year.

Club after a vigorous experimental time in which a number of inexpert young ladies had vainly tried to produce home cooking for a small number of diners. Tony Costello brought professional expertise and introduced a cuisine of plain continental food. For the first weeks he was alone in the dining-room, cook, waiter and washer-up, producing ten or fifteen meals per sitting, but business soon began to build. His first staff appointment was Edmund from Guinea, who still works in the kitchen. Tony is now dining-room manager with a staff of four waitresses and the chef is his brother Ricky Gibbs. The food is freshly bought each day – the kitchen possesses no freezer or microwave – and the dining-room serves thirty to forty lunches and more than one hundred dinners each evening. It is a long lunch around the white scrubbed table. During good summer weather in the garden, lunchtime drifts well into the afternoon.

No time passes, it seems, before the evening drift to the Club has begun. Some come along the Fulham Road, with perhaps a brief stop at the Queen's Elm to check if friends have gathered there, past the flower-sellers on the corner, fumbling for keys to the little door on Old Church Street. As Andrew Logan described: 'It's like *Alice in Wonderland*. As you stoop to go through this little door, drink a bottle that says 'Drink Me', and this great expanse opens up with croquet players on the lawn and pink flamingos.' The better-dressed members come from the Sloane Square end of the King's Road for a meal with clients in the media or publishing. Already the noise from the bar has a bite and a boom to it, and snooker has begun with great concentration. A great deal of energetic conversation, dining, perhaps a final visit to the bar where the piano is now being played (sadly no longer by Slim Gaillard), concludes a typical evening in the Club.

During this centenary year the Council, under the Chairmanship of Hugh Gilbert, has been looking at its own structure and also at its future, making a number of changes which directly affect the membership. The first of these is felt as soon as a new member joins the Club and is asked to contribute a work of art on paper. The aim is to establish a contemporary collection of work within the Club. This will be augmented from time to time by purchases of works made through the Chelsea Arts Club Trust. This Trust, begun under the recent Chairmanship of Bill English, is able to distribute awards for 'the education of residents of Chelsea and Kensington' and is loosely structured for the widest application. There are also plans to resurrect and extend the Club Library and to improve the range of exhibitions in the entrance corridor.

The Club has had its centenary marked by television and reported in the press. A grand cricket match reviving the argument between Whistler and Ruskin was bravely fought and a giant birthday cake in the shape of the Clubhouse, decorated with a hundred candles, marked the centenary on 18 March 1991. The Vice-Chairman, Barry Martin, has invited a number of Club members to contribute a 'Centenary Portfolio of Prints'. Part of this scheme is a plan for the future: ten of these portfolios will be retained, five for sale in 25 years' time and five in 50 years' time. In the words of Hugh Gilbert:

Overall the abiding concern of the Council during the Centenary Year is to ensure that in another hundred years' time, the Club is still an attractive place for practitioners of the graphic and plastic arts to gather. Past Chairmen all agree that the focus of the Club must be maintained for the benefit of the practising artists. The Chelsea Arts Club is a special place, which will always guard passionately that special flavour brought about by its members, the artists and their associates.

Over the last hundred years the Chelsea Arts Club has played an important, and at times a central, place in British artistic life. Since it was first formed as a select club for gentlemen artists, many changes have taken place and these have quickened of recent years. The need to admit non-artists as associate members was inevitable if the Club was to survive without the continued support of the Arts Balls. Another wholly beneficial decision, to admit women as members, further altered the character of the Club; the pace was accelerated by the large increase in membership that occurred in the 1980s. The Club now has a new and very different organization from any it has previously known – and it is one with which members are still wrestling. The membership includes many who are prominent in the visual arts, as well as other related activities. The old Clubhouse has served its members in very many ways, as a convivial meeting-place, an arena for celebration, for discussion and vigorous disagreement. It has been a retreat from the more arduous aspects of life, a companionable centre where shared interests can be enjoyed. It has been a drinking Club, a dining place, a refuge and a safe haven. Can the Club continue to be true to the ideals of its founders, namely a place for social intercourse for artists? The answer of course lies in the future, perhaps when the bicentenary is celebrated.

Lady Elizabeth Trehane cutting the 100th Birthday Cake at the Chelsea Arts Club, 18 March 1991.

Appendix A

CHAIRMEN OF THE CHELSEA ARTS CLUB

1891 T. Stirling Lee	1917 Sir John Lavery	1940 E.R. Bevan	1967 Ley Kenyon
1894 F. Short	1919 F.M. Lutyens	1946 J. Cosmo Clark	1971 Dennis Stevens
1897 H. Goodall	1921 Alex Jamieson	1948 Loris Rey	1973 Frederick Deane
1899 T. Cowper	1922 Algernon Talmage	1950 Charles Wheeler	1975 William Thompson
1900 D. O'Brian	1924 G. Sherwood Foster	1952 Edward I. Halliday	1977 John Warner
1902 F. Lynn Jenkins	1925 Terrick Williams	1954 A.S.G. Butler	1978 Barry Fantoni
1904 Fred Pegram	1927 Percy B. Tubbs	1955 Harry Riley	1980 Jane Coyle
1906 Captain Adrian Jones	1929 Sir William Orpen	1957 C. Randle Jackson	1982 Adrian Forsyth
1908 George Henry	1931 T.C. Dugdale	1959 John Ware	1984 Roger McGough
1910 J.J. Shannon	1933 Will Dyson	1961 Leonard Boden	1986 Patrick Hughes
1912 T. Stirling Lee	1935 L. Rome Guthrie	1962 T.H.H. Hancock	1987 Nicholas Tucker
1913 Basil Gotto	1936 Henry Rushbury	1964 Henry Carr	1989 Bill English
1915 Henry Poole	1938 Sidney Causer	1965 Edward Bishop	1990 Hugh Gilbert

Appendix B

THE FIRST MEMBERS OF THE CHELSEA ARTS CLUB

F = Founder-Member M = Those present at the meeting of 18 March 1891
O = Original members who joined the Club during its first year

Beach, Ernest	O	Gray, Ronald	F	Norris, W.	MF
Bedford, F.D.	F	Gribble, Bernard	O	Palin, W.M.	F
Benoni, Irwin	O	Gribble, H.A.	O	Parsons, Alfred	O
Black, Arthur J.	MO	Hare, St.G.	F	Pegram, Fred.	MF
Brangwyn, Frank	F	Hartley, Alfred	MF	Petrie, Graham	MF
Brown, Frank	O	Hartrick, A.S.	O	Piffard, Harold	O
Brown, Prof. Fred	MF	Haynes, Arthur S.	O	Pitt, D. Fox	O
Brown, H. Harris	O	Hill, Joseph	MO	Poole, F. Victor	O
Brown, W.E.	MO	Hitchens, A.	F	Riley, T.	MF
Brydon, J.M.	MF	Hollins, H.P.	MO	Roussel, Theodore	F
Bucconi, A.	MF	Holmes, George A.	F	Roderbush, J. Heywood	O
Buhrer, Conrad	MF	Hudson, H.J.	MF	Russell, W.W.	O
Calvert, L.D.	F	Hudson, A.Ford	F	Ryle, A.H.	O
Christie, J.E.	MF	Hughes, E.R.	MF	Sassoon, A.	O
Charles, Jas.	O	Jacomb-Hood, G.P.	MF	Shannon, J.J.	MF
Clarke, E.F.C.	O	Jacomb-Hood, S.	M	Short, Frank	F
Clausen, Geo.	MF	Kelsey, F	O	Sibley, H.T.	MF
Clifford, H.C.	F	Kennington, T.B.	MF	Sickert, Walter	MO
Coles, Wm. C.	O	Knight, Buxton	O	Simpson, J.F.M.	MF
Collins, W.W.	F	Knight, J.	MF	Skipworth, F. Markham	MF
Cooke, Ambrose	MO	Knowles, Davidson	MF	Spain, J.H.	O
Cooke, John	MO	Lee, T. Stirling	F	Stanton, H. Hughes	MF
Cookman	O	Limoner, M.P.	M	Steer, Philip Wilson	MF
Dawson, Nelson	MF	Lindner, Moffat	O	Stretton, Philip J.	MF
Dease, Kenneth	F	Llewellyn, W.	F	Tapper, W.J.	F
Donne, W.J.	MF	Lloyd, J.A.	O	Thompson, George	O
Dressler, Conrad	F	Lond, A. Bertram	MO	Toft, Albert	F
Drury, Alfred	MF	McCormick, A.D.	F	Tonks, Harry	O
Dunning, J.T.	O	Macklin, J. Eyre	F	Townsend, F.H.	O
Elliott, E.	O	Maitland, Paul	F	Trood, W.H.	F
Ethridge, George	O	Marriott, F.	MO	Tuke, H.S.	F
Eyre, John	MF	May, Phil	O	Tulk, A.	MO
Finchett, Thos.	O	Mease, Christopher G.	MF	Walker, A.G.	F
Fontana, G.D.	MF	Morgan, W.J.	O	Ward, E.A.	F
Frith, W.S.	F.	Morrow, Albert G.	MF	Watson, C.J.	MF
Furse, C.W.	MO	Morton, G.	O	Whipple	F
Giles, G.D.	MO	Mostyn, Hon. Harold	O	Whistler, J. McNeill	F
Glazebrook, H. de T.	O	Nash, B.	O	Williams, Terrick	O
Goodall, Herbert	O	Newton, C.M.	O	Winter, J.G.	F
Goodall, T.F.	F	Nicholas, G.S.	F.		

Picture Acknowledgements

Pictures and photographs are from the collection of the Chelsea Arts Club unless as stated below:

The Bateman Estate: 37, 52, 101, 134
Peter Blake: 160 (lower)
Paul Cox: 155 (top)
Barry Fantoni: 148
Don Grant: 151
George Grimm: 103, 131
Mrs D.M. Harvey: 50
Bunny Hudaly: 157 (top)
Patrick Hughes: 153
Bill Michael: back of dust jacket
Imperial War Museum: 49, 53 (top), 56–57, 97, 102
National Portrait Gallery: 16, 18, 23, 24, 25, 31, 33, 34, 72, 131 (top)
Newport Art Gallery: 92
Andrei Puncuh: 44, 78, 87, 88 (lower), 135 (top), 141, 143 (lower), 149, 155 (lower)
William Redgrave: 139
Renfrew District Museums and Art Gallery: 15
John Rose: 68
The Royal Academy: 104 (lower)
Tate Gallery: 126
John Timbers: 156 (top)
Carel Weight: 128

Abbreviations

A	Associate		RCamA	Royal Cambrian Academy
AA	Architectural Association		RE	Royal Society of Painter-Etchers and Engravers
AWG	Art Workers' Guild			
BWS	British Water-colour Society		RHA	Royal Hibernian Academy
F	Fellow		RI	Royal Institute of Painters in Water-colours
GI	Royal Glasgow Institute of Fine Arts		RIBA	Royal Institute of British Architects
H	Honorary Member		RMS	Royal Society of Miniature Painters
IS	International Society of Sculptors, Painters and Gravers		ROI	Royal Institute of Oil Painters
			RP	Royal Society of Portrait Painters
LAA	Liverpool Academy of Arts		RSA	Royal Scottish Academy
LG	London Group		RSW	Royal Scottish Society of Painters in Water-colours
MAFA	Manchester Academy of Fine Arts			
NA	National Academy of Design (New York)		RUA	Royal Ulster Academy
NBA	North British Academy		RWA	Royal West of England Academy
NEAC	New English Art Club		RWS	Royal Society of Painters in Water-colours
NPS	National Portrait Society		SC	Senefelder Club
NS	National Society of Painters, Sculptors and Gravers		SGA	Society of Graphic Art
			SM	Society of Miniaturists
NSA	New Society of Artists		SMP	Society of Mural Painters
P	President		SSA	Society of Scottish Artists
PS	Pastel Society		SSWA	Scottish Society of Women Artists
RA	Royal Academy		SWA	Society of Women Artists
RBA	Royal Society of British Artists		SWE	Society of Wood Engravers
RBC	Royal British Colonial Society of Artists		UA	United Artists
RBS	Royal Society of British Sculptors		VP	Vice-President
RBSA	Royal Birmingham Society of Artists		WIAC	Women's International Art Club
RCA	Royal College of Art			

Notes

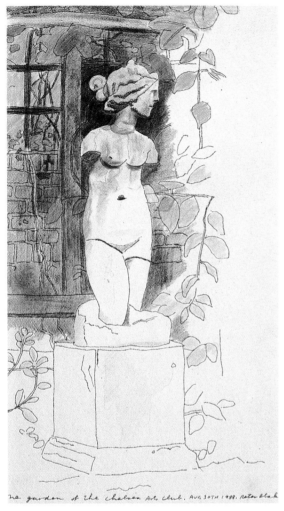

*'The Garden of the Chelsea Arts Club August 30th 1988'
by Peter Blake RA. One of the works that was auctioned
at Sotheby's on behalf of the Club in October 1988.*

Introduction: A Village of Palaces.

General information on the history of Chelsea from:
Chelsea by Thea Holme, Hamish Hamilton Ltd.,
London, 1972; *Two Villages, the Story of Chelsea and
Kensington* by Mary Cathcart Borer, W.H. Allen,
London, 1973; *Chelsea* by William Gaunt, B.T. Batsford,
London, 1954; *Chelsea Reach* by Tom Pocock, Hodder
and Stoughton, London, 1970.

1. The Formation of the Chelsea Arts Club.

1. *Magazine of Art*, 1881.
2. *Brangwyn, a Study at Close Quarters* by Philip
 Macer-Wright, Hutchinson, London, 1940.
3. Macer-Wright, op. cit.
4. Information relating to the formation of the Club
 and early meetings is taken from Minutes of
 Council and General Meetings, members' books
 and other Club records.
5. *Bohemia in London* by Arthur Ransome, Chapman
 and Hall, London, 1907.
6. A list of Chairmen of the Club is included as
 Appendix A.
7. *With Brush and Pencil* by G.P. Jacomb-Hood, John
 Murray, London, 1925.
8. A list of members present at the launch of the Club
 on 18 March 1891, together with the founders and
 other early members, is included as Appendix B.
9. 'Reminiscences' by Ronald Gray, unpublished
 manuscript.
10. There is a very large literature on Whistler. Sources
 include *The Life of James McNeill Whistler* by E.R.
 and J. Pennell (see below); *Men and Memories
 1900–1922* by William Rothenstein, Faber & Faber,
 London, 1932, as well as many others.
11. *A Most Agreeable Society* by Bernard Denvir, The
 Arts Club, London, 1989.
12. Club attendance book 1891.
13. Jacomb-Hood, op. cit.
14. *Brangwyn's Pilgrimage* by William de Belleroche,
 Chapman and Hall, London, 1948.

2. The Move to Church Street.

1. Jacomb-Hood, op. cit.
2. *The Echo*, 10 April 1885.
3. The present address of the Club is 143-145 Old
 Church St., but this name has changed over the
 years. Until the mid-nineteenth century the lane
 that ran from Chelsea Old Church to the King's
 Road was called Church Lane; the stretch from the
 King's Road to the Fulham Road was then known as
 Church St. In 1848 the whole street became known
 as Church St. In July 1937 the upper section was
 renamed Old Church Street. This naming has been
 used in this book.
4. Letter from S. Jacomb-Hood, Hon. Solicitor to the
 Club.
5. *Fifty Years of the New English Art Club* by Alfred
 Thornton, London, 1935.
6. *The Times*, 10 January 1941.
7. 'The Slade' by Andrew Forge, *Motif*, 1960.
8. Rothenstein, op. cit.
9. Letter from Sickert to Alfred Pollard, quoted in
 Sickert by Wendy Baron, Phaidon, London, 1973.
10. Rothenstein, op. cit.
11. Basil Gotto, unpublished memoirs.
12. Gotto, op. cit.
13. *The Whistler Journal* by E.R. and J. Pennell,
 Lippincott, Philadelphia, 1921.

14. *The Life of James McNeill Whistler* by E.R. and J. Pennell, Heinemann, London, 1908.
15. *The World of James McNeill Whistler* by Horace Gregory, Hutchinson, London, 1961.

3. Coming of Age.

1. *Augustus John* by Michael Holroyd, vol. 1 *The Years of Innocence*, Heinemann, London, 1974.
2. *Chiaroscuro* by Augustus John, Jonathan Cape, London, 1952.
3. *Works and Days* by Michael Field (the pen-name of Miss Katharine Bradley and Miss Edith Cooper, friends of the Rothensteins), John Murray, London, 1933.
4. Rothenstein, op. cit.
5. *John Singer Sargent* by Charles Merrill Mount, Cresset Press, London, 1957 and *John Singer Sargent* by Richard Ormond, Phaidon, London, 1970.
6. Mount, op. cit.
7. Jacomb-Hood, op. cit.
8. *The Studio*, June 1907.
9. *Phil May* by James Thorpe, Art & Technics, London, 1948.
10. *An Artist's Life* by A.J. Munnings, Museum Press, London, 1951.
11. *The Man who was H.M. Bateman* by Anthony Anderson, Webb and Bower, Exeter, 1982.
12. Gotto, op. cit.
13. Basil Gotto, letter of May 1914.
14. Letter from Sherwood Foster to R. Sloane Stanley, 3 July 1913.

4. Artists Go to War.

1. *Memories of Chelsea* by Dora Coats.
2. This and other memories of this period are taken from 'Reminiscences of a Steward' by Albert William Smith (unpublished manuscript).
3. *The War Artists* by Merion and Susie Harries, Michael Joseph, London, 1983.
4. Smith, op. cit.
5. Harries, op. cit.
6. Anderson, op. cit.
7. The Club produced a record of this time entitled 'Members' War Service', which details the contribution to the war made by 120 members. This is stored, with other important documents of the early part of the Club's history, in the Local Studies Department of Chelsea Public Library.
8. *The Life of Sir Edwin Lutyens* by Christopher Hussey, Country Life, London, 1953.

5. The Chelsea Arts Balls.

1. Jacomb-Hood, op. cit.
2. *The Royal Albert Hall* by Ronald W. Clark, Hamish Hamilton, London, 1958.

3. General information relating to the Arts Balls from the Minute Books of Chelsea Arts Ball Ltd and from correspondence in the possession of the Club.
4. Smith, op. cit.
5. *Souvenir Programme of the Chelsea Arts Ball and Bystander Coming of Age Celebrations*, 1924.
6. Minutes of the AGM, 1924.
7. Information supplied by John Rose.

6. The Nineteen-Twenties.

1. Letter from Phillip Baynes, 11 March 1913.
2. Munnings, op cit. and *'What a Go', the Life of Alfred Munnings* by Jean Goodman, Collins, London, 1988.
3. *The Builder*, 8 April 1920.
4. Letter to the *Daily Telegraph*, 29 March 1920.
5. *Westminster Gazette*, 11 May 1922.
6. *The Star*, 10 March 1924.
7. *Memoirs of a Soldier Artist* by Adrian Jones, Stanley Paul, London, 1933.

7. A Confident Club.

1. *Souvenir Programme of the Chelsea Arts Ball and Bystander Coming of Age Celebrations*, 1924.
2. *Australian Painting, 1788 to 1970* by Bernard Smith, Oxford University Press, Oxford and Melbourne, 1971.
3. *Australia at War* by Lieut. Will Dyson, with an introduction by G.K. Chesterton, Cecil Putner and Hayward, London, 1918.
4. Letter from F.L. Paviere, 13 April 1935.
5. Letter to Sir George Clausen from students of the Slade School, October 1931.
6. *The Times*, 21 May 1920.
7. Letter of 5 February 1923 by T.E. Lawrence, writing under the name of J.H. Ross, Tate Gallery Archives.
8. *The Drawings of Henry Moore* by Alan G. Wilkinson, Tate Gallery, London, 1977.
9. *Sculpture of Today* by S. Casson, Studio Special, London, 1939.
10. *Lilliput*, September 1958.
11. *Hugh Casson's London* by Hugh Casson, London, 1983.
12. *Naum Gabo talks to Maurice de Sausmarez and Ben Nicholson*, Studio International, London, 1969.

8. War and Post-War.

1. Shelter Log, Chelsea Arts Club, 15 September 1940, by J.L. Pemberton.
2. *Chelsea Old Church: Bombing and rebuilding 1941-1950* by Leslie Matthews, London, 1957.
3. With the coming Jubilee of the Club in 1941 it was hoped to write a history of the Club. A group of senior members were approached and asked for their reminiscences. A number of extracts from these previously unpublished notes have been included in this book. It was also decided to ask A.P.

Herbert or James Laver to write the history, but this ambitious project was not completed.

4. Henry Rushbury writing to his daughter Julia, March 1942.
5. Adrian Bury writing in *The Studio*, vol. 144, 1952.
6. *Just a Moment, Time* by Adrian Bury, Charles Skilton, London, 1967.
7. Bury, op.cit.
8. Goodman, op.cit.
9. Speech by Sir Alfred Munnings at the Royal Academy Banquet, 1949.
10. *'High Relief', the Autobiography of Charles Wheeler*, Country Life Books, London, 1968.
11. Holroyd, op.cit.
12. *Daily Telegraph*, November 1961.

9. The Last of the Balls.

1. Ronald W. Clark, op. cit.
2. Correspondence with Loris Rey.
3. Report by Loris Rey.
4. *Not All a Ball* by John Moynihan, Macgibbon & Kee Ltd., London, 1970.
5. *Evening Standard,* 3 October 1984.
6. *Dance Till the Stars Come Down* by Frances Spalding, Hodder and Stoughton, London, 1991.
7. Alan O'Brian in *Lilliput*, September 1958.

10. Changes in Chelsea.

1. *The Royal College of Art* by Christopher Frayling, Royal College of Art, London, 1987.
2. *Rodrigo Moynihan* by John Ashbery and Richard Shone, Thames and Hudson, London, 1988.
3. Spalding, op. cit.
4. *Journal* by Keith Vaughan, John Ball, London, 1949.
5. Paul Wyeth's painting was exhibited at the Royal Academy in 1960.

6. *Two Flamboyant Fathers* by Nicolette Devas, Collins, London, 1966.
7. *The Times*, 1930.
8. *Lais and Xenocrates*, after Gerrit van Honthorst, appears in the background of Thomas Dugdale's painting of members in the Club dining-room. Reproduced on p.84.

11. From Crisis to Catastrophe.

1. Conversations with Frederick Deane and other members.
2. Paper circulated to members, summer 1966.
3. Letter from Harold Underwood Thompson to the author.
4. Letter from Dame Laura Knight, 16 December 1966.
5. Conversations with Ley Kenyon.
6. Conversations with Stanley Ayres.
7. Conversations with John Frye Bourne.
8. Conversations with Frederick Deane.
9. *A Strange Lot of People to be Sure* by Jeffrey Bernard, *Sunday Times*, 13 May 1975.
10. Letter by F.H. Potter, 5 May 1975.
11. *Robert Buhler* by Colin Hayes, Weidenfeld and Nicolson, London, 1986.
12. Ruskin Spear writing in the Club magazine, 1989.
13. *Ruskin Spear* by Mervyn Levy, Weidenfeld and Nicolson, London, 1985.
14. Robert Buhler writing in the Club magazine, 1989.

12. Ingredients of Success

1. Barry Fantoni, *Tatler*, November 1988.
2. Conversations with Jane Coyle.
3. The Club magazine, 1989.
4. 'Twenty-Four Lines from the Chairman' by Roger McGough.
5. Molly Parkin, *Tatler*, 1980.

Index

Note: Page references to illustrations are in italics.